COMICS EXPERIENCE® GUIDE TO WRITING COMICS

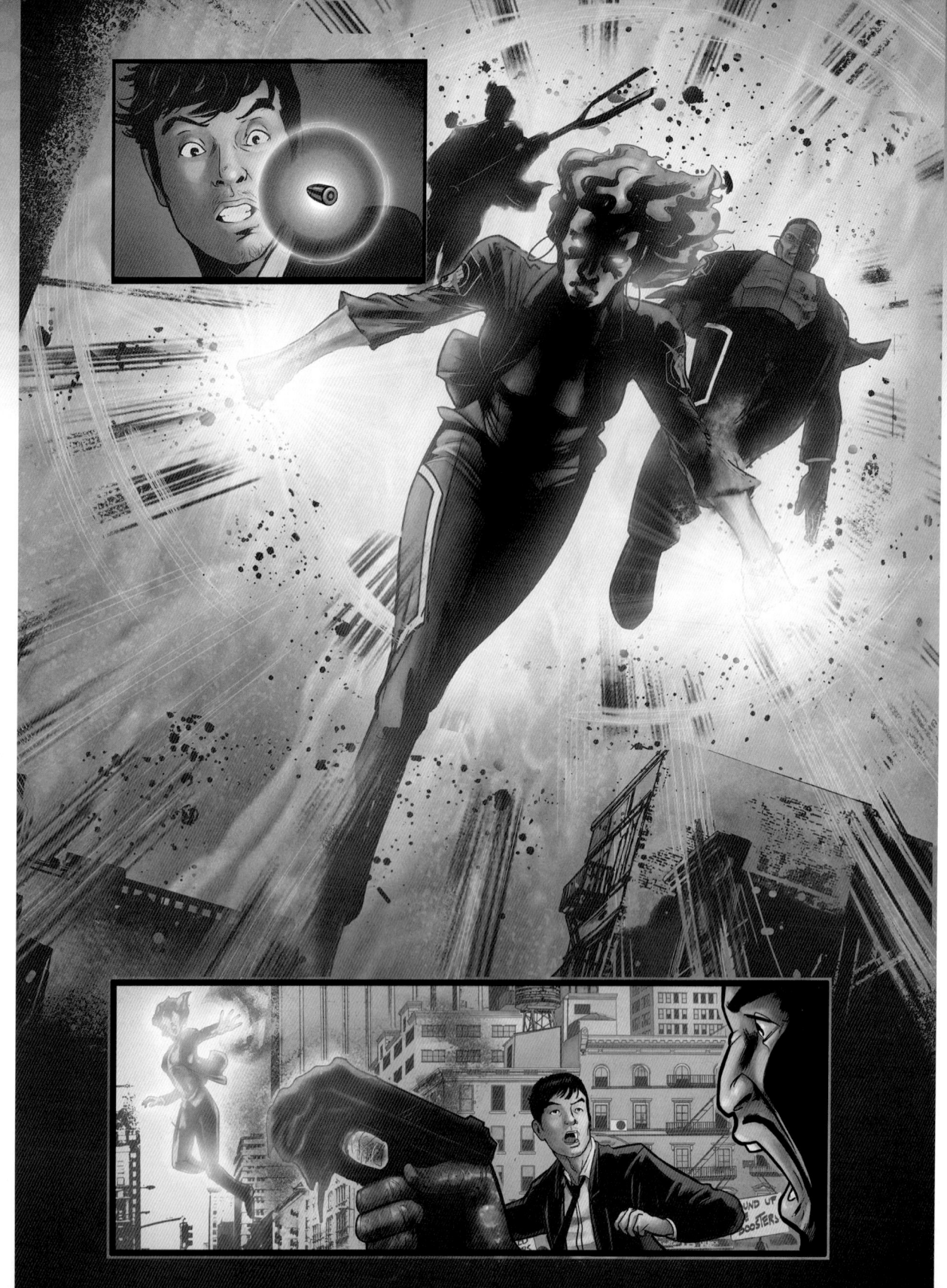

COMICS EXPERIENCE GUIDE TO WRITING COMICS

SCRIPTING YOUR STORY IDEAS FROM START TO FINISH

ANDY SCHMIDT

Achilles Inc. no. 1, interior. Interior art by Daniel Maine and Francesca Zambon. Copyright Andy Schmidt, 2017.

IMPACT
CINCINNATI, OHIO
IMPACTUniverse.com

CONTENTS

Introduction 6

PART 1
BREAKING STORY 8

1. STORY 10
Get started with a vocabulary lesson on all the important terminology used by writers and artists in the comics industry, then learn how to develop your initial concept an basic story structure.

2. CHARACTER 22
Your characters are the most important aspect of your story, not to mention how your readers will connect with it as a whole. Learn to build compelling characters from scratch that will drive the action of your narrative and keep your readers coming back for more.

3. THE STORY SENTENCE 36
Learn to compose a story sentence, which is the seed from which your story will grow. Your story sentence is made up of four essential elements that make up the foundation of your story: character, goal, action and conclusion.

4. LEVEL-UP THE STORY 52
Delve into some of the more advanced topics of storytelling, such as theme, symbolism, pacing and genre, to expand your skill set as you grow as a professional storyteller.

PART 2
WRITING FOR COMICS 66

5. LAYERING 68
The scalable process learned in this chapter can be just as successfully applied to a five-page short story or twelve-issue graphic novel. Learn to break down your story synopsis into progressively detailed layers such as chapters and scenes, plus acquire great tips and tricks for adding in exposition.

6. OUTLINING 82
Expand on the layering process of Chapter 5 by creating a detailed outline of your story. By breaking down your story scene by scene and then page by page, not only will your comic book take on its full shape, but you will gain the confidence you need to formulate your first story pitch.

7. Writing Visually for Your Artist 92

From the anatomy of a comic page to script formatting, this chapter teaches you how to write effective panel descriptions so that your artist can interpret your vision to the reader.

8. Writing Visually for the Reader 108

This chapter covers the unique aspects of writing for the visual medium of comics. Learn how to create the ultimate comics reading experience by maximizing key tools such as the page turn and splash page and get the most out of the relationship between your text and the art.

9. Writing Dialogue for Comics 122

There's no sugarcoating it: Writing natural and believable dialogue is tough work. Here we break down the basics of comic-book dialogue from script formatting to balloon placement to the power of subtext so you can connect your story and art in the best way possible.

10. Overview and Quick Guide 138

This chapter presents a recap of everything we've covered up to this point through a real-life comic script example about four astronauts and their quest to save the Earth.

PART 3
Navigating the Comics Industry 150

11. Networking and Collaboration 152

Unless you plan to design, ink, pencil, publish and market your comic-book script all by yourself, you will need skilled artists and collaborators to help bring your comic to life. Master the art of networking at comic conventions and on social media to meet the folks who can help you do just that.

12. Building a Career in Comics 164

The comics industry is constantly evolving, and focusing on your growth as a storyteller and building your personal network are the two best ways to stay ahead. This chapter discusses some of the nuances of the business and some of the ways you can break in.

Index 172
About the Author 175
Acknowledgments 175

INTRODUCTION

I'm assuming you're going to write. There are many books on the subject of writing that take us from "why we write" to "story structures" and "dos and don'ts." That's not this book. This book is nuts-and-bolts fiction writing—but not just fiction—fiction for comics.

As such, the book is broken into three sections:
1. **Breaking Story.** Most of this section applies to story in any medium.
2. **Writing for Comics.** This is how we break story for comics, where what you write stops being a story and becomes a comic-book script.
3. **Navigating the Comics Industry.** This part isn't as fun for many people, but there's no getting around the importance of knowing the industry and getting to know people in it. This section will help you do just that.

In the cases of Parts 1 and 2, I'll outline and drill down on proven ways to break story. This isn't paint by numbers—that doesn't do any of us any good and leads to more mediocre and bad fiction. These are ways to help you get *your* story out, to help you become the writer inside of yourself—not a clone of me.

As we move into the comics-script-writing side, there's one issue I have with most comics-script-writing books: They tell you the truth. Wait, is that a complaint? Not really. I don't fault any of those books for telling the truth, but not everyone needs to hear the truth. The truth is that there is no set way to write a comic-book script. There is no set format, no industry standard. Ultimately, what works, works. And that, dear readers, is absolutely true.

Unfortunately, it's not terribly helpful to those of us trying to figure out how to write excellent comic-book scripts (like I was in St. Louis, Missouri, circa 1998). When I was reading books on comics writing, I was getting theory, but what I needed was the how-to knowledge of what makes a good script. How do I write compelling panel descriptions for my artist?

How much dialogue works on a page? How much story can I cram into each panel? That book didn't exist then, and it doesn't exist now (at the time of this writing).

What I've learned through years of teaching, both as a comics editor (on staff at Marvel Comics and IDW Publishing) and through my Introduction to Writing Comics class at Comics Experience, is another simple truth: While it is true that there are no industry standards, it is equally true that someone learning to write comics—learning to do anything for the first time, really—needs structure.

They need guidance, and when they look at a blank computer screen and start pounding away on a keyboard to create a script that an artist will draft from or that a letterer will letter from, that blank screen is too open. You can do anything on that screen. While freedom is an awesome and powerful thing, it can also be scary.

You have a story to tell. It's your story. But in order to tell it in comics, you have to be extremely good at all the obvious things that go with telling stories: character development, crafting character arcs, setting up conflict, plotting and creating highs and lows for your characters. Of course you have to do all that. And that's hard. In comics, you also have to be a co-creator, a collaborator and a partner, you have to be an art director, a problem solver and a project manager; you have to have an ear for dialogue, you must know pacing (visual as well as verbal), you have to inspire your artist, and you must compel your reader to push on from one page to the next. All this stuff is even harder!

Who of us is born with all of those skills, fully formed, inside of us? I'll tell you who—none of us. Don't believe me? Read the introductory chapters of *Words for Pictures* by Brian Michael Bendis or *Making Comics Like the Pros* by Greg Pak and Fred Van Lente. I'm paraphrasing what Bendis, Van Lente and Pak all said about their own work early on when I say, "It sucked." They all had to learn the craft! Every one of them had some kind of mentor and made the

right connections in the industry, and it worked out for them.

I'm no different. And neither are you.

This book, based on the online Introduction to Comics Writing class that I created when I founded Comics Experience, is not a true substitute for the course itself. I can't give you the personal feedback that you get in my course. You won't meet and work with the other talented people that would be in your class, and I can't pinpoint your strengths and weaknesses from these pages. There's only so much a book can do to help you. But the book can serve as your guide. It can help you, if you commit to it—right now. It can help you if you open your mind to the ideas and exercises inside.

Step one is looking at that blank screen and deciding where to begin. If you're committed to writing a short comic-book story with this book as your co-pilot, then I'll tell you where to begin.

Begin with yourself.

Exalt, interior. Interior art by Matt Triano. Copyright Andy Schmidt, 2017.

You have to know—not believe—*know*: You can do this. And you can. I'm telling you right now, *you can do this*. All you have to do is commit. Done? Great. Now, as I said, I'll tell you where to begin.

Begin with Chapter 1.

Continue Learning With Comics Experience

I started Comics Experience back in 2007 to create the kinds of courses and community that I wish had existed when I was starting out in comics. That's the litmus test I use for all of our courses: Is this something I wanted or needed to start or further my journey in comics?

We've expanded our roster of comics-writing and art courses to include lettering, coloring and even law for comics creators. We've created a private online community with our Creators Workshop, where we work together to help everyone improve their craft and talk about industry topics and how to produce their comics, whether printed or online!

We recently partnered with a comics publisher and help shepherd projects from idea to finished and published comic with national distribution and reach.

If seeing your work through or growing your skills is on your mind, please check out www.comicsexperience.com and see if we've got something that's right for you!

In the meantime, I hope you find this book to be a great resource!

Andy Schmidt
President
Comics Experience

PART 1

Breaking Story

In Part 1 we'll explore the fundamentals of story itself. The chapters and lessons found here can apply to story in any medium. Before you sit down to write a comic with all the particulars of comics-script writing, it's necessary to understand and master the fundamentals of story itself, an often overlooked or rushed part of the comics-writing process.

PRAETOR

CHAPTER 1

STORY

The word *story* brings to mind movies, novels, comics and, sometimes, terrifying tales around a campfire. All stories have common elements, but defining exactly what a story is can be tricky. When I teach my comics courses, my students might say a story has a "conflict" or "a beginning, middle and end" or is "a hero's journey." All of which are aspects of storytelling or, more to the point, are elements of stories well told.

But what is a story exactly? What are a story's essential ingredients? I could answer that right here, but I think there's great value in running through it one step at time. It's more important to understand what story is than to simply know the definition.

Praetor, development artwork. Art by Jose Ladronn. Copyright Andy Schmidt, 2016.

INDUSTRY DEFINITIONS AND TOOLS OF THE TRADE

The following list of definitions gives you a basic vocabulary for publishing, art and writing for comics. You'll want to bookmark this spread and refer back to it whenever necessary.

Comic-Book Roles

Writer: The person who writes the script for the artist. It is entirely possible that the writer may also be the artist, but a writer may only write a script that an artist will illustrate, and then a letterer will paste up the balloons and captions. There are several different kinds of comics scripts, but we will discuss those in Part 2.

Penciller: The artist of the book. The penciller's primary responsibilities are ensuring that the visual storytelling works and communicates clearly. This is the person who lays out all of the visual elements on the page and renders them fully before they are inked and colored. In general, the penciller, along with the writer, are considered the "storytellers" of the comic book. Please note: That's not meant to undercut the importance or the storytelling aspects of the other creators involved.

Inker: The inker, if different from the penciller, will take the penciled art from the penciller and overlay ink across the pages. The inker serves several important functions, including finalizing the look of the art, adding lighting and perspective aspects and rendering tone.

Color Artist or Colorist: After the inker is finished with the pages, she typically scans them and sends copies of the digital files to the colorist and the letterer. The colorist, typically using Photoshop these days, overlays color on the completed line art, adding depth of field and lighting effects and enhancing the overall storytelling.

Letterer: The letterer places the word balloons, captions and any text onto the pages. Do not underestimate the importance of a good letterer. A fre-

Robert Atkins is a seasoned comic book penciller and storyteller, having worked on hundreds of comics. He's taught the bulk of Comics Experience's art courses for the last eight years.

quent beginner mistake is to use a less experienced letterer on your book to save money. This is a trap because nothing signals to the reader that a book is not professionally done faster than poor lettering.

Editor: Many comics created by a writer and artist don't use editors, but having an extra set of eyes on all aspects of the work can be extremely useful. An experienced, well-trained editor can offer fantastic feedback on all aspects of the work, improving it considerably. Editors are also frequently tasked with keeping the trains running on time—essentially serving the function of project manager.

Publisher: This can be a company or a person. The publisher undertakes the marketing, printing and distribution aspects of a comic or graphic novel. No

Here's an art board page showing copy-safe, trim and bleed areas.

publisher can do this work without some assistance from the creators, but these are the publisher's primary duties.

Comic-Book Terms for Writers

Page: A page is one side of a sheet of paper from the fold in the middle out to one edge. It is read from top left to bottom right. It is usually comprised of more than one panel, but it can be one panel only.

Facing Pages: Two pages that are visible at the same time are called facing pages. They are read as two independent pages despite the fact that they are both visible.

Double-Page Spread: When two facing pages are joined by an overlapping element and intended to be read across the fold of the book, they are called a double-page spread. The story on a spread is read as if the two pages were one single page, so you read from upper-left to upper-right corner, moving over the fold or spine of the book. Once you've read all the way across to the top right corner of the right-hand page, your eyes move back to the next section down on the left side of the left-hand page and read from left to right again, repeating until you've reached the bottom right corner of the spread.

Panel: A single confined image within a page. Panels are the building blocks for comic-book storytelling.

Art Board: Bristol board is a specific type of art board made for comics to be printed at the standard North American size. The boards made specifically for comics are usually 11" × 17" (28cm × 43cm) in total and will include blue-lined information on them with places at the top for the title of the book, issue number, page number, the penciller's name and the name of the inker. They also include technical lines and information that are very valuable to the artist. The blue markings will not be picked up by a scanner set to scan in bitmap, so the board can clearly mark where your copy-safe and trim lines are, and those measurements won't show up in the final printed comic book.

Copy Safe: Copy safe is an invisible (to the reader) border that sits inside the trim lines, indicating where it is safe to place dialogue and important action. During the comic-book printing process, the printing press plates may shift slightly, so the content of a page could potentially shift in any direction on the page. The copy-safe area should prevent any important action or dialogue from being cut off the page if the plates do slip.

Trim: The trim is the second and outer invisible (to the reader) border on every page. The trim lines depict where the image will be cut (or, at least, should be if the plates don't slip upon printing). Anything outside of the trim lines will be trimmed off the page after printing.

13

Bleed: The bleed area on a page is everything that is outside of the copy safe and extends past the trim lines. This area can contain artwork, but it is called "bleed" because it will bleed off of the final page after it is cut.

Copy: Copy is any and all written language that appears on the final comic-book page. It can be free floating or written in word balloons, thought balloons, captions or sound effects.

Word Balloon: When characters speak, the dialogue typically fits into white balloons with black outlines. Each balloon will also have a short pointer extending from it toward the speaker, indicating to whom the dialogue is attributed.

Thought Balloon: This is the same as a word balloon except its edges and pointer look like puffy clouds, indicating that the words contained inside are the character's inner (unspoken) monologue.

Caption: Captions are boxes that contain copy inside them. They can be any shape, though they're usually rectangular, and typically sit on top of the artwork, like a dialogue balloon. A caption can be any kind of narration, be it first person, an omniscient narrator or any other narrative device.

Sound Effect: Sound effects indicate a noise of some kind relating to the panel in which the sound effect appears and are not usually contained in a box or bubble. The "bang!" from a gunshot is a sound effect and would not be contained in a caption box.

WHAT'S THIS ALL ABOUT?

Now that you know your way around the comic-book page, let's get back to story. Your story is about . . . *something*. For many writers, we often start out not fully knowing what that something is. We just know we're compelled to write. But here's the thing: You've got to figure it out.

You may want to explore a particular idea like man's relationship with technology or what happens when one person wields power over another or any other idea. Or you may want to explore a theme like the tragedy of war or man's battle with nature. There are thousands of these types of themes to explore.

But most of us today, especially if we're trying to write something with the intent to earn money from it, tend to lean into a *high concept*. A high concept might be something like "An asteroid is headed for Earth" or, in the case of *Gutter Magic* by Rich Douek and Brett Barkley, "What if World War II was fought with magic instead of technology?" High concepts are designed to hook a reader by just the idea itself.

The interesting thing about high concepts is that they are not indicative of how good the story will actually be. What makes a story good is *how it is told*.

Consider this: Have you ever read a book with a fantastic high concept and found that not only was it not what you expected, but it also wasn't particularly compelling? I'm sure you have. And if not a book, then a movie. It's a disappointment that we've all felt. That high concept may still be exciting, but the

> ### Works in Progress
>
> Throughout this book, I'll be using both published works like Five Days to Die and Achilles Inc. and unpublished works such as Exalt, Avalon, Praetor and Babylon. These unpublished projects are currently in development. You're seeing them as I'm working on them—a snapshot into the process as it currently exists. And, once published, you can see how they changed and evolved from here.
>
> It also means that I'm using working files for many of our demonstrations and that the conversations and thought processes are fresh. I'll be talking about the process of writing comics while giving you examples from my current process—a thing that is always evolving.

execution of the story—how the story was told—just wasn't that great.

On the flip side, have you ever seen a movie or read a novel where you weren't all that interested in the concept, but once you got into the story, you found that you loved it? I have. I distinctly remember as a child being dragged kicking and screaming to a movie called *The Princess Bride*. I absolutely didn't want to see some romance movie about a princess—even the title turned me off. Well, it turns out that the film and book are both excellent—compelling, humorous, adventurous. To this day, it's one of my favorite stories. The high concept still doesn't grab me, but it's just so well told that I love every minute of it.

WHERE STORIES COME FROM

While a high concept can be useful, they don't always occur to me. I often start with something else, and if I'm lucky, I may back into a high concept. I tend to start with one of the following:

Character. More often than not, a character pops into my head. Not always fully formed. In fact, sometimes it's just an image that I find interesting and I'll find myself wondering (and discovering) what that person is all about. What is her desire? What can she do? Where is she from? And so on. Then, from that character, I'll wind up defining the world she inhabits and the story she will propel herself through.

Genre. I tend to go through phases—especially with movies. At the time of this writing, I'm going through an eighties and early nineties action movie phase. I'm eating them up and having a great time watching them with friends. While that's fun and all, it wouldn't surprise me if watching these (admittedly pretty bad) films encourages me to do something in the action/thriller genre. And while that may be my start—to write the proverbial good action story—my story won't actually resemble the films we're watching outright. I won't be stealing scenes or characters.

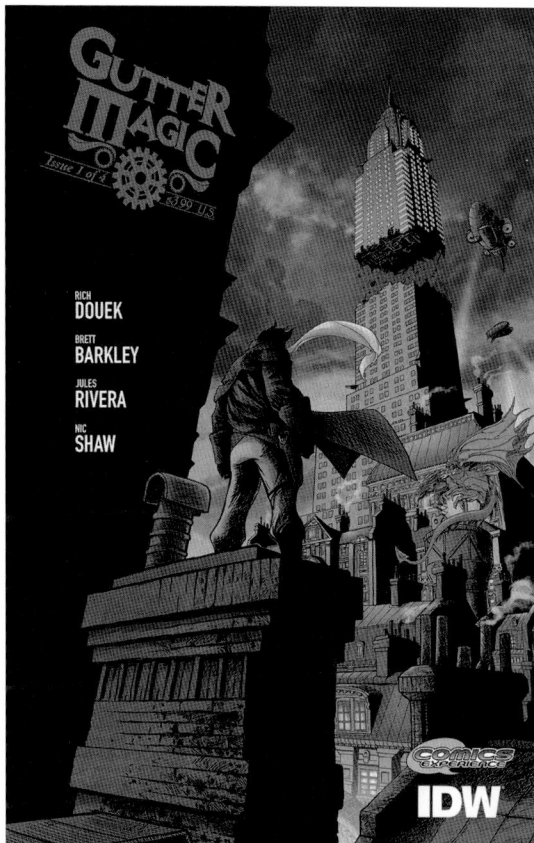

***Gutter Magic*'s** premise asks the question, "What would the world be like today if World War II had been fought with magic instead of science?" It's an intriguing concept that resulted in high interest in the comic as it launched.

Gutter Magic no. 1, cover. Written by Rich Douek, illustrated by Brett Barkley. Published by Comics Experience and IDW Publishing, 2016.

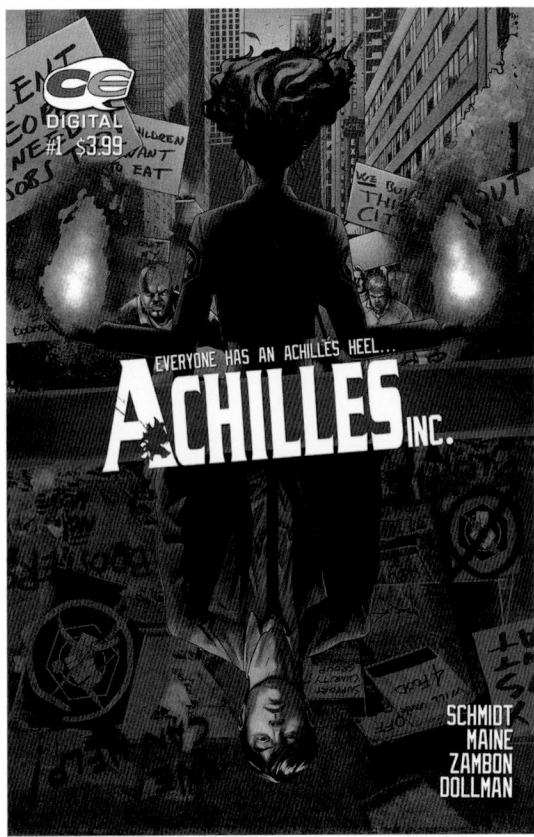 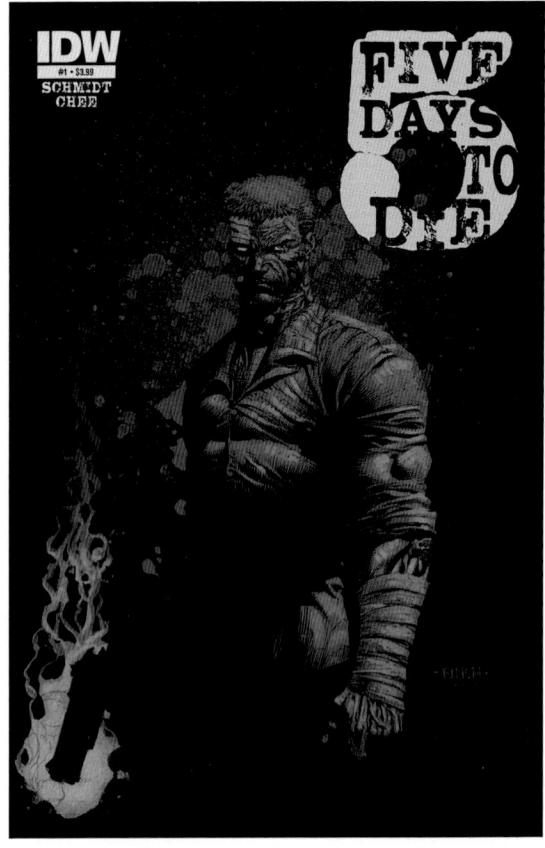

This comic book started out as a scene in my brain. Then it became about the main character and who he was, which eventually lead to the final premise.

Achilles Inc. no. 1, cover. Written by Andy Schmidt, illustrated by Daniel Maine and Francesca Zambon. Published by Comics Experience and Source Point Press, 2018.

In this action-thriller, our hero is given just five days before he will die and he must make a choice: Pursue his archnemesis or reconnect with his daughter before he goes.

Five Days to Die no. 1, cover. Written by Andy Schmidt, illustrated by Chee. Published by IDW Publishing, 2010. Cover by David Finch and Chris Sotomayor.

The desire to tell a story in that genre will prompt me to create new characters and come up with new situations for my story.

Scene. Sometimes a scene occurs to me almost completely written, and it will just take over my mind. Usually, a scene sets up a situation and has more than one character in it. This happens to me fairly regularly. My comic book *Achilles Inc.* started this way. A scene occurred to me in which a clever human, using just his intellect, turns the tables on a superpowered individual about to kill him. The scene entered my brain almost fully written. I wrote the scene out and let it sit for nearly fifteen years before I fleshed it out into the graphic novel it is today. The interesting thing about this approach for me is that the initial scene that pops into my brain almost never winds up in the final product. Workshopping a story into shape based on this kind of an idea almost always renders the original scene unusable in the greater context of the story.

The most interesting case with my own work was my comic book *Five Days to Die* (with co-creator Chee). I had the title before anything else. The title holds in it the nugget of a high concept, which I fleshed out to be: A cop has five days to stop a crime lord or reconcile with his daughter before he dies. It also lent a clear structure—five issues, each issue exploring a single day until the end.

It's not important to know where your story comes from or how you got there if you know why you're writing it. What is it that interests you? What compels you to write *this* story? What was most interesting about how *Five Days to Die* was formed was that it wasn't until I was writing the fourth issue that it occurred to me why I had to write this story. I finally realized that this cop thriller, though no one would ever know it just from the story itself, was really about me becoming a father for the first time. I wrote an essay about it that appeared in the back of the first issue and learned that it meant a lot to many readers and provided a unique context for the book they were reading. That wasn't my intent when writing the essay, but it was nice to realize it connected with people.

In the story itself, Ray, the main character, is estranged from his daughter and has immersed himself in his detective work. He's then confronted with the impending end of his own life. He has a rather simple choice to make—dive further into his work and wrap up the biggest loose end of his career or abandon the job and reconnect with his daughter. And that was the decision I was faced with as a new father: Should I dump some of the workload I had taken on and spend as much time as possible with my new son or continue to use work as an escape from parenting, something I wasn't terribly comfortable with. Ultimately, Ray was much farther down that path than I was, but writing this book helped me realize I wanted to concentrate on becoming a good parent.

Not everything you'll write will wind up coming from as personal a place as *Five Days to Die* did for me. And if someone reads it and doesn't understand what was going on with me, that doesn't mean they won't be able to enjoy it on its own terms. It doesn't matter if the reader knows why I wrote my story or why you're writing yours.

Now, before I get too hoity-toity on you, yes, it's absolutely fine if the reason you're writing something is to see if you can or because you happen to love a particular genre or to make money. The reason is important in so far as you know what inspires you. But here's a secret: Sometimes you think you're writing something for one reason, but you may discover in your writing process that you're actually dealing with something more personal than you realized.

All of this amounts to one simple thing: Story ideas come from anywhere, and they can start in any number of ways. But ideas are still just ideas, worth very little by themselves because they're not yet turned into a story.

THE PROMISE

That's enough about you and why you're writing your comic; let's talk about your reader!

As a storyteller, you're making a promise to your reader, whether you know it or not. When you start a story—any story—you're promising your reader that you will bring it to a satisfying and complete conclusion. You're promising that it will all make sense. It's easy to tell when someone breaks this promise to you.

A good friend of mine, and I won't name names here, is the world's worst storyteller. And that's because he doesn't know what a story is made up of. He starts a story and gives me the situation, and then it goes on and on. And he ramps up some rising action, and I think it's coming to a conclusion, and then it . . . just keeps going . . . and eventually . . . fizzles . . . out. Ugh.

I imagine it's likely that you have a friend like this. And if you don't, there's a fantastically funny scene in the film *Grumpier Old Men* (yes, that's the sequel) in which Burgess Meredith's character tells his son (played by Jack Lemmon) a great story. It's intense and exciting the way he tells it, and when he's through, his son has no idea what he just listened to or why.

Let's quickly unpack what I said above. You're promising to bring the story to a satisfying conclusion. That means there's going to be some kind of conflict, and that conflict will be resolved.

Resolving a conflict means that it's done. This conflict is definitively over. It's not the conflict in which the bad guy runs away shaking his fist at the hero, saying he'll get the hero next time. That's by nature not definitive. This is the conflict in which the bad guy goes to jail, repents his crimes or winds up dead.

Likewise, if the central conflict is a quest, say for a certain lost Ark of the Covenant, that story is only satisfactorily concluded if the Ark is discovered, the bad guys defeated and the Ark secured by our heroes back home (even if it does wind up in a giant warehouse). The Nazi threat to the Ark and to Indiana Jones in this scenario from *Raiders of the Lost Ark* is concluded.

You're also promising that the scenes in your story and the characters are all necessary. You're promising not to go off on tangents that ultimately add up to nothing. To be clear, it's okay to appear to go off on a tangent as long as it ultimately does pertain to the story in a meaningful way.

CONCEPT VS. STORY

One thing that often gets confused is the difference between a story concept (or a hook) and the story itself. Sometimes it's easier to show what something is by way of examples. And, in this case, we have Hollywood to guide the way.

The story concept (often, but not always, the hook) is the idea that launches a story. It's often an inciting incident—that event in your story that sets your characters in motion and propels them to the story's inevitable conclusion. In *Raiders of the Lost Ark*, the inciting incident is the government goons coming to Indiana Jones and sending him to find the lost Ark of the Covenant. In *The Lord of the Rings: The Fellowship of the Ring*, the inciting incident is Frodo being given the ring and told to destroy it in Mount Doom.

These are the ideas behind the stories. They are not the stories themselves. Indiana Jones's story could have been about him hitting a bunch of libraries, paging through old books and determining the location of the lost ark, then flying there on a commercial airplane, going to an abandoned spot in the desert and digging a hole by himself—bingo—there's the ark! Not very exciting but hey, he found the ark.

In Frodo's case, he could have quietly walked all the way to Mount Doom, encountering no other characters, slipped into Mordor unnoticed, and thrown the ring into the fires below. Again, not very entertaining. And the inciting incident in both cases

would remain unchanged—the *story*, however, as written, is totally different in both cases.

If you're still not sure what the difference is between the concept and the story, Hollywood once again was nice enough to give us this great example in the summer of 1998 when two films were released just a couple of weeks apart. They were *Armageddon* and *Deep Impact*. These two films have the exact same story concept, hook and inciting incident. They are both about giant asteroids on a collision course with Earth. The discovery of the asteroid sets all the characters in motion in both stories. The same concept, the same inciting incident, the same hook. But the stories are vastly different.

In *Armageddon*, the heroes of the story take off into space, land on the asteroid and drill into the center of it to destroy the asteroid and save humanity. Everyone cheers. By contrast, *Deep Impact* is about the fatalist notion that there is nothing to be done to stop the asteroid. The story is largely about the people here on Earth, both preparing for impact and then trying to survive the aftermath—totally different in tone, scope and execution. The two films, while clearly spawned from the same concept, could hardly be more different.

STORY STRUCTURE

Most people I know who read about writing comics tend to look at books on writing movie scripts or novels. There's nothing wrong with doing either. In fact, *On Writing* by Stephen King is a phenomenal book, and I highly recommend it. I also recommend Syd Field's *Screenplay* and Robert McKee's *Story*.

Because of the proliferation of books on writing for film, and by the nature of film itself and the popularity of the medium, the three-act structure has gotten more attention than it probably deserves. The important thing to understand about structure is the role it serves. Then you can decide how dogmatic you want to be about following it. Here's what you need to know for writing comics:

Stories are broken into acts. Contrary to popular belief, your story has as many acts as it and you require to complete it satisfactorily.

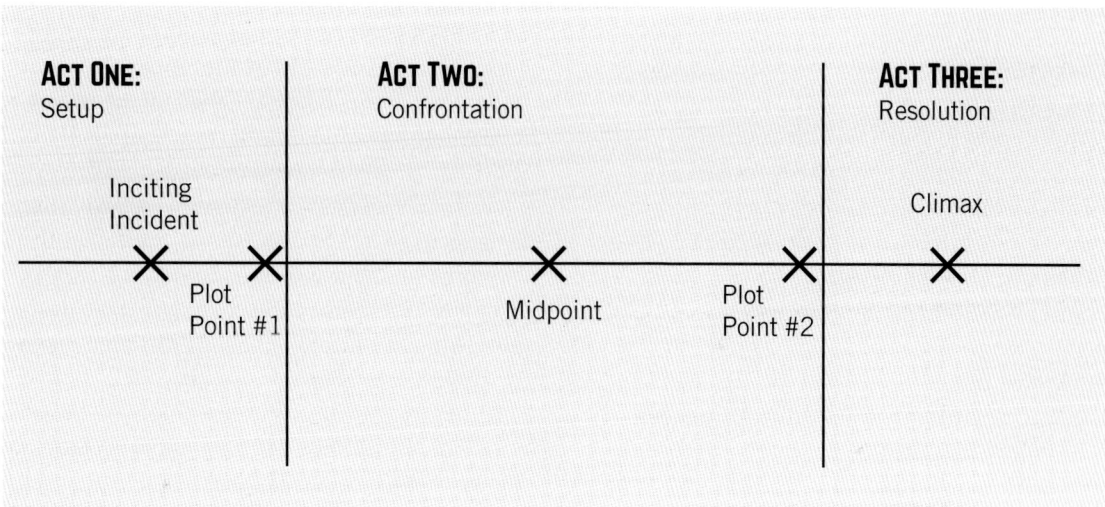

This graph shows the standard story structure for a comic book.

Acts are defined by story events. An act typically begins with low energy in your story, and then the action rises (or the tension builds) until there is a story event called a *major turning point*. Then a new act begins, and the action rises again until we reach another turning point, which leads to a third act and so on, until one of these major turning points is the climax followed by falling action or the resolution.

The most popularized story structure of the last twenty years goes like this:

Act 1

Opening leads to the inciting incident.
 INCITING INCIDENT
Inciting incident sets the story and character in motion toward the inevitable conclusion.

The character takes action, and that action multiplies or intensifies challenges until there is a major turning point—often a change of location—or a major conflict signals the turning point.
 TURNING POINT

Act 2

The character follows new information or has to make an adjustment to achieve his goal. This results in increasing challenges until there is another major turning point.
 TURNING POINT

Act 3

The character follows new information or has to make an adjustment to achieve his goal. This escalates challenges until there is another major turning point.
 REPEAT AS OFTEN AS NEEDED.

The Final Act

The final act sees the character rise to a final conflict in which the pursuit of her goal is either finally achieved (e.g., the empire falls, the treasure is found or she falls in love for real) or decisively not achieved and clearly never will be (e.g., the hero is killed and the rebellion crushed, the treasure is lost in the Pacific Ocean and sinks to the bottom or she turns her back on her lover and pursues her career instead of her relationship).

The denouement simply winds down your story. Minor storylines are resolved, and the reader usually gets a sense of either a return to normal for the characters or an understanding of what the new normal will be.

The important thing to realize is that the story structure is a guideline. Your story doesn't have to be three or four acts. It can be one. It can be five (this is common in television due to commercial breaks), or it can be many more. You determine how many acts your story has, or, probably more accurately, you will create an outline and then *identify* how many acts your story has according to the outline as well as your major character's story arc. But we'll get to all that soon enough.

TO SUM UP

The story is not a hook, it's not an inciting incident, it's not a character, and it's not conflict or genre. The story is the *execution* of all of those things together. The story encompasses all elements above. We talk about a story being good because it is well told. To be precise: A story is about a character that strives to achieve a specific goal and either succeeds or fails completely.

Now at this point, you should have your story's shape forming in your mind. It's time to boil this down to the very first thing you need to build a story: the story sentence.

Your story sentence—the thing you will cling to for dear life as you endeavor to create a beautiful storytelling tapestry on a blank computer screen—goes

> ## EXERCISE
>
> ### What's Your Story
>
> Take the story sentence (i.e., character is trying to achieve goal by taking this action), and plug your story into it!
>
> Who is your character? What is his ultimate goal—that thing he can't do without or is driven to achieve? And what steps would your character take to achieve it?
>
> ### Here's an example:
>
> Star Wars: Luke Skywalker (character) is trying to live a life of adventure (goal) by learning the ways of the Force (action) and joining the Rebellion.
>
> Does he succeed? What complications does he face along the way?
>
> Let's see what you've got cooked up already!

like this: *character* is trying to achieve *goal* by taking this *action*.

Write this down. Go ahead. Write it down. Everything will come from this.

Now, you may not have all of those elements collected in your head for your story right now. Don't worry, a huge part of writing is taking a piece or a few pieces of a potential story and figuring out the rest as you go. The methodology we'll use in the rest of this book will, one step at a time, get you from a story fragment like you may have now, to a finished comic-book script.

To be continued....

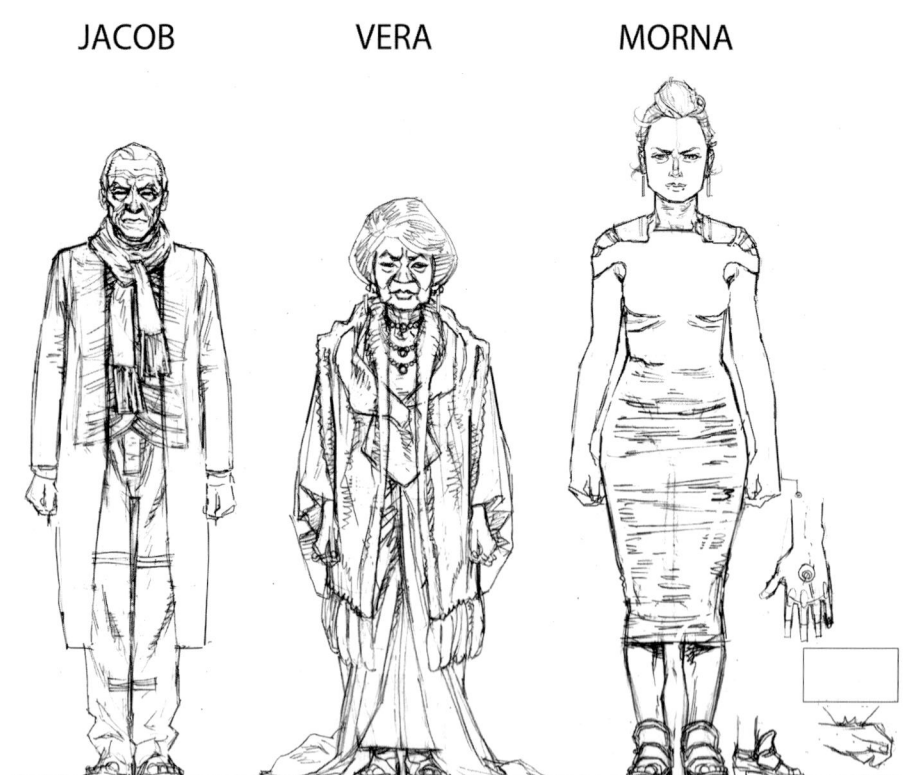
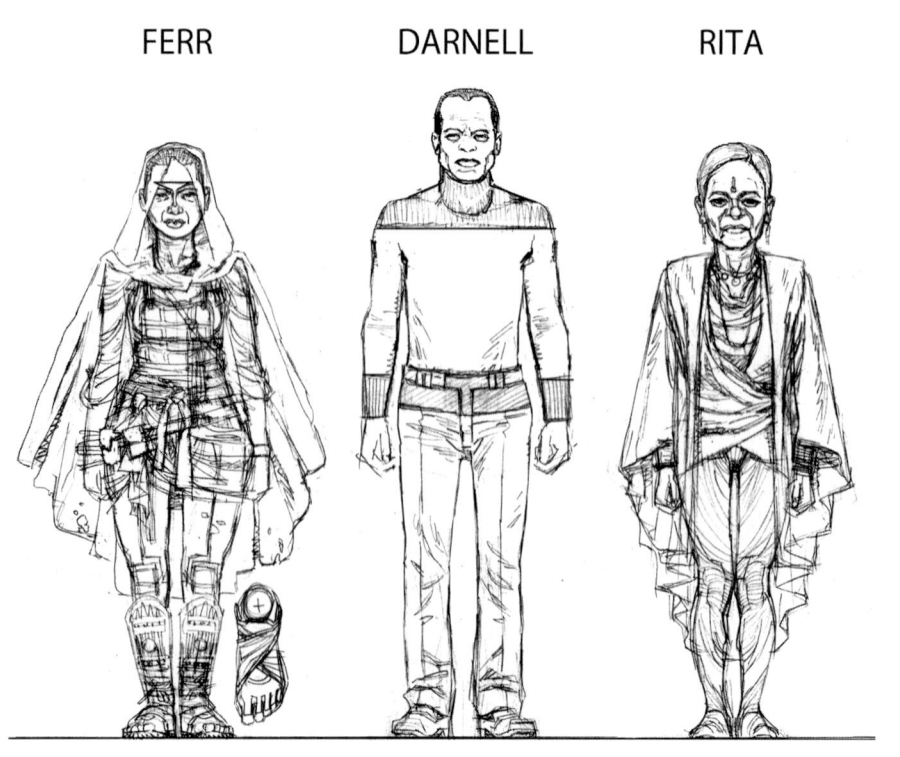

CHAPTER 2

Character

Most people don't really understand the importance of characters to a story. But the truth is that it's not the concept behind a story or the plot itself that make us want to come back, though those are the two things we tend to jump to when we describe a story we've read or seen. It's the characters. We want to spend time with them again and again.

The characters and how the audience relates to them determine how successful, both creatively and financially, a story will be. But how do we build a character from scratch? How do we create characters on a blank screen or an empty page?

In this case, artist Matt Triano and I designed characters who stood apart from each other and held true to their various upbringings. We wanted to communicate ethnic identity, wealth, social status and type of work.

Exalt, character designs. Written by Paul Allor and Andy Schmidt; illustrated by Matt Triano. Copyright Andy Schmidt, 2017.

CHARACTER AND PLOT

You might wonder why we're talking about character before we talk about the plot. And if you are, that's a good question. The two—character and plot—are linked and should not be able to be separated.

When I was an editor reviewing story proposals for Marvel or IDW Publishing, I frequently used this simple litmus test: If the main character in the story were swapped out for a different character, would the story change much? If the answer is no, then you're just plugging a character into a plot template but the story isn't about the character. If the answer is yes, it would change dramatically, then that's a good sign.

It's fine to have an idea for your plot first, but it must be linked to your main character in a way that means if you alter either, the other must also change. Your character's decisions will drive the plot and, more importantly, how events unfold—especially your ending.

Imagine, if you will, a simple action movie's plot. Let's use the film *Speed* as the example. The film posits that if a bus goes under fifty miles per hour, a bomb will detonate. It's up to our hero to get the people off the bus and beat the bad guy without

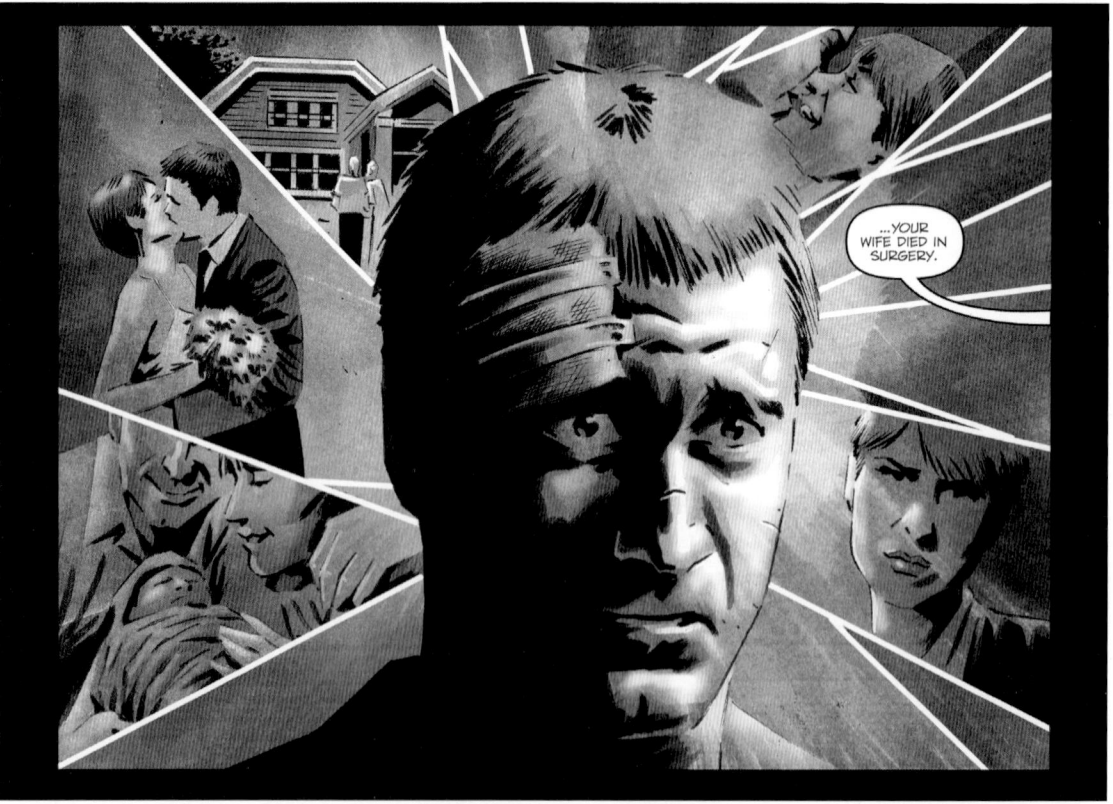

Ray's life shatters when he's informed of his wife's death. Chee illustrated this with the literal shattered effect of Ray's life behind him. This is his character. It determines what kind of obstacles he must overcome as well as what drives him to overcome them. Plot follows from character.

Five Days to Die no. 1, interior. Written by Andy Schmidt; illustrated by Chee. Published by IDW Publishing, 2010.

anyone dying. Here, our hero is a police officer of the variety only Hollywood can provide.

Now, let's imagine this same plot but with, oh, Superman as the hero. Superman swoops through the bus at super-speed, rescues all of the passengers and kicks the bus off the highway so it explodes without causing injuries. Then he uses his X-ray vision to find the bad guy. Movie over.

This is an obvious case, but it makes the point—swap Superman with Keanu Reeves, and the plot is very different. What this example doesn't show is how the character arc is different for your main character. That's a little harder to illustrate, but I think you'll get the idea as we work our way through this chapter.

CHARACTERS

We love them. We hate them. We laugh at them. It's all okay, just as long as we care about them!

The Essential Ingredients of Great Characters

Boiled down, there are a few traits that every character has. Sometimes we're told them outright, and other times we have to infer them, but they're always there for our major players. Here's a quick list:

- **Goal:** Most people think that a character's motivation is the primary ingredient, but we get that motivation from the goal. The goal is what your character is trying to achieve in your story. It needs to be clear, it needs to be obtainable, and your character needs to succeed or definitively fail.
- **Unique Attributes:** And I don't mean superpowers, but they can be. What are your character's unique attributes that make her the right person for the job? Or—this often works for comedies or horror—what makes your character the exact wrong person for the job? The fool thrust into a super-spy mission, maybe? The hardened warrior sent to raise two-year-old quintuplets, perhaps? Regardless, what makes your character the best candidate for this story?
- **Motivation:** There it is! Motivation is designed to justify that goal. Whatever motivates your character is what makes it impossible for your character to do anything but try to achieve that goal.
- **Background:** Like motivation, your character's background or history is there to justify those unique traits. Your character has to have medical knowledge? She was a doctor in developing countries. She needs to be able to climb the outside of a building? Great, she's also a mountain climber in her spare time. And that history is going to be linked to her motivation, which in turn justifies the goal.

There are other traits, but, for a writer, these tend to be the biggest—the ones you absolutely can't do without.

Character Goals

Building a character becomes much easier when you know your character's goal. Like writing an essay in high school, the goal is your thesis statement, and everything else is your evidence to support that statement.

Everything about your main character, your antagonist and your supporting cast comes from the goal. The motivation is created to justify the need to achieve the goal. The history gives us the situation that created the motivation. The unique attributes are designed to help your character achieve the goal. The history justifies why your character has those attributes.

The physical design of your character is going to come from what we now know about her attributes and her history. If she's a doctor, then she may look one way. If she's an environmentalist, then she may live in a certain type of house—one with solar panels and a lot of streaming natural light, for example.

One important note about the goal: In longer form fiction, the goal can change. Your character

may start out with one goal, but during the course of the story may come to realize that she needs to reject that original goal in pursuit of a newer, more enlightened goal.

For example, consider the story of a financial advisor who's trying to get a promotion to become the first super-rich female executive at a male-dominated firm. The original goal is clear: beat out her competition for the giant promotion and bucket of money. But along the way, in pursuit of that goal, she winds up stomping on her competition, and one of them, perhaps a family man, loses his job or maybe loses all of his wealth, and she does real damage to his entire family. For the first time, she's confronted with the consequences of her actions. There are kids now out on the streets because of her. She has a change of heart and decides that her new goal—her more enlightened goal—is to help those less fortunate than herself. She may still get the promotion but then reject it in favor of starting her own non-profit firm to help those who have fallen on hard times.

In this example, her goal changed from getting a promotion to prove her business acumen to helping people who have fallen on hard times. But the goal changed because of her journey, and it makes sense. We see this a lot in films and certainly in novels.

CHARACTER TRAITS

As you can see in the Create a Character sidebar, your character is built from particular character traits. It's useful to spend time defining what these traits are and how we identify them. Let's break them up into a few categories:

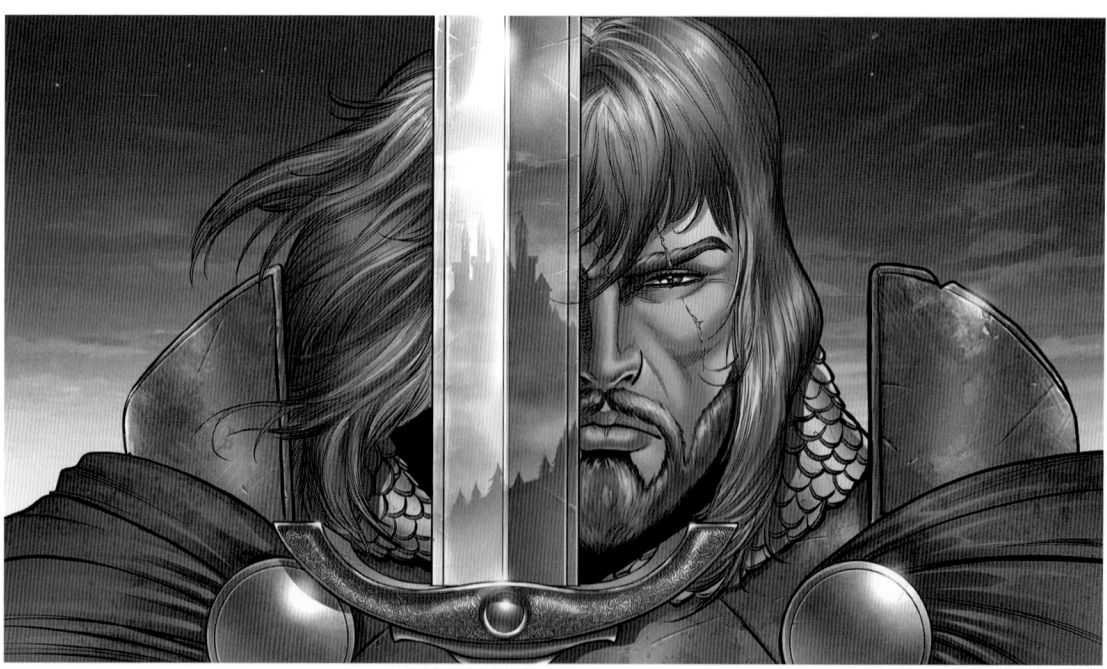

Artist Andrea Di Vito and I sought to capture a well-loved hero from lore—King Arthur. But it was also important to depict some differences from previous incarnations. Note the different armor and the scar on his face. He's noble but clearly been through the ringer a few times. Building character is subtle work, even with a larger-than-life hero such as Arthur.

Avalon, promotional art. Written by Andy Schmidt; illustrated by Andrea Di Vito. Copyright 2017.

EXERCISE

Create a Character

Using the diagram template provided, build your own character! What are you missing? What can you add? Do new dramatic turns of events occur to you as you explore and flesh out the character? Everything that you build from here comes from your story sentence and your character. Everything is designed around your character.

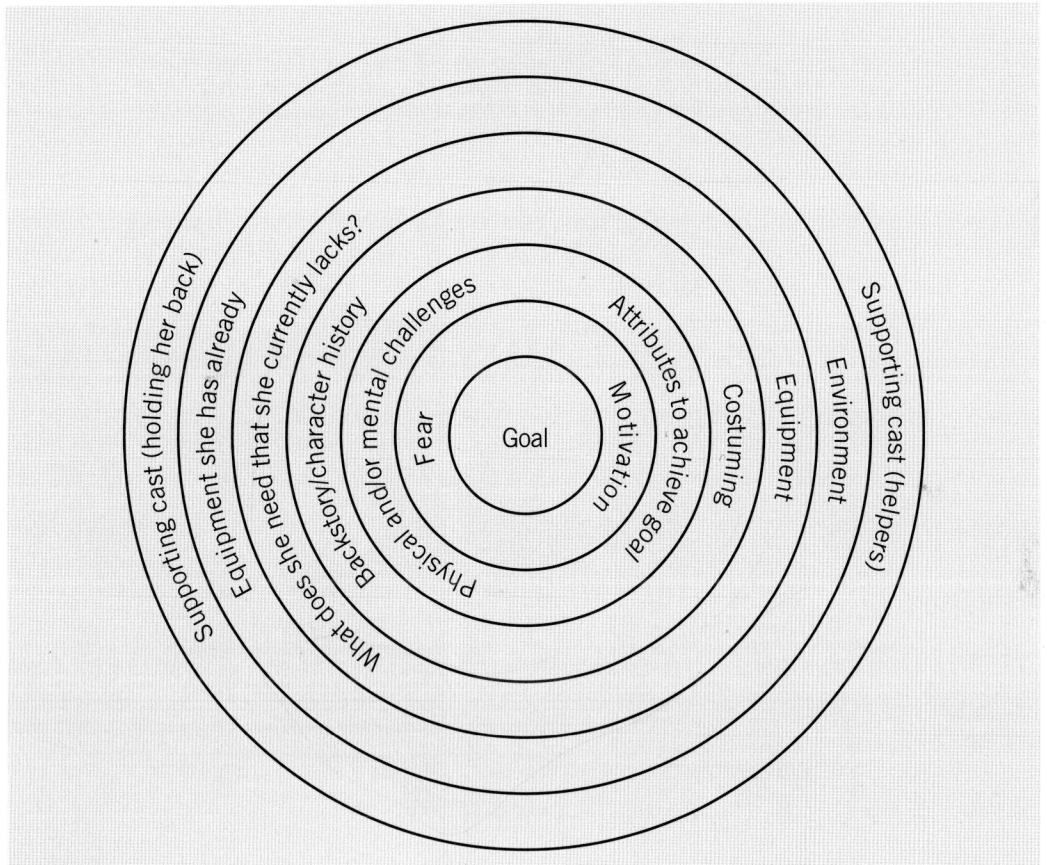

Character-Diagram Template

At the center of the diagram is your character's goal. Start in the middle and diagram out from there, using concentric circles to add more information. To the right are all the things generally working in your character's favor, and to the left are the traits working against your character. Remember, we humans have a habit of getting in our own way. Use this diagram to tell yourself everything you need to know about your character.

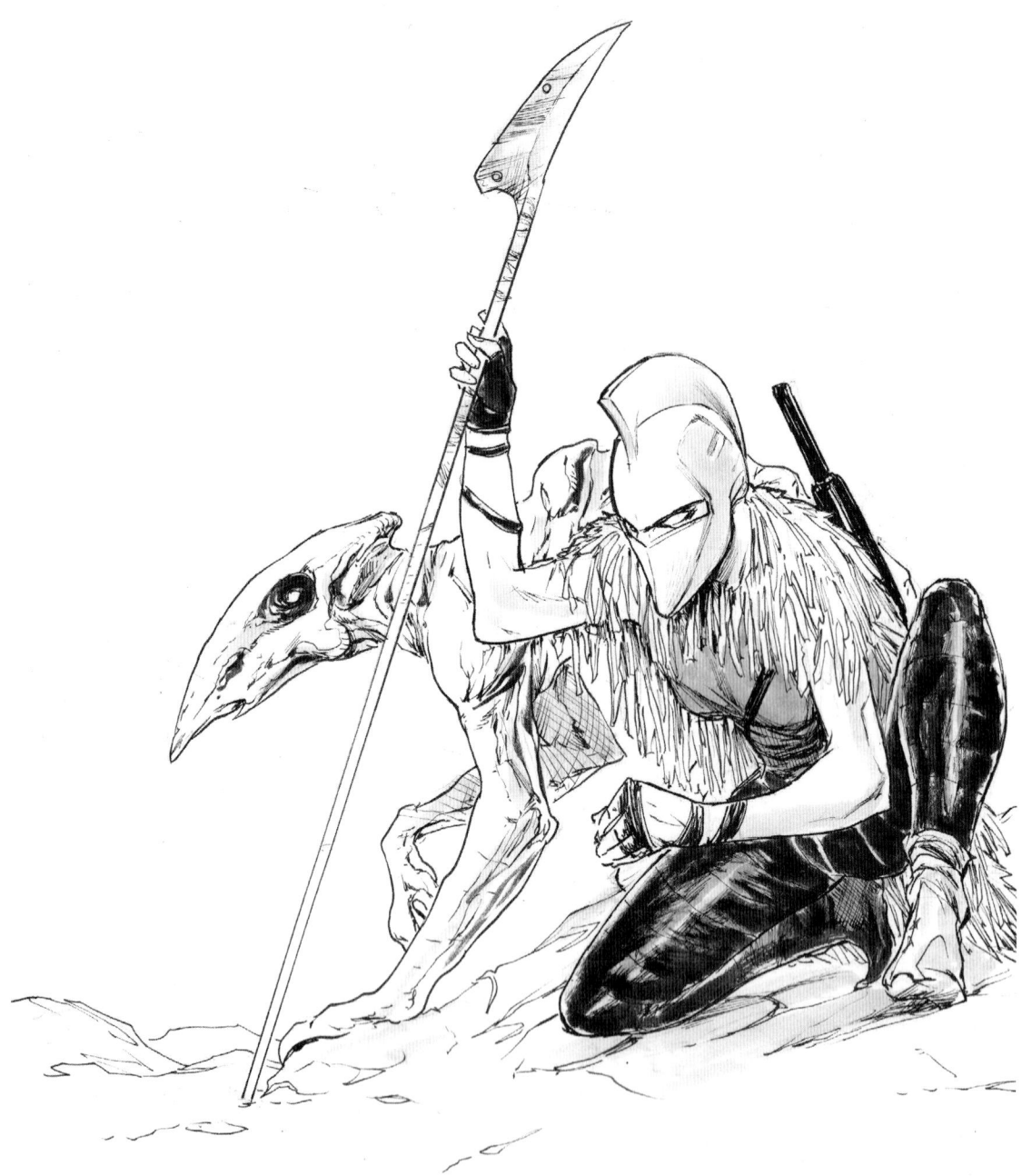

Forager is a galaxy-traveling bounty hunter. Her character design encompasses aspects of who she is and her history. She was raised in caves as a slave. For that reason she remains silent. Her helmet is a trophy taken from a soldier she killed, her spear is made out of a bone from a creature she hunted, and her alien companion is from her home world. She travels light as she grew up with nothing of her own, and she relies heavily on her senses and instincts. That is reflected in her physical design, even if you don't instantly pick up all of it.

Praetor, character design. Written by Andy Schmidt; illustrated by Ryan Gutierrez. Copyright Andy Schmidt, 2017.

Driving Traits

These are the traits that define your character and force him to constantly move forward. These essential traits drive your character to the ultimate goal. They form your character's motivation, the thing that makes achieving that goal a thing of passion.

For example, in the novel *First Blood* by David Morrell, Rambo is an expert killer who fights in a harsh war, and the war transforms him into someone that society no longer wants. His role as a trained killer and society's subsequent rejection when he returns home are essential to who he is and what drives him in the story.

Boons

These are the additional characteristics that help your character on the journey to achieve the goal as defined by the driving traits. Your character is a computer-science genius, a super spy and a gifted writer. These traits don't have to be obvious. In fact, sometimes the subtle ones are the best. The point is that these characteristics intrinsically help your character advance as she goes along.

The major character traits are easy to see, so here's an example of a more subtle characteristic: In the screenplay *The Long Kiss Goodnight* by Shane Black, the lead character's daughter has a retainer that she wears to straighten her teeth. It's no big deal—lots of kids have these, and it's set up early in the screenplay, within the first twenty minutes. But it winds up being a boon later on because the retainer is featured in a spectacular escape sequence in which it is used to direct poured gasoline under a locked door. The little girl has bad teeth, which actually becomes a positive characteristic (a nice example of a flaw turning out to be a life-saving attribute). It also tells us something about the leading woman who uses it, that she is resourceful enough to use her daughter's retainer to save both of their lives.

Challenges

These characteristics are the opposite of boons. They're the things about your character that get in his way. They can be physical, mental, spiritual, whatever. We're often our own worst enemies, aren't we? A trick I picked up from screenwriter Andrew Kevin Walker (*Se7en*, *The Game*) is to write down my character's name and draw one arrow to the left and another to the right of the name. On one side I put the character's desire and on the other the character's fear.

Fear. That's the key. What does your character fear? Is it in direct opposition to his goal? Is it someone else's vulnerability? Is it losing respect? What does your character most fear? His greatest fear is the biggest challenge that he must face in your story.

An obvious example of a character having to overcome his fear is Indiana Jones' extreme fear of snakes in *Raiders of the Lost Ark*. He hates them! And when he sees his goal—the lost Ark of the Covenant—within his reach, the only thing standing between him and it is a pit crawling with thousands of asps. In order to achieve his goal, he has to overcome his fear. Textbook.

Details or Idiosyncrasies

I tend to think of these as flavor for your character. These are the little details that are sometimes thrown in. In some cases, they're little bits of you or a nervous tick that makes the character stand out a bit. These details are often used to great effect with supporting or minor characters.

Recently I wrote a short story about an intergalactic bounty hunter I had previously created. And it occurred to me that thousands of years in the future, Cholula hot sauce would still exist (because it's delicious), and this giant of a man would be nigh obsessed with the stuff. So it's become a running gag that he loves it. Is it important? Nope. Is it a setup with a much-needed awesome payoff? Nope. So why include it?

Two reasons immediately come to mind. The first is that it's memorable (and hopefully a bit funny), and the second is that there is a need for some things that don't pay off. If everything pays off all the time, our readers will come to expect such payoffs more than they already do. So hopefully, by not always paying something off in a big way, we create the illusion that not everything matters. It's a sleight of hand that keeps the reader uneasy—never quite seeing all the tricks we use.

VISUALIZING YOUR CHARACTERS

We've talked a lot about goals and motivations and even character ticks. But we haven't spent much time on how those things influence the visual representation of your characters, and there are a few key traits that are worth going over.

As stated, we start with your character's goal and build from there. But comics is a visual medium, and here we are, roughly thirty pages into a book about writing comics, and we're just now addressing this quandary. You're writing a script that's going to be *drawn*. Your words (many of them) are going to be translated into pictures.

Depending on your working arrangement (if you even have one yet), you may be working with a different person who will design your characters, or perhaps you're both writer and artist for your project. Either way, as the writer, you're going to have some input on the visual design of your characters.

Much of what we do as creators in a visual medium has to do with contrast. It's a concept that will come up a lot in your work because it's essential to storytelling in a myriad of ways.

The following are the key elements, from an artist's point of view, for designing a distinctive and appropriate character.

> **EXERCISE**
>
> ### Create Characteristics For Your Character
>
> Now that we've talked about character traits, let's start putting the concepts into practice. I'll give you a goal, and you give me at least one of each characteristic described in the Character Traits section.
>
> We'll do this twice. The first time, just do it straight. The second time, we'll level-up.
>
> Your goal is: "Get to Heaven."
>
> - What is the driving characteristic your character has that makes her try to get to Heaven? There can be more than one.
> - What boons will help your character get to Heaven?
> - What challenges does your character face within herself? How might that fear get in her way?
> - Lastly, what are her idiosyncrasies?
>
> Okay, now let's do it again, only this time a little differently. I want you to disguise a boon and a challenge as an idiosyncrasy. Make it look like a boon is nothing more than some character tick. But how will it help your character achieve her goal? And how will another get in her way? Then try it again with the new goal of "Get to Mexico." Go!

Color Scheme

One way to contrast your characters with one another is through color schemes, so it's helpful to design color schemes for each of your characters. Think of the Power Rangers. While that's way on the nose, you get the core concept here.

Along with simply making the characters distinct, colors have themes associated with them. Warm colors like red and orange tend to say someone is active, high energy or fast. Cold colors like blue and gray tend to make us think of stability, power or responsibility. And of course light and dark are associated with good and evil, respectively. These are all tools to add to your storytelling toolbox. Use them directly, or use them to throw off your reader. The character that's dressed head to toe in black . . . turns out to be your hero! What?! Shocking, I know.

Silhouette

Another point of contrast is the silhouette of your characters. If you're dealing with a group, it's useful to make one thin and one stocky and include different genders or clothing that has distinctive shapes, like padded shoulders or a hat that a character always wears. Your reader should be able to identify every major character without color or detail, simply by his shape.

Ideally, that shape would say something about your character or be based on his background. Maybe one character had a particularly rough childhood, so you give him a cane to use, for example.

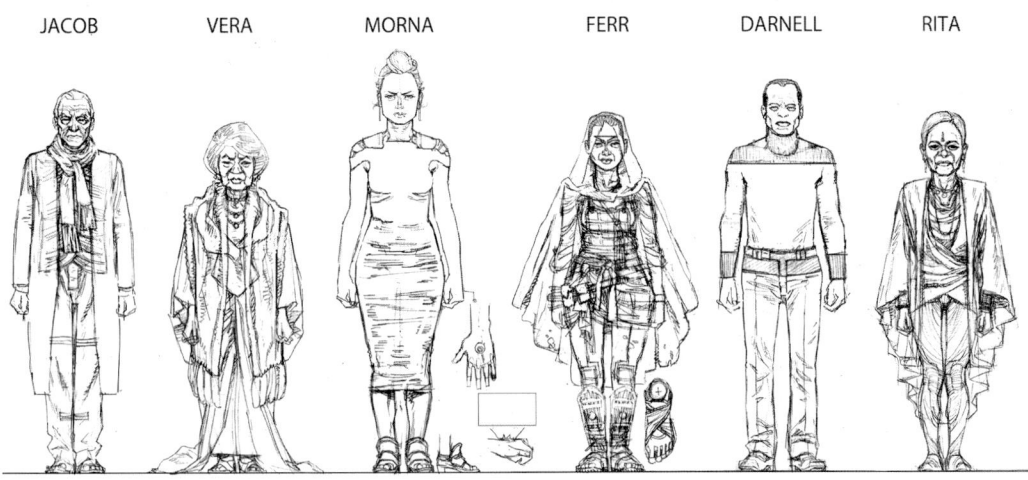

Designing one character at a time is great, but that method runs the risk of making the characters look too similar. In this example, you can see that Matt deliberately varied the heights of characters, the body types, the clothing and ethnicities. These differences work in conjunction with the story functions each character serves and their backgrounds and abilities, and they serve to give each a unique silhouette. The two characters who are most similar in design are also the most similar in the story, but, and this is important, they are never in the same scene together. They represent reflections of each other in two different parts of the world.

Exalt, character designs. Written by Paul Allor and Andy Schmidt; illustrated by Matt Triano. Copyright Andy Schmidt, 2017.

The bottom line is that we can always recognize an iconic character like Batman by his equally iconic silhouette.

Distinctive Markings

Your artist is not a camera. That means that while your character may have a specific design, you're not going to get exactly the same face every single time in every single panel. In part for this reason, it's a good idea to give your characters distinctive visual traits.

This is where the cliché eyepatch or scar running through the eye comes in. We've all seen these types of distinguishing marks. And it makes it very easy to tell who is who. Ideally, these marks will come from character. A scar on the war-torn hero's face is great. Maybe a beauty mark on the affluent duchess and so on (except, you know, less cliché than those examples).

Functionality

When designing costuming, you'll want to think first of functionality. What does your character physically require in terms of costuming? Is it cold outside? Do they need gadgets or a utility belt? If they're being sneaky, don't put them in hot pink—that sort of thing. Use storytelling markers to help define your characters' looks. Batman needs a lot of pouches on his belt for all his gadgets. The fact that he's trying to imitate a bat inspires his distinctive cape and cowl.

Matching Looks and Traits

Along with functionality, you have to ask what the costuming says about your character's past, attitude, position in society and so on. Is your character one who wears bright colors or drab colors? Is everything she wears top-of-the-line or used and old? Well dressed or rags? What does your character's look tell your reader about who your character is and where she comes from?

CHARACTER ARCS

It's been said that every story begins with one of these two plot devices: "A stranger comes to town" or "A man (or woman) leaves town on a journey." Those setups are strangely compelling in their simplicity. Something breaks the status quo doesn't it? That's where we begin . . . but begin what?

Your character's journey or *character arc* will take your character out of his comfort zone and to another place altogether. It can be a literal other place, like another country, another planet or another time. It can be a different state of mind or heightened awareness. But a path must be taken to get to this destination—be it literal or figurative.

The journey is what the story is all about. It's not about the premise or the destination. Your story—the heart of it—is in the journey. Now you may be wondering why. Why is it that the heart of the story is in the journey? Does it have to be? Good question and thanks for asking it. The answer is that it *should* be.

If you're telling your story well, then the heart is in the journey, and that's because it is the journey that forces your character to change. And that change, whether gradual or very sudden—like the Grinch who stole Christmas—is the heart of your story. Your character's change may pay off in the end, but it actually occurs during the journey itself.

Crafting a character isn't as complicated as it may seem at first. Consider it this way: In its most basic form, your character simply has to change from one type of person to another type of person. The change doesn't even have to go in one particular direction, like from bad to good. An equally compelling story may see your character change from good to bad. But your character *must* change. So what you need to determine is where your character starts and where your character ends.

The rest is the arc of the character arc/journey. This is also where the plot becomes inextricably tied to your character. Because your plot will push your character into situations that will cause him to face his fears to try to achieve his goal, and likewise, your character's decisions and actions will push the plot in new and different directions. That will happen quite naturally once you determine the character's fears, desires and motivations. You will know exactly what kind of obstacles to throw in the way. Whatever the obstacles are, they must force your character to question his beliefs or motivations. And upon questioning them, he must change. So the arc—the events in your story that change your character—will move him toward where your character must end up, which you've already decided.

A word about backsliding. It happens to us because we're all human. Sometimes we're met with a challenge, and we overcome it, changing for the better, moving in the right direction. But it also happens that we get beaten, that we change for the worse. That's called *backsliding*. The power of backsliding is twofold.

Remember that your reader is rooting for your character. A backsliding event, where he slips into his old bad habits or moves in the wrong direction, can be really upsetting to your reader. And that's good. Because now we want him to succeed all the more because, clearly, this journey is not an easy one—it will be a monumental victory when your hero finally achieves his goal.

Backsliding also means that your arc doesn't move in a straight line. Which lends an element of unpredictability, and unpredictability is also a good thing. It means you're keeping your readers on their toes and more engaged because they aren't sure what will happen next.

Your character's arc has a beginning point and a different end point. And in between are decisions that he makes, the actions that he takes that will push him toward or away from those points.

> **EXERCISE**
>
> ### Draw the Character's Arc
>
> Sometimes it's helpful to create a simple drawing. In this exercise, draw a straight line (or curved since this is an arc, after all) across a sheet of paper. On one end of the line, describe her defining characteristics. At the other end of the line, describe what the character is like at the end of your story. Those characteristics, or at least some of them, should change pretty drastically.
>
> If the two descriptions are virtually the same, take a look again and make sure you know what your character's arc actually is. Or that your character has an arc.
>
> If your character does change, then go back on that line and pinpoint the events that the character goes through, actions she takes and decisions she makes that turn your character into that new person at the end. These events should make your character's changes inevitable.
>
> If you can do that, you've nailed down your character arc. You have the beginning and end, and you've defined what causes the change(s).
>
> One fun note: Remember that your characters are supposed to seem real, so let them backslide from time to time, just like real people do. This can lead to even more meaningful character beats.

Whether your character ultimately reaches that final destination at the end of the character arc is up to you. Perhaps your character isn't capable of true change, no matter how hard she tries. Maybe she is. But be true to your character and true to yourself as a storyteller. Your audience will respond to that.

The page of artwork accompanying this section comes at the end of my story *Five Days to Die* and is illustrated by my co-creator, Chee. In this scene, the young officer, Matt, who has always put his job ahead of his wife, has just witnessed his mentor, Ray—an equally hard-driven workaholic—die. And before he died, Ray failed to reconcile with his wife and daughter. Ray spent his whole life distant from them.

This scene, Ray's funeral, represents the end of Matt's character arc. Ray failed to come around to his family in time, and Matt witnessed it. So here's Matt at his friend's funeral, having just watched a potential and horrible future version of himself end his life in disaster. The sergeant tells him he's needed at work. Then his cell phone rings. It's his wife. He looks at the phone, deciding whether to speak with his wife or send her to voicemail again. He answers the phone and walks away from the sergeant. Pretty simple.

What we, as the audience (hopefully) come to realize is that while Ray couldn't change the course of his own life, the lessons Ray learned didn't fall on deaf ears. Because of the events in the story, Matt will turn out differently—Matt's family will have a husband and a father. Matt's bright future is captured on this page as he ignores the sergeant asking him to come back to the police station, and instead, he takes a phone call from his wife, the first time he hasn't sent her to voicemail in the series. He's now chosen his family over his job for the first time. It signals to the reader what the new normal for Matt will be.

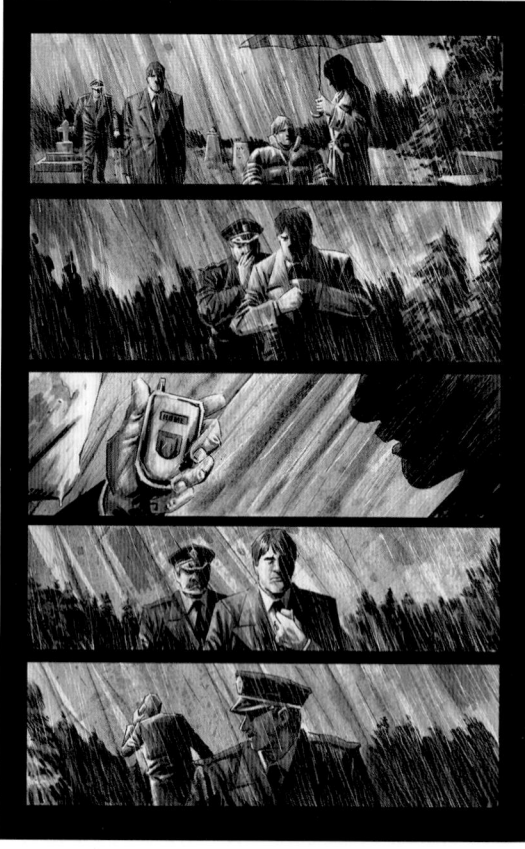

Matt finally picks up the phone and concentrates on what's really important. Good job, Matt!

Five Days to Die no. 5, interior. Written by Andy Schmidt; illustrated by Chee. Published by IDW Publishing, 2010.

TO SUM UP

The character is the most important part of your story. It's the aspect of your story that we, the readers, connect with the most. Remember how I said we would want to spend more time with your character, not as much with your plot?

Let's refresh the story sentence we recited at the end of Chapter 1: *Character* is trying to achieve *goal* by taking this *action*. While this chapter explored only the first word of that sentence, it gives you the framework for the whole thing. When you build a compelling *character*, she will give you her *goal* (and motivation), and the *action(s)* that she undertakes will come from those character traits.

If you've gone through this chapter and you've struggled with your main character and you've got a clear and strong story sentence, you are well on your way to having your first comic-book script!

To be continued....

CHAPTER 3

THE STORY SENTENCE

So far we've discussed characters and story in the abstract, but now we're talking about your story. The one you're about to tell. Believe it or not, every story can be whittled down to a single sentence.

As I mentioned at the end of Chapter 1, you need a story sentence. Every story has one. We'll cover this in detail in this chapter, and hopefully, you'll see why.

Five Days to Die no. 1, cover. Written by Andy Schmidt; illustrated by Chee. Cover by David Finch and Chris Sotomayor. Published by IDW Publishing, 2010.

STORY SENTENCE

Let's start by clarifying exactly what your story sentence is. Think of it as the smallest expression of your story or your story whittled down to its most elemental parts.

Speaking of parts, there are really only three (well, four) parts to the sentence. They are:

1. **Character.** Your story is about one character. You can have other characters and their stories can intertwine, but each of those stories is about a single character as well. Your story, the main one, is about a single character.
2. **Goal.** Your character has a goal, as we've already gone over in detail in the previous chapter. The goal must be achievable. Your reader must understand what the character's driving goal is and be able to recognize if it's achieved or not. The obvious ones are things like quests for physical objects. But finding love and other non-physical goals work well as long as you, the writer, supply the parameters for your readers so they know if that goal is achieved or not.
3. **Action.** Your character will be taking a specific action or type of action in order to achieve that goal. The key about the action section of your story sentence is that the more specific it is, the better. "Trying to" isn't an action. An action has specificity, more like "climbs a mountain" or "sets traps across the city" or "writes a novel." And the action must line up with who your character is.
4. **Conclusion.** The fourth and final piece of the sentence is simply an acknowledgment of whether your character succeeds in achieving

> ### EXERCISE
>
> ### Map Multiple Stories in a Single Narrative
>
> For this exercise, use a work of fiction that you're familiar with. For me, I'd choose something with an ensemble cast, like Star Wars, and figure out the main story. In the case of Star Wars, that would be Luke's story. Map his story sentence.
>
> Now, it's important to understand that what we call a story usually has more than one, though there is always just one driving story. So if Luke's story is the driving story, how many other stories are contained in Star Wars? To clarify, I'm talking about the original 1977 feature film only.
>
> Here's a hint: If you've ever heard the term subplot, these often are just other stories that intersect with your main story. Not always, but often.
>
> One way to figure this out is to think of the other characters in the work. Ask yourself: Could you have told this story with that person's goal and action as the main driver?
>
> Continuing with Star Wars, certainly both Princess Leia and Han Solo have their own stories. In fact, the film starts with Princess Leia's story. What about Obi-Wan Kenobi? Or Darth Vader? Or Grand Moff Tarkin? Do they have their own stories to tell? Break them down and see what you come up with.
>
> Once you have their stories boiled down to a single sentence, then map where they intersect. That is, where do these stories collide with each other. Several are simple, like Tarkin and Vader sharing a similar objective and being a part of the same chain of command. But how does Leia's story intersect with Luke's? And how does Han's story intersect with Luke and Leia's?
>
> Once you start mastering the story sentence, you will really take control of your own capacity to tell your own stories!

his goal. Remember: Because of your promise to the reader, the character will either achieve his goal or definitively not achieve it. Those are the only two options.

Let's break down a few famous stories. *The Lord of the Rings* by J. R. R. Tolkien is, generally speaking, about one thousand pages long. It has hundreds of characters, many with their own motivations and goals, but all of those stories are wrapped around a single character and his goal. Boiled down, this story is: Frodo Baggins journeys across dangerous terrain in order to throw a cursed ring into the fires of Mount Doom (and, spoiler alert, succeeds).

Let's quickly break that down into those pieces.

1. Frodo Baggins (character)
2. Journeys across dangerous terrain (action)
3. In order to throw a cursed ring into the fires of Mount Doom (goal)
4. And, spoiler alert, succeeds (conclusion).

You'll notice that the order of events in your story isn't going to follow the order in which you normally determine them. Above, we start with a character who then takes an action and achieves a goal. That's typically the order of events in a story. However, as the writer, you're going to determine who your character is and what his or her goal is first. Then those two elements combined will guide you to the specific action your character would take in an attempt to achieve his or her goal.

For example, if your character (John) is a basketball player and his goal is to get a cat out of a tree, then I might consider that he would use those high-jumping basketball skills to leap (his action) to grab the cat out of the tree. Character + goal = action (more or less).

But what if John is short and an expert craftsman? In that case, he'd likely get his ladder (or, even better, build one) in order to climb up and rescue the cat out of the tree. *Who* your character is matters very much in determining the particular *action* (or actions) that your character will take to achieve his or her goal.

This sentence, which is harder to refine and pin down than you might suspect, is the seed from which your story grows. From this, you will grow a story spine.

OBSTACLES AND ANTAGONISTS

So you've got your seed. Your character (let's call him Joe) is going to accomplish a goal by taking a specific action. If you write a story in which Joe states, "I'm thirsty, so I'll buy a soda from that vending machine" and then proceeds to walk over, put a few coins in, press a button, pop out a soda, open it and drink, well, we have all the elements as stated in your story sentence—don't we? Joe takes a couple of specific actions and achieves his goal, enjoying a frosty-cold beverage. But, it's lacking something; isn't it?

It's lacking an important ingredient present in *entertaining* stories. That ingredient is *conflict*. The story as stated above is rather dull, wouldn't you agree? But if we inject some conflict into it, maybe we can liven it up. Before we do that, however, let's talk about a few types of conflict.

Conflict typically comes in one of two forms. The first and most common is the *antagonist*. Typically, your main character is the *protagonist*. The antagonist is another character who is working against your main character. We often simply refer to this character as the villain. But not all antagonists have to be villains—a villain, if we're being pedantic, is just one type of antagonist. But you get the idea.

The second type of conflict comes from *obstacles*. Obstacles come in many forms. There are physical obstacles, like walls or bank vaults or guns shooting at your protagonist. They can be character traits, like your own character's self-doubt. They can be a lack of knowledge—your character wants to steal a treasure but needs a map to find it! Or they can be time-related. If you've ever heard the term "ticking clock," that's usually the form time takes as an obstacle.

One of my favorite examples of establishing the ticking clock is when, in the film *Flash Gordon*, Dale Arden says, "Flash, I love you! But we only have fourteen hours to save the Earth!" I mean, who doesn't have to proclaim their love for someone they just met and then also inform that person that the planet is going to be destroyed in less than a day? Makes total sense to me!

Any one of these obstacles offers conflict, or you could use a combination of some or all of them. Let's take a quick look at that thirsty Joe of ours and see if we can't add some forms of conflict to make his story a bit more entertaining.

Joe states, "I'm thirsty, so I'll buy a soda from that vending machine," but as he starts to walk over, he notices that there is only one soda left, and another patron is headed right for the machine! Oh no, he's got to move fast, vaulting over a park bench to beat his opponent. Joe body-slams the unlucky park-goer and stands at the machine.

The park-goer is rubbing his head, trying to recover his senses, as Joe shoves his hand in his pocket only to realize he may not have the right change. What if he doesn't? What will he do? He begins to sweat as he sorts the change in the palm of his hand. It's fifty-five cents. He has only one quarter. Then three nickels, and . . . two dimes! He's got enough.

But does the machine take only exact change? I don't know. Do I have exact change? He looks again, but before he finds his answer, that park-goer is back and karate-kicks Joe in the head! Now Joe has to shake off his wounds and get back to the machine, slamming the park-goer again. Joe puts his money in, hoping the exact change is right. He pushes the button, and the machine vends the drink. But the park-goer snatches it and runs off. However, Joe has a rope (because he's a cowboy) and lassos the park-goer, recovering his soda in the process. Joe pops it open and drinks.

Okay, let's see: We've got an antagonist: the park-goer. We've got a ticking clock because he has to beat the park-goer to the machine. We've got physical obstacles: vaulting over the park bench and the fight with the park-goer. We've got a little self-doubt when he's unsure if he has the right change and so on. Now, the story is still silly. But somewhere in that ridiculous scenario, you likely started to see it come together, hopefully, as a comedy. This could easily be developed into a short humorous comic that plays up the absurdity of it all. The reason it's beginning to work is that the character has a clear goal, takes clear action and then runs into conflict along the way.

CENTRAL CONFLICT

Conflict comes from any obstacle that gets in the way of your character. The central conflict is the largest conflict of them all. The central conflict is usually something personal to your main character.

In the case where your main character is driving the story (and she should be), the central conflict is usually more personal than simple survival. The central conflict is the main thing preventing your character from achieving her goal. That conflict can be seen either thematically or overtly through the smaller conflicts along the way.

The central conflict is always the single biggest obstacle. And it is usually the cause, either directly or indirectly, for the majority of smaller obstacles that stand in the way of your main character.

Let's give an example. Going back to Joe and his unquenchable thirst, the park-goer represents the central conflict. Joe's thirst is the reason he wants the soda, so it's his motivation. But the park-goer is the conflict that makes many of the other conflicts work. Without the park-goer, there is no ticking clock. Joe can take his time sorting his change and leisurely insert his coins in the machine. He's also the cause of Joe's head wound and the physical fight. Without the ticking clock that the competing park-goer provides, the bench that Joe has to jump over is not an issue.

In order to achieve the goal, your main character must resolve the central conflict, and in order to do that, she will need to overcome any number of minor conflicts along the way.

CREATING GREAT VILLAINS

The mother of all antagonists is the villain. Villains are worth spending a little time discussing because they're so common. However, there are also several pitfalls to avoid when creating a villain.

It's important to note that a villain is typically a bad guy or gal. This is to say that when you analyze the character's motivations or methods, you should find a moral failing. Sometimes it's the villain's goal itself, but more often than not, it's actually in how the villain goes about trying to achieve that goal. Which brings us to our first major character trait for a villain.

A villain also needs a clear and relatable goal. If your villain is evil for evil's sake, you've got an issue. The most boring villains are the hand-wringing ones—the ones that have no particular point of view

I love creating villains. In the case of Morna, we're really not sure how formidable or ruthless she is until this moment when she callously turns her firearm on her friend. I asked for Matt to make her look evil in that bottom right panel, and he nailed it! Villains are fun to write, but I'm glad I don't know too many in real life. . . .

Exalt, interior. Written by Paul Allor and Andy Schmidt; illustrated by Matt Triano. Copyright Andy Schmidt, 2017.

and who are literally attempting to do evil. One of my favorite supervillain group names of all time is the Masters of Evil from Marvel Comics. These guys sat around and decided that they were going to do evil things. Why? Because they're a bunch of bad guys, that's why.

Marvel also had The Brotherhood of Evil Mutants led by Magneto in their X-Men comic-book line. But Magneto's only considered evil because he's willing to kill in pursuit of his cause, right? Over time, Magneto dropped "Evil" from the group's name, and now they're simply the Brotherhood of Mutants or even just The Brotherhood. Magneto has a real goal. He wants to save the mutant race. From his perspective, he's the hero. The issue is that he's willing to destroy all the humans on Earth to do it.

To create a truly compelling villain, go back to Chapter 2 and follow the same steps you went through to create your main character. Just make sure you create your main character first, because your villain has to be designed to oppose him.

Your villain could have the same (or some version of the same) goal as your hero. Indiana Jones was seeking the lost Ark. His villain was also looking for the Ark. They shared a goal, but they couldn't work together because they wanted to do different things with the Ark once they found it.

Your villain could have a plan that needs to be stopped, like destroying a city block full of housing so that he can build a shopping mall, but he's not concerned about evacuating the tenants before the wrecking balls show up. Your hero will need to stop him. Now, a word of caution in a story in which your main character is reacting to someone else: It's very easy for your main character to get lost in this story. You still need to design this threat—this villain and his plan—around your main character's arc. So in a case like this, you *must* ask how your main character is affected by this story, by this particular conflict and by how she changes during the course of the story.

There are any number of ways to build a villain, but they all start by building the villain as a foil to your main character. What makes this villain the perfect foil for your hero? Are they ideologically different? Does your villain represent something that the main character opposes or must oppose? Does the villain force your main character to evolve beyond who he already is? He should do all of these things. The best villains do because they are great characters first and villains only by circumstance or point of view.

STORY STRUCTURE

By this point, your story's structure is hopefully starting to present itself in your mind. As you create and define your main character, certain plot points will come to light as will certain obstacles. As you create a character's arc, you'll start to see the trials that your character must overcome in order to truly evolve or change.

But let's talk structure for a moment. There's a lot of talk about formula in story structures, especially when talking about television or film stories. And some of those structures are designed because of the confines of the medium (like commercial breaks, for example). Such parameters may break your story's spell. The trick in those cases is to make it feel like they're not an intrusion.

Comics don't have those distinctly overt parameters all of the time. You may or may not be limited on your page count. You probably won't know exactly what page an ad will fall on to avoid staging a cliffhanger right before an advertisement. But we have a tendency here in North America to create comics that tell stories in single-issue chapters. And, for decades, this has defined our structure, ending every twenty pages or so on a big cliffhanger to entice readers to return for the following issue.

Those are parameters that affect structure. They're not, however, structure itself. We could spend an entire chapter (an entire book, really) on

EXERCISE

Map a Movie

Most people reading this book have favorite comics or favorite movies. One reason I like to use movies as examples and for exercises is that it's helpful to apply what you read about comics to other media. It's easier to dissect something that more people talk about regularly. So with that in mind, try this:

Watch a favorite film and identify the acts and major turning points. Unless your favorite film is experimental in its storytelling, it will have major turning points that define act breaks. Everything from Star Wars to Remains of the Day has turning points and acts. So your job is to watch that movie and make note of when it turns and why.

There are some common cues: A major change of location or time often signals a new act. A new "mission" or goal often signals a new act. The turning point—where the act changes—is usually an important story beat, either emotionally for the main character or from a plotting standpoint (ideally both).

As you identify them, chart it out like the diagram included here. See if you can spot the rising action, the climax and the relaxation as the film moves into a new act.

Here are a few films to try this with:
WALL-E
Toy Story
Captain America: The First Avenger
Star Wars
Pirates of the Caribbean
Raiders of the Lost Ark
The Lord of the Rings: The Two Towers
Saving Private Ryan (rated R)
Schindler's List (rated R)
The Thin Red Line (rated R)

These films, in the order listed, get increasingly more complicated in the act structure, and some have sequences that may feel like acts but aren't. For example, Captain America has a prologue and an epilogue. Those aren't acts, but they might trick you into thinking they are.

Map a Movie Diagram:

Act 1
Inciting Incident
Number of Scenes _____
Turning Point/Climax

Act 2
Inciting Incident
Number of Scenes _____
Turning Point/Climax

Act 3
Inciting Incident
Number of Scenes _____
Turning Point/Climax

Take as many acts as you need.

Final Act
Inciting Incident
Number of Scenes _____
Climax
Denouement

structure alone, but we're not going to. We will touch on structure throughout the book, but here are a few specific points about it:

- Every aspect of your story is built with a certain structure underneath it. That's the nature of creation.
- For our purposes, structure is discussed primarily in terms of acts, scenes, character structure (the creation of the character) and turning points.
- The structure of your story is a series of acts that ultimately end in a final climax.
- Structure is largely a thing for you to discover, rather than for you to decide and then build a story on top of.

Let's discuss that last point for a moment. What does it mean that you'll discover your story structure instead of create it? It means that if you build your characters and their goals properly, you will look at your story as you develop it, and you will see the identifying marks of the acts and scenes. That will tell you what the structure of your story is.

If no structure presents itself, then that is a red flag that your story may need more work. If that's the case, you'll want to look at your characters, look at the conflicts and see if everything is engaging properly. If your character meets no conflicts, then it's hard to have true act breaks. If your antagonist has a different agenda than your character, then you may be forcing them to meet artificially. In these cases, you'll need to change the characters until the structure starts to come together.

Discovering your structure also means you are designing your story first. You'll look at your story and discover that it's five acts or it's three or maybe it's just one or maybe it's twelve. It doesn't matter. The story has as many acts as it needs to have. But this way, you'll look at the story and determine its length and act breaks based on the story itself, rather than deciding you're going to write a five-act story and then creating to fill the acts you have arbitrarily decided that you will have. Filling the acts usually means you've got—you guessed it—filler. And filler is exactly what it sounds like—something you don't want.

It's worth noting that if you're writing for a client, the way I often am, you may be told that you have to write a certain number of acts and that they have to be a certain length of time and so on. If you're a professional writer, you'll get plenty of experience doing that, but if you're creating your own comics (which is my favorite way to work), try letting the structure reveal itself to you.

ACTS

From a structure standpoint, acts are the largest segments of your story. Each act begins with a relatively low level of tension, and then tension rises fairly consistently over the course of sequences and scenes until tension is released in some way in either an act climax or a turning-point event.

Once the act climaxes, the tension in the story drops or lowers. Typically a new act begins, and tension starts rising all over again.

The two places where this cycle is a little different is in your very first act, simply because the inciting incident that kicks off your story must be there. And in your story's final act, there is a slightly different denouement that follows instead of the beginning of an all-new act.

Consider the beginning of *Star Wars*. The inciting incident is Darth Vader capturing the rebel ship and imprisoning Princess Leia. After that, two droids are cast off to the desert planet Tatooine with the plans to the Death Star that Darth Vader is trying to retrieve. From here, the droids wander the desert and are captured and then traded to a young farmer who dreams of leaving the planet someday. The droids run away from Luke, the young farmer, and he pursues them right into an ambush by Sand People. Tension rises until Luke is knocked unconscious and rescued by an old man. After this, the old man and

Luke sit down for a talk and decide to return to his home, where Luke discovers that his aunt and uncle have been killed.

Can you identify the act break or breaks? The fun thing about story structure is that answers are often debatable. For me, the first act ends when Luke discovers his deceased relatives. That's the highest tension after the inciting incident, and it is followed by a change of direction and tone in the story. From that point on, Luke's life has changed course as he learns about the Jedi and his real father.

SCENES

Scenes are the individual components that make up each act. A scene is usually identified by a change of location. But a scene is really one segment of story that pertains to a certain topic. If that topic extends from one scene to the next, the two (or more) scenes together are referred to as a sequence. This is all a bit technical, and the specific definitions aren't all that important.

What is important is that you understand the function of every scene that you write. And the function of a scene is to drive the story forward, to ratchet up the tension or release tension.

That's an easy thing to say because hey, why would you write a scene if it doesn't move the story forward? I'm glad you asked, because you *will* write scenes that don't drive the story forward.

Ninety-nine times out of a hundred, the reason you've written a scene that doesn't move your story along is because you wanted to drop some exposition on your reader. We will deal with exposition specifically in Chapter 5, but for now, all you need to know about exposition is that it's story information.

The paradox of exposition is this: No reader wants it, even though he needs it. And that's why you can never have a scene where the sole purpose is to deliver exposition to the reader. It's the drama and the tension that keeps your reader engaged, so that must be present in every scene.

The next question you should be asking is: "How will I know if my scene moves the story forward?"

> **EXERCISE**
>
> ### Find the Turning Points in a Scene
>
> The great thing about this exercise is that you can do it while watching TV or movies—any TV show or movie, really.
>
> Keep a piece of paper and pencil with you as you watch. At the start of every scene, write down the emotional charge. When the scene ends, write down the emotional charge. Are they different? If so, watch the scene again (or use that short-term memory of yours!) and identify where the scene turned—where did the emotional charge change?
>
> If the emotional charge is the same at the beginning and the end, then shame on the filmmaker! But it's up to you to figure out why the scene was included, and remember: Ninety-nine times out of a hundred it's for exposition. If so, what exposition did you, as the viewer, need to get?
>
> Do this often, and you'll have the hang of it in no time! Do not try it at a party—you could suck the joy out of the movie for everyone!

ANATOMY OF A SCENE

All scenes have a few things in common. They take place at a particular location and at a particular time. Technically speaking, a montage isn't a scene. That doesn't mean a montage can't drive a story forward, but it's not, technically, a scene. So, for the purposes

of our discussion here, we're talking about scenes and how they function.

Every scene has a beginning, and, typically speaking, it's in this beginning that you should try to establish the "who, what, where and when" of the scene. We'll get into establishing more later, but it's important to ground or orient your reader with each scene. If it's an obvious continuation of the last scene, you won't have a lot of work to do to orient your reader.

Then you'll have the end of your scene. Now, these two things, a beginning and end, may in and of themselves be obvious. The reason it's important to identify them is because it is by evaluating your beginning and ending that we can tell if your scene functions.

In Robert McKee's book *Story*, he talks at length about the charge of a scene or a moment in a scene. What it boils down to is this: At any given point, the charge of your scene is positive, neutral or negative. Scenes may also be classified as super-positive or super-negative.

The charge is usually determined by the situation from your main character's perspective or, possibly, from the main character of that scene's perspective. So if your character is heading into a dark, dilapidated house, looking for clues she doesn't have and fearing someone may be lurking inside that might harm her, we'd say that the scene opens up with a negative charge.

Now skip to the end of the scene: She's gotten the clues she needs from the house, she's on her way to solving her problem, and she's safe from harm, so we've got a fairly positive charge at the end of the scene. Starts with a negative charge, ends with a positive charge. That's important.

If the charge is different at the end than it was in the beginning, then we know *something* happened in the scene that changed the course of the story. Even if it's not a major revelation, it affected the story and the character. It is knowing that "something" occurred that lets us know that the scene has served its function. This is called a *turning point* (and there can be more than one), the moment in which a scene makes a dramatic shift in direction and/or tone.

There are many possible turning-point options for our detective. If she enters the spooky house and is attacked, we just went from negative to super-negative. She went from afraid to fighting for her life—clearly a turn for the worse. If during the struggle with her attacker she wounds the assailant and shoves him into a dresser that shatters on impact, knocking out the assailant, the scene shifts to neutral. There's one assailant down, but there could be others. She looks down, and the clue she needs has fallen out of the shattered dresser—positive improvement! She gets what she needs and hurries out of the house with no further difficulty. All of these events are turning points, the biggest of which is finding the clue she needs.

Each turning point shifts the charge of a scene in one direction or the other, and it doesn't matter which direction. What matters is that your scene does not start and end on the same basic emotional charge.

Had our detective not found a clue, then she would have walked out of the house in the same basic position as when she walked in. The story would not have moved one way or the other. So look at the beginning and the end of a scene to determine the charges, and make sure that the charge is different.

If the charge is not different, then you must ask yourself why you wrote it. And ninety-nine times out of a hundred, the answer is going to be that you needed to provide the reader with some information.

Consider the previous scene, but this time she doesn't find a clue. However, while searching, she grumbles that her training in the military didn't include searching dark houses for clues. Chances are, that's why the scene is there. The scene doesn't drive the story forward, but it lets your reader know

she's ex-military, knowledge that may be important for a later scene.

In a case like this, your job (hard as it may be) is to rip the scene up and throw it away. Write down the exposition that you need to communicate to the reader, and then look for another scene that does move the story forward, and slip it into that scene—the more subtle or natural, the better. You don't want your reader noticing that they're being fed exposition, and that's a tricky thing!

To sum up, all you need to know about the anatomy of your scene is what the charge is at the beginning and at the end so that you can compare them. If different, look for the turning point or points. If they're not different, make sure you know why you wrote the scene—write down the reason that you wrote the scene, then delete the scene itself, and find some other way to get that information across to your reader.

It's hard at first, but it starts to come more naturally the more often you do it.

ANCILLARY CHARACTERS

Ancillary characters are all of those characters who have a role to play but aren't driving a story of their own. That doesn't mean that they don't have goals or motivations (it's better if they do), but it does mean that your story is not primarily about them.

The key is understanding for yourself, as the writer, the exact function of each ancillary character. Don't overplay the character. Have fun with him, but don't try to expand the character's role beyond where it needs to be for this story. If you wind up loving an ancillary character, then write a separate story about him. Don't force the character into more scenes where he doesn't really belong; you'll just wind up damaging this story.

These characters tend to be the ones that writers have the most fun with. Most ancillary characters fall into tropes—the wise old mentor, the funny or nice sidekick, the loving mother, the hard father, the troublemaker best friend and so on. We've seen them all a hundred times. It's your job as a writer to recognize these tropes, especially the ones that have become cliché, and then decide how you're going to avoid them.

One way to avoid clichés is to go in the opposite direction—whatever it is that we as readers expect to find, do the opposite. Writer Joss Whedon, creator of *Buffy the Vampire Slayer*, has used this tactic to great effect in almost all of his work. We expect to find the wise old mentor; instead we find a cocky, twelve-year-old girl. She winds up serving the same story purpose as the wise old mentor, but she defies our expectations.

You can turn the trope or the character on its ear. The wise old mentor doesn't help our main character but instead needs the help of the main character. Or you can do something different altogether. There is no mentor of any kind. In fact, your hero who came looking for answers has found only hollow space, with no knowledge to be had at all.

Don't shy away from having fun with these characters. In fact, embrace it. Because if you're not having fun with your ancillary characters, then chances are, neither is your reader.

STORY SPINE

You understand your characters, both the good and the bad, and you understand how your ancillary characters function and not to overuse them. You know how acts and scenes work. You've got your fundamental story sentence. Now you're ready to build the story spine.

The hard work is largely already done. Your goal now is to take that story sentence and what you know about your characters and figure out the sequence of events in your story.

You want to keep it short for when you have to go back to it. And you likely will. The goal, even for

Short Pitch

Here is a pitch that I wrote ages ago, when I first left Marvel Comics as an editor. I hadn't established myself as a writer yet, so I very carefully wrote a pitch document for a story idea I had at the time. I've written my own new commentary into the document that follows so that you can see some of the differences that I use in determining what I write for myself and for my collaborators versus what I might find useful (or not) in a pitch sent to a publisher. Ultimately, each section has to serve a specific function.

Totally coincidentally, during the writing of this book, a different artist and I have decided to take a second look at this project. Who knows what might happen with it.

The Courier
by Andy Schmidt
Revised 03/28/08
Copyright © Andy Schmidt

Genre
Science Fiction/Action
Content concerns: Violence/mild language. Mild sexual overtones.

Story Sentence *(Written for me, the writer — not included in the pitch.)*
The Courier uses all of his robot evading and destroying skills to deliver a digital package from one end of a robot-controlled city to the center of its mainframe—to take down the robot overlords for good.

Premise *(Reworked for a pitch, a little more punchy than the above.)*
The Courier has downloaded unknown data and been hired to deliver it to an unknown recipient in the city's computer brain center. Everyone is out to interrupt delivery—and I do mean everyone.

But what is this precious cargo? The Courier seems convinced that it will help free the human slaves that he meets beneath the city, but he may not have all the facts. Either way, something is changing inside him. He's starting to care about Mia, the slave girl he meets, and wonder if maybe he has a higher calling than deliveryman-with-guns.

Setting
It's the year 2444. The cities are cluttered with skyscrapers. No one but the absolute dregs of society sets foot on the ground. Bridges and flying cars enable the Elite to avoid the streets. A middle-class robot interacts with and serves the Elite. Even the robots don't have reason to mix with the underclass street men.

Characters *(These need to tell me what the characters goals are, or at least what their arcs are, if they're major players.)*

The Courier
He's a nineteen-year-old cyborg. **His part-computer brain enables him to download information into his mind and deliver it. He's a cross between a Terminator in his single-minded objective and a character from *The Matrix* in terms of his cyber-enhanced abilities.**

He's a highly-trained combatant with the ability to download any data he needs via a wireless connection to the Internet. While on the run, he constantly downloads maps, directions, building schematics, training manuals and so on to fit whatever situation he finds himself in.

His emotions are more machinelike and cold than his steel body parts. Upon learning of the underground society of enslaved drones, his heart begins to warm. It's not that he doesn't care about people, but rather, before he discovered the enslaved, he never knew anyone worth caring about. It's a little girl named Mia who begins to open his eyes.

The Elite
This small group of rich snobs controls the robots and the drone humans beneath the city. Years ago, their corporations began buying smaller corporations until five corporations with five heads realized that they controlled and owned 95 percent of the globe.

They held annual meetings and solved global problems. But as their power and authority was questioned, **their need to stay on top of the world** took hold, and they slowly began to devise ways to create unrest in the world and manipulate events, even nature, to help them stay in power. Years go by, and they realize that independent thought in the people is a real problem. That's when they begin to develop drugs that will become Truth.

Mia
A little girl living in the drone segment of society. She, along with all the children under thirteen years old, administers Truth—a drug that destroys higher brain functions—to the adults. Truth also replaces those brain functions as long as the person is taking it. Thus, people on Truth will be docile yet able to think. If they go off the drug, they'll become savages, acting only on basic instincts.

Mia's happy and all too ready to grow up. She's smart yet not prone to questioning authority. She's lived a sheltered life in that there are never any questions to answer, so she's always believed what she's been told—either from her parents or the media.

Mia discovers that the Courier doesn't need the drug because he's never been on it. He grew up outside of the system, so he doesn't belong to either the Elite or the underground enslaved societies. Upon realizing this, **Mia begins to open her mind to other possibilities about the world. She begins to question authority.**

The Story (This is the story spine. I've spruced it up slightly to read as a pitch, but you'll notice all of the plot events are here in bold text.)
In this world, the lower-class people are used as mindless drones. They're not robots but might as well be. They're fed only with deadening drugs, TV and lies. They're nearly mindless, and they don't care. Only the top .05 percent of the population are the Elite that run everything and have free will. These Elite are served by robots, a kind of middle class. The Elite don't like mixing with the drugged-up people of society, so they'd rather interact with the sterile robots and machines.

The Courier is hired by an unknown employer to deliver data to an unknown recipient across the city by midnight tonight. The pay is outstanding. He accepts the job, never asking about the data. **As soon as he steps foot out of the door, the bullets start flying.** His employer is blown out a window, but it doesn't matter—he gets paid upon delivery.

A preliminary sketch of what the Courier might look like.

The Courier, development artwork. Written by Andy Schmidt; illustrated by Joshua Flower. Copyright Andy Schmidt, 2017.

The Courier spends the rest of the adventure **fighting off robot armies and military men to achieve his goal. He's forced to go underground and discovers the slaves. After meeting Mia** and seeing how millions of people are kept oppressed below the streets with media and drugs, **the Courier determines that the data he's carrying must be able to free these people.** Without knowing it, the Courier gets mixed up in a revolution.

The mayor of the city has scrambled every force at his command to find the Courier, but the Courier is too smart, fast and skilled for the mayor's troops. The mayor's top advisors are all desperate to find him. They know what he has and what it can do.

Finally, after an amazing action sequence involving troops, tanks, helicopters, rockets, guns, grenades and more than a handful of chicken eggs, the **courier reaches his destination**. The recipient is the master computer that controls all the robots.

The computer downloads the data and immediately shuts down. It's quiet for a moment until it reboots and **asks the Courier a question: "Who am I?"**

Then the Courier sits back in his chair, **realizing he was only half right. He was delivering something that would start a revolution and free the slaves—only not the human ones.**

The robots all over the city stop serving the men and women of the Elite. They turn and ask their masters, "Who am I?" The masters are afraid. Then, slowly building over the next few minutes, down on the streets, screams can be heard as **the Elite fall from their windows.** And **the people in the streets go on about their business, not caring as the Elite explode upon impact.**

a large, epic-like story, is to keep your story spine to roughly a single page.

Your story will now look something like this:
- Story sentence
- Main character description and biography
- Antagonist (or major obstacle) description and biography
- Story spine

None of the first three items really have turning points or plot events. That's what you get when you write your story spine. You know what your character is after, so why does he start that quest now? Because X just happened, forcing him to start now.

Great, X is now your inciting incident, that thing that kicks off your story. That's going to happen very early, probably in the first ten pages of your story. It could happen on page one.

After that event, what does your character do? Well, he'd go see person Y. Great, that's your next story event. And what happens when he gets there? Story event number three. What's your antagonist up to at this point? Okay, write that in there. And so on, until you reach the climax of your story and its resolution.

It's important to remain aware that your main character must be challenged throughout the story. If it's a series of successes for your character with no real challenges, then you need to figure out better obstacles to create stronger conflict (yes, even for a comedy). It's the struggle that we, your readers, will relate to and want to see your character overcome.

On the previous few pages is an example of a story spine that I wrote back in 2007. I've highlighted the pertinent sections in bold text: the story sentence, the parts of the character bios that show the character's goal and arc and the story events in the story spine. Take a look and you'll see it's all there. The rest is added to give context, elaboration or (hopefully) excite the reader.

Looking at this now, ten years later, I can see how I'd write it differently today. I can also see how there were themes in this idea that I would later use in different ways, even pieces of each character. But none of that is important. For the sake of helping you, take a look at how it's constructed. It may not be a great story, but it's a competent one.

TO SUM UP

You've just completed the foundation of your story! Everything you need is right there. You've poured a very nice foundation for your proverbial house, and now you've got every supply and tool you'll need to start building it. It's time to get started!

To be continued....

FIVE DAYS TO DIE

CHAPTER 4

LEVEL-UP THE STORY

To this point, we've tackled only fundamental elements of building a story: characters and their goals, plots and story spines, conflict. Next, we will cover a few important elements to help elevate your story. We'll push beyond basic professional-level work and expand your storytelling powers. This chapter isn't an exhaustive list of narrative techniques. Incorporating the elements we'll cover here and striving to level-up, along with experimentation and lots of practice, are key to becoming a truly great comics storyteller.

Five Days to Die no. 1, variant cover. Written by Andy Schmidt; illustrated by Chee. Cover by Chee. Published by IDW Publishing, 2010.

THEME, SYMBOLS AND IMAGERY

Storytellers often talk about theme and symbolism. A little less frequently, they'll talk about imagery. As someone about to write a comic or graphic novel, I highly recommend you think about, understand and experiment with these elements.

But first, let's get to some working definitions. To clarify, this is how I use the terms when thinking of my own work—not how a textbook would typically define them. When in doubt, I err on the side of how I use something rather than how it's defined academically.

Theme

A theme or a motif is a story element that not only reoccurs but also carries some meaning by association. To me, themes tend to be fairly broad in nature, like the classic man vs. nature motif. Elements that come up again and again in the story.

Theme can be identified with color or a setting. In *Star Wars*, blue and green are associated with good, and black and red are associated with bad. Simple but effective. In general, green is often associated with nature, red with violence or passion and pink with love. These are all broad and, when used consistently in a story, thematic. They become representations of the theme (as a topic) that the work explores.

The question for you, as a writer, is what themes are you exploring? And, once identified, how can you represent that theme consistently in your story?

In *Five Days to Die*, Chee colored the book in cool hues except in moments of action and violence; then the panels became washed out in warm reds. It was effective and very fun. There are other ways to be more subtle, but these in-your-face examples are useful to illustrate what we're discussing.

Symbolism

Symbolism, the way I use it, relies on readers' shared (or presumed shared) experiences. For example, in North America, the cross is normally associated with Christianity or Jesus Christ. Similarly, the swastika is associated with the European Nazi populist movement in the 1930s and 1940s.

The symbol in the work doesn't always have to be a literal extension of these things. But we use images, words or situations that are commonly known or associated with subjects in the real world to apply their meaning—to graft their meaning—to the subject within our story.

This probably sounds a bit technical, but it's important. A blatant example is to introduce a character who has a shaved head and a swastika tattooed on his face. These symbols make a statement about who that character is—or at least who he was when he got the tattoo. A writer can use these symbols as shorthand to show who this character is or, alternatively, defy expectations by revealing a character with a more nuanced worldview.

In the film *Cool Hand Luke* (look it up, kids; it's great!), Luke passes out on a table, laid out flat on his back. The camera pulls up to show that his arms are extended straight out and his legs are crossed at the ankles. At this point, Luke hasn't done that much to earn him the Christlike image. It's a symbol that alludes to things to come. It's important to note that symbolism is typically used to relate one subject (a broader one usually, like Christ as a whole) to a particular (like Luke). It's not drawing a one-to-one. It's not saying that Luke *is* Jesus Christ. It signals us to look for some similarity or commonality between their stories.

Symbolism causes the reader, should she notice it, to work harder with the text. The reader becomes proactive on a new level, now searching the text for more clues, or thinking back on the text for earlier clues, depending on when the symbolism takes place in the story. In other words, when the reader picks up on the symbolism, the reader becomes more engaged. If the reader misses the symbolism or is out getting popcorn when the scene occurs, well, that's okay, too. It's not imperative to the story in most cases, but it does enrich the viewing or reading experience.

Imagery

Imagery is talked about a lot less in writing circles, yet I find imagery to be the most interesting because unlike symbolism, which relies on our shared common experience for meaning, imagery actually creates meaning within the story itself.

The other way in which imagery is different from theme or symbolism is its specificity. Imagery refers to a specific image. In a story, you could argue that a specific turn of phrase can also take on a meaning and be called imagery. We recognize these things but often don't label them. In *The Empire Strikes Back*, when Leia tells Han Solo that she loves him, he responds, "I know." In the sequel film, *Return of the Jedi*, Han tells Leia that he loves her and she responds, "I know." Her spoken response is an example of imagery because "I know" takes on a different meaning due to the context within the film. "I know," between these two characters, has become code for "I love you, too." As an audience, we intuitively get that.

In order for the above example to work, it has to be specific. Had Leia responded, "I am aware of that fact," instead of using the exact two words that Han had used in the previous film, it wouldn't work because the phrase lacks the specificity of what Han had said earlier.

Now, let's use a more subtle example that Chee and I attempted in *Five Days to Die*. Take a look at the following five images. They all have a figure, face down, with their arms stretched across another per-

1. Ray's wife lies dead across the hood of the car after a bad car accident. Note the body position. This is the first time that we use this image. This occurs just six pages into the first issue.

Five Days to Die no. 1, interior. Written by Andy Schmidt; illustrated by Chee. Cover by Chee. Published by IDW Publishing, 2010.

2. The final page of the first issue calls back to the position. Ray now lies across his daughter's bed as she lies in a coma.

Five Days to Die no. 1, interior. Written by Andy Schmidt; illustrated by Chee. Cover by Chee. Published by IDW Publishing, 2010.

3. Ray's widow's sister now lies, arms stretched across her sister's casket, at a funeral that Ray decided to skip.

Five Days to Die no. 4, interior. Written by Andy Schmidt; illustrated by Chee. Cover by Chee. Published by IDW Publishing, 2010.

4. The villain's daughter lies across her father, who, shot by Ray, is now dying. Ray sees this and recognizes the inversion of himself with his daughter at the end of issue no. 1.

Five Days to Die no. 5, interior. Written by Andy Schmidt; illustrated by Chee. Cover by Chee. Published by IDW Publishing, 2010.

5. Matt, Ray's protégé, who has now rejected Ray's workaholic tendencies and decided to focus on his family, kneels and lies across his wife's pregnant belly in the final moment of the series.

Five Days to Die no. 5, interior. Written by Andy Schmidt; illustrated by Chee. Cover by Chee. Published by IDW Publishing, 2010.

son or object in a similar way. This was intentional. Let's take a quick look:
- The first image is of an injured woman draped across the hood of her car after a truck rammed her.
- The second image is of a father draped across his injured daughter (from the same car accident).
- The third image is of the woman's sister draped across the woman's coffin.
- The fourth is of a daughter draped across her dying father.
- The fifth image is of a young man draped across his wife's pregnant belly.

That particular image, of the body draped across someone or something else, doesn't have preexisting meaning. So it's not a symbol that brings power to the piece through shared common experience. And it's not really a theme, though it's connected to one. It's a specific image that takes on meaning during the course of the story. The first time we see it is on the sixth page of the first chapter. The last time we see it is on the last page of the fifth and final chapter—the very last image of the book.

For me, the image is about the character's deepest love. Admittedly, the first use isn't perfect, but the idea is that the woman in the first image is in a loveless marriage and that she is alone as she dies.

The second image depicts the deep love of a father for his daughter. The third shows the deep love of a sister for her deceased sibling and the fourth shows the deep love of a daughter for her father, a reversal of the second use. The last image depicts the love of a father for his unborn child.

Sensing a theme within the image? The image takes on a deeper meaning by its consistent use and consistent attachment to a theme or idea.

Think it over. See if you think the way Chee and I used them resonates with you. How can you use symbolism, theme and imagery in the story you want to tell?

THE NARRATOR

Every story is told from a point of view. If the story is told by a character within the story, it's that character's point of view. Even if you have no actual narration, you can present the story with no narrative captions and it will have your point of view by default.

Consider a story in which Thor, the Norse god of thunder combats Loki, the Norse god of mischief. The two characters have a bitter rivalry. Now, Thor is a straightforward kind of god. He sees something, and he does something about it, attacking problems head-on. Loki, by contrast, seeks to elevate his station in life, usually with lies and deceit.

So if our story is narrated by Thor, the narration would likely be plain, stern and wooden, kind of like the character. Narrating events as they unfold, perhaps while Thor and Loki are working together, Thor does all the hard work and in his narration he comments on how useless, pathetic and frightened Loki is throughout the adventure.

Now, consider the same events—Thor and Loki journey together, Thor knocking beasts out of their way and achieving victory for them both—but this time it's narrated by Loki. Here's a god that likes to paint himself in the best light, even if it means lying. His narration would greatly downplay Thor's role, perhaps even casting Thor as the frightened child that he, the mighty Loki, had to protect and rescue along the way.

In a story like this, particularly a comic-book version, the visuals of the comic could show us what really happened, while Loki's narration skews the facts. It could be an extremely powerful and memorable way to tell what otherwise might be a rather simple and forgettable story.

Consider an unreliable narrator for your story. The narrator is lying to you, the reader, or at least not telling you all the facts.

Alternately, consider a narrator who is a character in the story, but your reader doesn't know which character it is. Brian K. Vaughan expertly uses narration in his book *Saga* (illustrated by Fiona Staples). It appears that the series is narrated by a character remembering the events or, at least, telling us about them in the past tense. In fact, the narrator is in the story, but she's a baby. As a result, the narrator has a very different perspective on the events that unfold during the series, and it's used to great effect.

I bring up narrators as a way to bring personality to your story, as a way to potentially give your story a fresh or unique perspective. I'll list a few types of narrators and narration here. Feel free to research more on your own. Narrators are a ton of fun!

First Person (Protagonist)
Usually the main character, she narrates the events as they happen and in a way that is clear they are happening to her. This can be used in past tense as well as present tense.

First Person (Secondary Character)
The same as first person, except the point of view is from a side character. It allows for a little distance from your main character and makes it easier to keep a certain mystery about who the main character is.

Second Person
The protagonist or another main character is referred to by second-person personal pronouns like "you." This is most commonly used in manuals.

Third Person (Omniscient)
The narrator knows all, sees all and has no connection to the story. This is a kind of default narrator style. The advantage with this narrator is that he can go anywhere, see anything and get into any character's thoughts.

Third Person (Limited)
The narrator knows only what the main character or characters know. More restrictive but increases suspense and intrigue. Good for mysteries.

Third Person (Detached Observer)
The narrator sticks to telling the story and never inserts her own opinions—never slips in an "I" or a "me" except in direct dialogue. This narrator is unobtrusive and has little voice of her own. The major difference between third-person limited and detached observer is that the detached observer can't get inside any character's thoughts.

Third Person (Commentator)
This narrator never physically enters the story but does appear to comment on the story and its characters. This narrator allows for a distinct voice without having to worry about where the narrator in the story is. The commentator can be limited or omniscient.

Third Person (Interviewer)
This narrator has gathered data after the fact and spells things out for the reader in a way that heightens our sense of reality, as these things did happen already in the story. The narrator's knowledge can be anywhere on the spectrum between omniscient and limited. He can also be a commentator or not—there is much leeway with this type of narrator.

Third Person (Secret Character)
Use this device as a way to surprise your reader. The character is pretending to be someone else or pretending to not be there at all. This is used to great effect in the film *The Usual Suspects*.

Third Person (Unreliable Narrator)
Usually in first person, but occasionally in third person. This narrator is biased or actively trying to trick you, much like Loki in the Thor vs. Loki example used earlier.

Narrators can come in many forms. I tend to use older narrators, seasoned and experienced people who provide a certain context for events.

Exalt, interior. Written by Paul Allor and Andy Schmidt; illustrated by Matt Triano. Copyright Andy Schmidt, 2017.

TIME IN COMICS

Comics aren't shown to us the way television or film is. That is to say, the time it takes to read them is up to us. We can pause, read more slowly or more quickly and flip between pages. It's all there. It's all present all the time. That gives the reader a lot more control. And it all affects how time works in comics.

Without getting into some of the more nuanced effects of time in comics and ways to manipulate the reader, let's take a look at its general uses.

Time and Size

We tend to equate the size of an image on a comic-book page with a couple of different aspects—namely time and importance. The larger the panel, the more important we think it is. As a writer or an artist, we can use this to our advantage in a number of ways.

We also tend to attribute aspects of time to panel size. So a long panel that stretches across a page will seem to take more time in the story than a short-width panel that is tall.

This is the first key to understanding how you, as a comic creator, can manipulate time for your reader. Understanding the relationship of size, especially an image's width, to time is key to understanding what we call moment-to-moment action.

Moment-to-Moment Action

In this layout, a single image represents a single moment in time. The image that follows represents the moment taking place right after the first one. And so on and so forth until there is a scene change. Your typical American comic book tells stories in this fashion.

How long each moment is depends on the pacing of the page, but they can be very fast, much less than a second, to about a minute in length—especially if there is an abundance of dialogue.

Time Expansion

This is kind of like bullet time in the Matrix films. It's a technique we use to make the reader slow down time, to hang on a moment and absorb aspects of that moment. It can be used to ratchet up tension, to increase contemplation and more.

In this technique, the creators chop up a moment that may take place quickly, maybe two panels in a moment-to-moment fashion, into small panels. They make close-ups to focus in on nuance. Let's say the action is Doctor Repugnant punching our hero Captain Justice. You can easily do this in a single panel. POW. Done. But if we want to increase the tension, we cut it up into small panels. Maybe these panels take up the same space as a single panel would have; let's say five small panels. The first is Repugnant's fist pulling back, then a closeup of Justice's eye bulging in surprise. Then the fist, blurred, traveling through the air, then Repugnant's furious face as he yells. And, lastly, BAM—contact!

You can see the effect this would have on the reader. It slows down that moment, increases the tension. However, to increase the tension, something else must decrease, and that is the impact of any single panel. The larger panel is going to carry more weight with it and likely be more dynamic. Note that this technique may cause the reader to focus on the emotional state of the characters more than simply the action.

Time Jump

As with a film, sometimes a comic will jump in time. Usually, this involves a scene change. When you do this, it's important to key your reader into the jump. There are times when you may withhold this information for dramatic effect, but generally speaking, you want your reader to understand when and where we are in the story and the world.

So with a time jump, be sure to include some visual evidence of the jump. The easy ones are a clear change in location or time of day, a change of clothes or a change of the cast of characters from one scene to the next.

Flashbacks

The device used to indicate a flashback doesn't really matter. It can be tattered borders, black-and-white pages, blurry color treatment or a different art style altogether. Whatever it is, it must be consistent.

It's important that you establish what your flashback effect is and how it works the first time you use it. Your first flashback must overtly tell the reader that he is in a flashback, thus associating your flashback effect (e.g., rounded corners, sepia tone, whatever) with the shift in time.

If you draw that connection between the effect and the flashback clearly, then you've given the flashback effect its meaning—much like how we discussed imagery getting meaning from the context of the story itself. It's the same principle. The key is to make that association overt the first time you do it.

> **EXERCISE**
>
> ### Exercise: Dissecting Flashbacks
>
> Go through your comic collection to look for flashbacks. If you've got one that goes back a number of years, try to spread out through the years and find three examples of flashbacks in comics. Then dissect them by asking and answering these questions:
> - What is the device used to indicate that we are in a flashback?
> - Did the creators make it clear in the first use that the flashback was in the past without the use of the narrative device? For example, do you see a date somewhere that tells you this is the past? Or does a character mention a time landmark, such as a newspaper with a date on it?
> - Is the device used again? And the second time, do the creators bother to make it clear in some other way that you are now in a flashback or do they trust that the device is now established in the reader's mind?

Once the flashback effect is established, simply using the effect itself will signal to your reader that he has entered a flashback each subsequent time you use it. Of course, this also means you can't use that flashback effect in any other way or you will break the association with the device to flashbacks and confuse your reader.

Here, we go into a full-page flashback (and montage) using puzzle pieces as a type of panel border. The captions make it clear that we're in a flashback, but the anchored puzzle pieces also indicate that we're in a flashback. The dislodged puzzle piece in the moment that the narrator's life takes a bad turn is a visual representation of that personal breaking point.

Achilles Inc. no. 4, interior. Written by Andy Schmidt; illustrated by Daniel Maine. Published by Comics Experience and Source Point Press, 2018.

PACING

Pacing is the building and release of tension. There's an ebb and a flow to it, much like in our own lives. Pacing and the manipulation of it can increase and decrease tension, increase and decrease tempo, and increase and decrease energy within your story.

Rhythm is about time (and space) in comics. The length of a scene, in terms of how much room it takes, indicates a certain passage of time. You don't want your reader getting too comfortable, so to the best of your ability, arrange short scenes next to long ones next to medium ones and so on. Ebb and flow, from short scenes to long scenes. There's an order to it but also an element of unpredictability. This helps keep your reader engaged.

The Effect of Energy

Energy is about action. How much and how energetic is your action in the scene? A quiet conversation versus a heated argument versus a barroom brawl versus storming the beach at Normandy. Each example is more energetic than the last, and they probably bring to mind images. Think on those images—the more chaotic, the higher the energy level.

Now think of that in terms of a scene. Pacing a scene to make more action in smaller spans of time—more action in less space—creates a sense of urgency, a sense of chaos; it spikes the energy. There are other factors that you can add to the effect, but that's what you need to learn to manipulate—the energy of the scene.

Beats

Beats are about focus, about bringing the reader's attention to something in particular. You hang on a moment, a facial expression, an object or just one panel, and it becomes a beat, forcing the reader to look a moment longer and a little deeper. The beat is usually a lowering of energy but an increase in focus—the opposite in some respects to chaos.

On these three pages from **Achilles Inc.** no. 4, I intentionally set my base line at four panels on the first page. I also used long, wide panels to make the panels feel like they're taking place in a steady, unrushed, pace. The intent is to make the reader feel fairly comfortable and safe, even as the characters are rushed and running. Then when we turn the page to the larger double-page-spread splash image, the energy goes up. Next, the four panels beneath are shorter in width, and the energy goes up even further from the leisurely paced first page.

Achilles Inc. no. 4, interior. Written by Andy Schmidt; illustrated by Daniel Maine. Published by Comics Experience and Source Point Press, 2018.

Manipulating Your Pacing

If you start with a base of say, four images to a page, four moments to a page and use that as your baseline, you might plan out a three-page scene with twelve images total.

To quicken the pace, shorten the space you give a scene while simultaneously increasing the level of activity/action—increasing the energy. To slow the pacing, increase the length of a scene while decreasing the activity.

In our example, maybe that three-page scene becomes two pages. Now you've got six images per page—more activity, more energy on each page. Better yet, can you cut panels so there are only ten images total? Each one becomes that much more important and eventful.

Beware of the dangers, as we mentioned above, of space on the page. If you increase the number of images on a page, the images will naturally get smaller and lose some of their impact. There is a natural tension created when trying to quicken the pace, and you may lose some impact. As a writer learning the craft, you'll have to see what works best for you and manage the inherent tug-of-war.

CONTRAST

As a concept, contrast applies to all aspects of creating a comic book. Think about how contrast is a consistent term when artists talk about characters, color, size, light and dark, speed, hard and soft and

> **EXERCISE**
>
> ### *Pinpointing Contrast in Storytelling*
>
> Contrast is conceptual. As with all things conceptual, it has applications across a wide variety of topics. In our case, every aspect of comic-book storytelling. So sit with it, and think on it. Observe contrast when you go to the movies or watch television or read a novel. How is the author of the work bringing contrast into play? That's for you to discover, dissect and then internalize so you can use contrast effectively in your own work.
>
> Look specifically for the following:
> - A slow pace that contrasts with a fast pace
> - Low energy that contrasts with high energy
> - Sadness that contrasts with elation
> - Dark scenes that contrast with bright scenes
> - If watching film or television, quiet scenes that contrast with loud ones
> - In a comic, a text-heavy scene that contrasts with a "quiet" scene

so on. All aspects of art have to deal with the concept of contrast.

For this reason, the importance of understanding the effects of contrast can't be overstated. If there is one single, driving conceptual element in telling great stories in comics, it's contrast.

Look back at the three-page sequence that opens *Achilles Inc.* no. 4. In that sequence, the small panels that precede the larger double-page spread serve the spread by making it feel larger and more important in contrast to the smaller panels.

If, instead, the first page had been one large image of our hero standing in front of the building, saying, "oh boy . . . " and then we turned the page, that would have worked. It would have played fair with the reader, but the contrast between the single image of a splash page and the image across the double-page spread would have been lessened.

The pacing of the first page is normal to a little fast, and then you turn the page and BOOM, a sweeping landscape—a sea of obstruction. So we are running (fast pace), and then we hit a wall (double-page spread, splash image). Quick and then fullstop!

Additionally, we see contrast in terms of character traits. Good and evil. Tall and short, fat and athletic and so on. This works for personality traits as well—kind-hearted, cold, funny, serious, introverted and extraverted. There should be contrast in the way your characters speak and behave.

Scenes should be light and dark, heavy and funny. The contrast of one against the other makes them both feel more vibrant, more real. A sad scene with a joke in it, if done properly, makes the joke that much funnier while also making the scene that much sadder.

GENRE AND GENRE BLENDING

Most people know the difference between genres. We tend not to confuse a western with, say, a political thriller or a fantasy with a romantic comedy. But the truth about genres once we get beyond the original two—comedy and tragedy—is that they all share a lot of common elements.

The reality is that genres are a kind of myth. We don't tend to confuse fantasy with a romantic comedy—except when we do. Consider *The Princess Bride*. It's both fantasy and romantic comedy—it also happens to be pure genius.

Genre blending has increased in recent years, and there are reasons for that. As a genre begins to take shape and cement itself, certain tropes become associated with it—events or character types or situations that we come to not only accept but expect. After

Judge a book by its cover! Okay, these aren't all covers, but at a quick glance you can see the genre or genreblends that these comics belong to. Now it's my job, along with my collaborators, to use and abuse their tropes in a way that entertains you!

64

a while, these tropes get old and tired, so creators come along and question the tropes of old and begin the process of reinventing a genre.

Genre blending was done famously with the film *Scream*, which turned every horror/slasher movie trope on its head. In the film, they quickly establish the rules that determine who lives and dies in a horror movie. Then they go about playing with those expectations for the rest of the film. It's a setup and payoff situation, but one that is based on subverting the tropes of the genre.

It used the fact that the audience would be familiar with the tropes as part of its appeal. *Scream* was a massive critical and financial success, and a wave of copycats followed. One could argue that *Scream* ushered in (or at least popularized) a new genre, the postmodern horror story.

That was about twenty years ago as of this writing, and the horror genre is receding again, waiting for a new wave of creators to come along and reinvent it.

Understanding the tropes of the genre you're playing in and knowing what they are and how and why they work gives you the ability to manipulate those tropes to your benefit. It helps you to understand both what you can get away with because it's accepted within your genre and what you can manipulate.

Remember how contrast is at play in everything we do as creators? It's no different in genre. Play with the tropes of your genre. Defy them at times; embrace them at others. Keep your reader guessing.

TO SUM UP

Strictly speaking, you can construct a story without giving much thought to any of the subjects we've covered here in Chapter 4. You learned the foundational elements in the previous chapters, but here we discovered how to elevate your story from simply being a story to being a well-told story, with nuance and thought and care paid to the craft of storytelling itself. Introducing you to these subjects gives you at least a glimpse into how to tell a story that doesn't just get you to first base, as we say in baseball. Understanding the techniques here can help you stretch that base hit into a double or even a triple.

It's my belief that those of you inspired to create comics don't aspire to create okay comics. You want to make great comics. And that starts on day one. That starts with planning; it starts with passion. It starts with what this chapter is really about—striving to achieve more and to do the best that you can. Not just the best you can do today, but the best that the potential in you can do. Striving to do that means being aware that there is more.

My goal isn't to train a bunch of people to write like me. I want to help the passionate achieve their creative potential. That means I want to help you become the best writer that you can be—to find your own voice.

This is the end of Part 1. Starting next chapter, we'll get into the thick of comic-book scripting. Up to this point, almost everything we've discussed applies to story in any medium. When you turn this page, we'll begin talking about how to take the story you've developed and turn it into a comic book.

To be continued....

PART 2

Writing for Comics

In Part 2 of this book, we'll explore the fundamentals of writing for comics. The information we covered in Part 1 applies almost entirely to story as a whole, no matter which medium you use to tell it. This section highlights exactly how a story becomes a comic book.

CHAPTER 5

Layering

Over the next few chapters, you're going to learn a methodology that I've developed over a number of years working in comics. The beauty of the methodology is that it's both repeatable and scalable.

What that means is whether you're doing a five-page short story or a twelve-issue graphic novel, the approach is essentially the same. This is not a system to teach you how to write like me; it's designed to allow you to become the writer you are supposed to become—to find your own voice, your own genre and so on.

Five Days to Die no. 2, interior. Written by Andy Schmidt; illustrated by Chee. Published by IDW Publishing, 2010.

STRUCTURING YOUR STORY INTO CHAPTERS

If you've been working along with the book, you've got a solid one-page story spine and a good handle on your character arcs that take place over the course of your story. Now it's time to begin what I have come to call layering.

The process of layering your storytelling is to keep going over what you've already got and flesh it out more and more. The key to layering is to have a specific goal with each layer (or pass) through the text. This will help to keep you from losing your way or digressing, which will happen anyway though, so don't feel bad when it does. More importantly, it will keep you focused on one task or aspect of storytelling at a time.

The first layer you want to do is fairly simple. You take the one-page synopsis you've already got and break it into chapters. Sounds easy, right? That's because it is. The best part of this approach to writing is that each layer is by itself a relatively simple thing.

How do you go about turning your synopsis into chapters? Fortunately, you've already got the tools for this. What you're looking for are those major turning points—probably the act breaks—in your story. You identify them by following the rising action in your story and noting the largest release of tension. Typically, an intense scene followed by a much less intense scene. It's a pretty good bet that the end of the tense scene was a major turning point in the story and the end of an act.

Most stories have more than one of these turning points. Hour-long TV shows these days tend to have four of them, giving us five acts total. Many Hollywood action films have three major turning points, giving us essentially four acts. Other stories, such as *Raiders of the Lost Ark*, have seven acts. Once you've identified the act breaks or major turning points, take a look at how many sections there are. Those are likely going to be your major acts in the story. They

Outline Excerpt

This excerpt from our original outline for Exalt shows where the chapter breaks are in the story. I looked for those moments of tension and release and labeled them appropriately. You can also see where we set out a page-count for the chapters. In the end, the chapters wound up being only eight pages.

Intro (Three pages)
Jacob Windsor announces to his wife and second-in-command that he is dying. Introduces that overall setup of the world.

Chapter 1 (Ten pages)
Ferr lives his life at sea. Introduces the other side of the world. He's on a floating city at sea. Surrounded by people that all work together to survive. They're good to one another. And then shots ring out. They're looking for him. But why? He runs.

Action scene as Ferr comes face to face with Darnell. The two are injured and fall into a deep hole. The fighting stops, and the rescue mission begins.

Chapter 2 (Ten pages)
Jacob and Vera have it out as Jacob is watching modern medicine do its thing. His own force fields are helping treat the cancer. Vera's angling for her piece of the company.

Meanwhile, Darnell is pulled out of the hole after being trapped for two days. His leg is broken, but he'll be okay. He calls off the search.

We find Ferr, washed through the system and dumped into the ocean, only to be caught up in a fisherman's net. He's rescued. Close to dead.

are usually fairly evenly spaced apart. That tends to happen naturally.

Count them up. The number of acts you have should give you the number of chapters your story contains. Seven acts = seven chapters. Now, don't get confused into thinking that if you have seven acts, then you must have seven issues of a comic book. If you wish, your comic can have short chapters in it. In the 1970s, many of Jack Kirby's (look him up if you don't know who he is, kids!) comics had four chapters in every issue. It reads kind of funny today, but the point is, you can have more than one chapter in any given twenty-page segment. And your issues don't have to be twenty pages at all. Those are standards imposed on comics in North America by large businesses. We're not aiming for standard, so we don't have to worry about conforming.

The bottom line is this—identify the turning points, and mark them as your chapter breaks.

One last note: Where, exactly, you break the chapter is up to you. You can break the chapter after the release of tension, giving the reader a sense of satisfaction, or break the chapter at the height of the tension, usually producing a cliffhanger. Those are the two most common choices. One compels the reader to come back for the next chapter, and the other gives a limited sense of closure for the chapter. The way you go is up to you and doesn't always have to be consistent.

For many people, this process of layering takes only a few minutes, but look what you've done. You've turned your one-page synopsis into a clear roadmap for your story, including chapter breaks and a pinpointed diagram of the highest moments of tension in your story.

CHARACTER TURNING POINTS VS. PLOT TURNING POINTS

In the story business, we talk a lot about turning points, and the term can feel vague. All turning

Our main character makes a major decision when faced with two bad options. In this moment, she accepts the significance of her place in the world and decides to face it rather than avoid it as she had prior to this point in her life.

Exalt, interior. Written by Paul Allor and Andy Schmidt; illustrated by Matt Triano. Copyright Andy Schmidt, 2017.

points boil down to two types. It's worth taking a moment to discuss the two types of turning points and their relationship to each other.

Character Turning Point

It's my opinion that this is the primary kind of turning point because, without these, the others have little to no meaning. The turning points for characters are those points of major import to the character. They are defined by something happening to the character or the character making an important decision. Either way, a turning point, as the name suggests, causes a change (or turn) in direction for the character.

For example, after using his newly discovered powers for self-gain and then finding himself responsible for his uncle's death, Peter Parker decides that he must use his powers to help others.

That's a turning point for the character. Notice that he is acting in his own self-interest until he makes this decision (the turning point), and starting in the very next scene, he's no longer selfishly using his abilities but is trying to help others—a total change of direction. There are plot mechanics in play (the death of his uncle), but that's not the actual turning point. The turning point—for the character—is his decision afterward. These types of moments can be powerful; they release tension and usually herald a new act.

Plot Turning Point

These also shift the direction of the narrative, but usually in a more direct and recognizable way. There is a break in the case, the bad guy reveals himself or our main character realizes he needs to find someone or something and travels to go get it. These are constructed in the plotting. That said, even though you may have a big revelation—the butler did it!—it only matters how it affects your characters. So even though you may construct a big moment in your plotting, it's imperative that you link it, either by direct impact on your major characters or by their reaction and acknowledgment of it as important to them personally.

For example, Uncle Ben is killed. This is what will eventually cause Peter Parker to decide to become Spider-Man. But Uncle Ben's death works because it is tied to Peter Parker's decision earlier in the day to let a criminal go, even when Peter could have stopped him. The criminal that Peter lets go is the same one who kills Uncle Ben. The fact that Uncle Ben was killed by a criminal might have been enough to convince Peter to go fight crime, but the fact that Peter feels culpable is what drives it home

EXERCISE

The Character-Swap Test

Chart out the plot of one of your favorite stories. Just a brief synopsis will do. Now, imagine this story, starting from the beginning, with a different main character going through the exact same plot—so, let's say you decide to swap The Punisher for Luke Skywalker in Star Wars. Or perhaps Wolverine for Frodo Baggins in The Lord of the Rings.

Now look at the story. How does changing the character necessitate a change to the plot? What's the first plot point that has to go differently because the character would make different decisions? In the case of Star Wars starring The Punisher, instead of going off to get training to become a Jedi, Frank Castle gathers as many blasters and bombs as he can carry and starts blowing up Imperial bases, working his way to the Emperor with massive amounts of destruction along the way. In the case of Wolverine in The Lord of the Rings, Gandalf takes one look at Wolverine and decides to give the ring to someone else, but the ring's influence is too great already, so Wolverine cuts down Gandalf and uses the ring to empower himself. Pretty different!

In both cases, who the character is must change the way events work out. Does The Punisher go after the Death Star at all? Maybe, but only because his true target is on it. Does Wolverine throw the ring into Mount Doom? Maybe but certainly not by the route Frodo took.

This is a test that I use when I evaluate pitches for preexisting characters. If I could swap another character for the writer's chosen protagonist and the events would basically still unfold the same way, it's an instant red flag that the story isn't character-driven. It was almost an automatic pass from me in those cases.

and gives it weight. Conversely, if the same criminal that he let go earlier in the day had killed someone that Peter didn't know at all, that would still get a reaction out of Peter but not nearly the turning point that we get when it's revealed to be Uncle Ben who is killed.

Also note that, in this example, the plot turning points are constructed to influence and maximize the impact on the character's turning point. This is why character turning points are primary. They are the ones that drive story—stories are about a character, not a plot.

The common pitfall for new writers is to dive into plot first and then try to graft a character arc on top of it. It can work; I won't say it's impossible, but it's rarely as compelling a result as if you start with the character's turning points and then craft the plot turning points to maximize and enhance what your character is going through.

OUTLINING

Layer number two! You've got your synopsis broken into chapters, and you've got a good handle on the turning points—both character and plot—and understand how they're linked. Now we're going to do another pass over it, adding another layer.

At this point, your synopsis is going to start to really grow, getting longer and longer as you add content and details. You've got your chapter breaks. Now you're going to break out and expand on each individual chapter. It's possible that your synopsis contains every scene you want to have in your chapter, but it's also possible that it doesn't. If there is just one or two sentences in your chapter-by-chapter outline, then now is the time to add in a note for each scene.

I like to take a chapter and turn it into a bulleted list. Each bullet point represents one complete scene. I'll write usually no more than five sentences about a scene and often, just one. Remember: This is the framework, and there's still plenty of time to flesh it out, but we want to see that the story will hold together.

Go chapter by chapter, and repeat. As you do this, you'll likely hit points as you go through, and you'll realize you need some event to have happened earlier in order to correctly set up a later one. For example, if you write that Indiana Jones opens a vault and finds asps lining the cave and he says he hates snakes, it makes sense to think: I have to set up that Indy hates snakes earlier.

You've got two options. The first is to simply make a notation off to the side that at some earlier point you need to slip in the detail that Indy hates snakes and then keep going with your outline. Then once you've gotten to the end, you'll likely have more than one of these notations, and you can go back over your outline and knock these notes out one by one. In the above example, you jump into the first sequence and Indy is on a plane with Jock's pet snake and freaks out. Great. Done.

Option two is to stop outlining right there and go back and find where to insert the reference to Indy hating snakes right in that moment and then come back and continue on.

Either way works; it's best to do what's comfortable for you. Personally, I tend to do a combination of both depending on my momentum. If I feel like I'm making strong progress, then I make a note in the margin and keep moving forward. On the other hand, if I'm feeling a bit pedantic and my concentration on detail is strong, I'll go back and implant the setup earlier in the outline right then.

If you're anything like me, you'll start outlining and breaking your synopsis into scenes and the first chapter will be, let's say, half a page long as a bulleted list. But then chapter 2 winds up being almost a whole page on its own. Then chapter 3 is a page and a half. And I look at the whole thing, and I realize that I did two things—I got more and more into the story, adding more and more detail to each scene as I went along, and I also made a lot of notes about how I

have to go back to previous chapters and add things, usually exposition rather than full additional scenes.

Then I'll spend time evening out the entire thing as I add those detail elements to the earlier chapters and layer in a bit more information. My outlines never look perfectly even, and there's no need for that at this stage.

The important thing is your mechanics—your framework is now erected. You can see how what your character goes through determines what plot turning points will happen and when.

When you're all done and you feel like you've got all your bases covered, look at every bullet point. Note the charge at the beginning of that scene and the charge at the end of it. Make sure they're different, and identify the turning point. Do this for every scene.

Once you've done that, you know your story is moving forward.

CLEANING UP YOUR OUTLINE

Look at your outline. I mean really look at it.

It's a mess; isn't it? Be honest. The truth is that there comes a point when things stop looking like they're under control. Maybe yours does look nice and organized still, but it won't for long. Creating stories and characters is messy work. There's a lot of excess stuff—ideas, characters, scenes that you'll throw out along the way. Scraps on the cutting room floor, as it were.

And that's all okay. It's all part of the process, and it all has value. Realize that every cut you make means you've learned something—either something about the craft that you'll use for years to come or something about this particular story—and, therefore, you've made it better.

There's an old adage that says that writing is rewriting, and I find it hard to argue with that. Many people think that a writer sits down and out spills a complete first draft of a work and then there's a brief rewriting process. In reality, we write an idea for something and then pretty much from that point on, it's rewriting. It's workshopping the story, the characters and the scenes. It's all rewriting.

At this point, with your (probably) messy outline, with its bullet points (if you chose to use those) and uneven chapters and all of that, you have to start making decisions.

The decisions you make during the outlining process can save you hours and hours of work later. As much as you may be tempted to jump straight into the next layer, stop here and stay for a while. Let it sit. Absorb it.

Read your outline again. You'll want to start filling in more details. Do it. You'll note that you haven't explained things. Go ahead, and explain them. If you can, insert that information in the place where you think it will ultimately wind up in your story. If you don't know where that is just yet, that's okay; put a note in the margin and keep going.

At this point, I like to clean up my mess a bit. During the outlining process, I type quickly, and I don't go back and edit as I go. I let typos stand, and my grammar is usually atrocious. So I need to clean up my outline from time to time.

I'll even add a little drama to the scenes as I clean them up. For example, I'll add just a touch of staging about a fight. It's "no holds barred" or "our hero hangs on to a cliff by one hand as the bad guy looms over her," or whatever little bits of flare add enough detail to start bringing the story to life.

When this cleanup process is over, I've got an outline that I should be able to hand over to someone else to read, and that person should be able to understand it. The other thing I've got is all those notes about things that still need to go into the story—the information that I need to implant. Cleaning up and refining will help, not just because it's more presentable and easier to read but because the act itself helps galvanize the story in my mind. I understand the story that much better, which

is important when I move into the more detailed aspects of storytelling.

EXPOSITION

I'm not going to lie to you. This next part isn't fun. We're dealing with exposition. Many writers see exposition as the bane of their existence. So let's break down exposition into its parts, why it's important and how to deal with it.

I've decided to put this section at this point in the book because you've already been dealing with it—it's impossible not to—but this is the earliest point where you can start to influence it and get a handle on it so that exposition flows smoothly in your story. If we tried to handle it earlier in the writing process, we likely would have gotten bogged down. Conversely, if we wait much longer, it may require a bunch of really unpleasant rewriting. So this feels like the right time to really dive into it. However, your mileage may vary. So if you want to deal with exposition earlier or later because that feels more natural to you, feel free to do so.

What Is Exposition?

Data. That's what exposition is. It's little bits of information that your reader needs in order to fully understand and appreciate your story. Put that way, you have to wonder why it's seen as such a problem. But the fact is that there is a tremendous amount of data that a reader needs for any story, even one in a familiar setting.

The key to dealing with exposition is economy. The more economical you can be in getting your exposition across, the better. Exposition typically doesn't move your story forward (we'll talk about the exceptions to that in a moment), so you want to get through it both quickly and unobtrusively.

Consider the first two X-Men films in the early 2000s. There's a lot of information that the viewer needs in order to understand what an X-man even is,

Daniel and I decided to drop some exposition and play with a theme that runs through **Achilles Inc.** right here on the cover of the first issue. You'll notice the signs being held up by the mob facing the woman with fire powers. That tells us something important about the world. A little less obvious is that the human is in the bottom half of the cover. All four covers are structured this way with the human on the bottom—the underdog.

Achilles Inc. no. 1, cover. Written by Andy Schmidt; illustrated by Daniel Maine. Published by Comics Experience and Source Point Press, 2018.

what Xavier's school is for, why people hate mutants, what every character's individual powers are and so on.

In the first film, which introduced viewers to all of this, there are some pretty heavy expositional scenes—there's an actual tour of the school, for

example. I wouldn't say it's unobtrusive, but it is fairly economical.

In the second film, the creators were faced with a different problem—viewers of the first film weren't going to want a big info dump again. But, at the same time, there were going to be people watching this film who hadn't seen the first one. The filmmakers' challenge was to squeeze in the exposition new viewers would need to understand the film.

Consider Wolverine's introduction in the second film, in which he meets with Xavier briefly and Xavier tells Wolverine to put out his cigar. In response, Wolverine treats Xavier with a certain amount of disrespect that only he can get away with. In the first two lines exchanged, they've established their relationship and what is unique about it. Then as Xavier demonstrates his abilities, Wolverine puts out his cigar on his own hand and we watch the burn mark heal instantly. All of this is character-driven bits about those two characters. But it also serves as entertaining, seamlessly injected exposition. It answers who they are, what their relationship is about, what both of their powers are and all in a matter of seconds. Very economical and completely unobtrusive. We don't even realize we're being fed exposition.

Examples of Exposition

Some exposition we simply forget to include. I used to use a checklist with things like "character names" on it to make sure they actually make it into the book. You'd be surprised how easy it is to assume your readers know what you know about the characters. Here is a brief list of things to make sure you've covered in your story.

- Character names
- Character skills
- Specific character knowledge
- Character desires
- Character goals
- Character flaws
- Place
- Time of day
- Relationships between characters
- How something works
- Where someone was before they appear on the page
- Ulterior motives
- Location of one object as it relates to another object

The list can go on and on, and as you flesh out your story, more and more little bits of information will come to mind that you'll need to work in. Once you start writing this all down for each character, you can quickly see how that list is going to grow and grow and grow. So how do you deal with it?

The Dos and Don'ts of Exposition

There are no hard and fast rules about how you must deal with exposition. There are only techniques, and I'll talk about a few of my favorites below. But first, let's talk about a common pitfall—the info dump.

The Info Dump: The info dump is what a writer does when she has compiled the list above, realizes there's a whole lot of information that the reader needs to know and decides, "I'll just get it all out of the way up front so we can get right into the story." Now, okay, that seems reasonable, and there are cases where a little of this is okay—think of the opening scrawl in the Star Wars films, but also notice how short those really are and how they're integrated very nicely into the aesthetic of the movies.

When most of us do this kind of thing, we simply shed readers. Readers don't want to cut their way through five pages of exposition before they meet someone they care about. It's far more effective to get your readers to care about a character first. Then smoothly handle the exposition from there.

Okay, with my one "suggested don't" out of the way, let's talk about some "dos:"

Order It: Make sure you have a clear understanding of when your reader needs to know each bit of information.

"Exposition as ammunition" is a phrase coined by Robert McKee in his book *Story*. It means that not all exposition is bad or needs to be given out as early as possible. There is some exposition that can be used for dramatic effect and may be much more useful if you withhold it for a while.

For example, you could write a scene that starts with a woman tucking a gun into her purse right before going to meet a man in a restaurant. As she nears the table, you call for the reader to see that the man she is meeting places a gun under his napkin, out of sight of the woman. Congratulations, you've set up a tense scene. We, as readers, know someone's getting shot in this scene, right? So we'll sit there wondering the whole time who is going to get whom. After a quick exchange, the woman pulls her gun on the man, and then the man shoots her under the table. You established the guns and their placement. It all works.

Now consider this scene again, only this time you withhold one piece of information. This time, we see the woman and her gun, but we don't see the man's gun. As far as we know, he's not armed. They argue, and it quickly escalates. "When is she going to shoot this guy?" we're thinking. Finally, she pulls the gun, but then unexpectedly—BAM BAM BAM—she goes down in a hail of bullets. The man stands at the table, and we see his smoking gun for the first time.

It's an identical scene, but it plays out very differently when the second gun is revealed after the firefight. This is using your exposition (literally in this case) as ammunition.

Setup and Payoff: One of my favorite screenwriters often talks about setup and payoff. Shane Black says that all writing is just setting up for things to pay off later, and the more you can set up without your viewer or reader realizing it's a setup, the better. It feels more natural that way.

Going back to the snakes example in *Raiders of the Lost Ark*, it's established in a hilarious way that Indiana Jones is afraid of snakes. It's funny because he's just survived some of the deadliest traps anyone

> **EXERCISE**
>
> ### Identifying Exposition Points
>
> Watch a scene from the first thirty minutes of a film that you know well and write down all the data that gets dropped in that scene. I mean everything! Any new information that's stated in dialogue, anything we pick up through the visuals in the scene. It could be what we learn about someone from a tattoo, the items in her house, what she's wearing, any actions she takes that tell us who she is or what's special about her.
>
> Once you're finished, review the list you've made. What's told to us through dialogue and what's just shown to us? How much information is conveyed? Is it done economically? It should be.
>
> Now think about the scene again. Prior to the exercise, did you think that the scene had that much exposition in it? Hopefully you didn't think there was too much exposition because the writer slipped the exposition into the scene in a way that wasn't obvious. If that's the case, that's good. That's the way it should be if the writer and director are doing their jobs well.

has ever encountered: He outran an army that was trying to kill him, swung into a river and got on an airplane. All of that didn't faze him, but then he sees the pilot's pet snake and loses his mind. Very funny—a great character bit. But it's also a great setup. Roughly two hours later in the film, Indy encounters snakes again. This time there are thousands of them, and they are the only thing between him and his ultimate goal. His eyes go wide, and he says, "Snakes. Why did it have to be snakes?" The

EXERCISE

Counting Data Points

Take a look at the first page from the first issue of Achilles Inc. Read the page, and see how it flows. Does it work? Feel natural? Is there a little tension?

Now look at it again, and see if you can count all the little tidbits of information. Some of them may be in the art itself, not just the dialogue.

I count twelve pieces of exposition at a minimum. How many did you see?

Now pick another comic book, and do it again. Dissect it, and feel out how exposition can be handled effectively, and also realize when it's not done well.

Achilles Inc. no. 1, interior. Written by Andy Schmidt; illustrated by Daniel Maine and Francesca Zambon. Published by Comics Experience and Source Point Press, 2018.

scene in the snake pit is a payoff from a setup that works perfectly. It's efficient and unobtrusive when introduced, and it has a huge payoff.

Make It Entertaining: Wolverine putting that cigar out on his hand and his attitude toward Xavier and Indiana Jones's fear of snakes serve as good examples of entertaining exposition. Both of those scenes serve a dual purpose of being good character moments as well as giving the viewer needed exposition about the characters.

When you can't use your exposition as ammunition and it's not setting up for a big payoff, then you roll up your sleeves and get to work to make the exposition as entertaining as possible. There are hundreds of tactics for doing this, but it's best to use this as a reserve option if the previous two techniques are not possible.

Make It Innocuous: When making the exposition entertaining isn't an option, then you're going to lean as heavily as you can on making it unobtrusive. Sometimes, you just need to slip bits of information into a script and try to make it seem conversational. The less your reader notices it, the better.

Avoid Repetition: The last thing that you need to know about exposition is this—once given, you want to avoid repeating it unnecessarily. This way, you can avoid bogging down your reader with information that he already has.

INDIVIDUAL CHAPTERS

Now that your story is broken into scenes, it's time to get a plan together for your individual chapters. Here are some things that you want to decide around this time:

1. Do you want your chapters to be the same number of pages, or does it not really matter to you?
2. Are you planning an original graphic novel or to serialize the story in individual issues?
3. If a graphic novel, then you don't need to pay too close attention to making page counts between chapters terribly consistent.
4. If you're going to serialize the story, then you're going to pay close attention to keep page counts consistent.

At this point, you're starting to layer your publishing structure onto your story.

We will talk about this in Part 3, but if you are self-financing your project, then taking your finances into consideration is going to be an enormous factor in determining how packed your story will be. From my own experience, it's a very quick process for me to determine if my eight-issue series can be done in just four. (Pssst. It can be.)

The above is worth thinking about now, but you may not need to make a determination just yet. So if you want, you can put off these decisions, but I bring them up because it's a good idea to be working on them in the back of your mind.

As for your individual chapters, you need to make sure of three things:

1. Do they flow properly? The tension in them rises to a suitable release.
2. What exposition does your climax (major turning point) need for the payoff to work?
3. Determine if you can tie the climax—the turning point—to a character. It should be a character turning point if you can manage it. How can you steer your plot to enhance and maximize that climax's impact on your character and your reader?

Now count your chapters. As a rule of thumb, your scenes should take up an average of about three pages each in the final comic book. Again, this is a rule of thumb. If you're doing a graphic novel, this won't matter as much, but it's worth looking to

Ferr narrowly escaped death and is literally fished out of the ocean here, a cliffhanger and a turning point on which we decided to end a chapter.

Exalt, interior. Written by Paul Allor and Andy Schmidt; illustrated by Matt Triano. Copyright Andy Schmidt, 2017.

see how many scenes you've got. I tend to think that for an American-style comic running about twenty pages long, you want fewer than eight scenes if you can manage it. Again, I can't emphasize enough that this is just a rule of thumb. There are some twenty-page comics that are made up entirely of a single scene, and there are others where each page is a separate scene. Both can work, but most of us don't write scripts that way. Those will be the exception, not the rule.

TO SUM UP

Up until now, you've been outlining your story without regard for the comic-book format. Act breaks and character beats, the character's arc and trajectory. This is all necessary before you've fully committed to the medium you're going to tell your story in. It's also a good point to gut-check that the comics medium really is the best for your story. Now's a good time to catch whether your story will be better served as a novel or a screenplay.

Okay, you're sure it's a comic now, right? Great! Let's dive into outlining for your comic book or graphic novel!

To be continued. . . .

CHAPTER 6

OUTLINING

You've got your story locked into place—leaving suitable room for inspiration to strike, I'm sure—and now we're going to descend into outlining your comic book. What you'll notice is that all we're really doing is layering in more and more detail. We're just filling in gaps, much like building a road. Chapter 5 helped us clear and level the road of debris. Now we'll put down the pavement. Once this is done, you will know what shape your story will take. You'll probably see it forming in your mind's eye as you move through these steps with your story.

It's time for takeoff, as this scene from *Babylon* illustrates. Now, let's go!

Babylon, interior. Written by Andy Schmidt; illustrated by Kieran McKeown. Copyright Andy Schmidt, 2017.

ISSUE OUTLINE

Once you've broken your story down into chapters, in most cases, those chapters will become issues. But an issue and a chapter don't necessarily have to be the same thing. (As I mentioned previously, back in the 1970s, a single comic book issue might have contained a story with four chapters.) But, for the sake of simplicity in this book, I'll refer to issues and chapters as the same thing: roughly twenty pages of story meant to encompass a larger act of your story.

The big question you need to consider is *story density*. Which is to say, how much story do you want to pack into your comic book—how much do you want to jam onto every page? It's quite possible to pack a lot of information and cover a lot of ground in a small amount of comic book space. For example, the Marvel Comics character Doctor Strange had his origin and his first adventure told in just five pages of comics story. In 2016, Hollywood took nearly two hours to tell the same story. But it's also possible to take time and space and tell very little story in twenty pages, focusing on tone, mood or character emotions more than driving the story forward. This is called *decompressed storytelling*.

There's a broad spectrum on which you can play. Most comic creators I know prefer decompressed storytelling. And why not? You can be methodical, and you can capture every nuance you want—sounds great. But there's also something really inviting about the notion of a compressed and energetic story.

Then there's the budget. I've refrained from talking too much about the financial implications of creating comics, but whether you're creating your own comics or working for a business to create a comic for it, you're going to have a limited number of pages that you are given (or allow yourself) in order to tell your story.

So, for you, the storyteller who has now broken your story into chapters or issues, here are a couple rules of thumb to help you figure out how much story can or should go in your issue. Remember: These ideas are based on about twenty pages of story in each issue.

What I've found both by reading thousands of comics and through my own editing and writing is that between five and eight scenes tend to be fairly comfortable for a twenty-page comic book. This allows you to have that ebb and flow in your scenes, some longer, some shorter, some with larger images and some more compact. A structure roughly like this is a pretty good estimating factor.

> **EXERCISE**
>
> ### Exercise: Make a Comic-Book Movie Adaptation
>
> As an exercise to help you understand how to place scenes into a comic book, try the following:
>
> Take any movie that you know well and watch it. As you watch it, you want to write down two things: the first is simply a list of all the scenes in sequence and the second is the major act breaks in the story (not scene turning points but your major acts).
>
> Once you've got your list, use the tools in this chapter to determine how many chapters or issues overall the movie adaptation should have, and then figure out what scenes would fit in each chapter and why.
>
> I once was commissioned to write the comic-book adaptation of Star Trek II: The Wrath of Khan (published by IDW Publishing). I was given just three issues to do it in. What I'm suggesting that you do above is something I've done myself, and it isn't easy! But I learned a ton about pacing scenes and chapters when doing this particular assignment.

Obviously, if you have a dense story, you might be looking at closer to eight or nine scenes per issue. If you have a simple linear story, you might be looking more at the four or five scenes per issue range, especially if it's got a lot of character nuance.

Typically, what happens as you increase your story's density is that the plot and staging tend to squeeze out the character moments. For that reason, more character-driven work tends to be more decompressed, while more plot-driven or event-style comics tend to be denser.

The bottom line is that you want to estimate accurately how many scenes you can put in each chapter or issue. And that's going to be determined by how dense you want (or need) your story to be.

FIRST ISSUE—WHAT IT NEEDS

It's worth taking a moment to talk about the difference between a first issue or chapter of a story and subsequent ones.

Your first issue is the one that has to establish the most about your characters and the world they inhabit. That said, it also has to grab your reader's attention and make your reader want to come back for more.

Every issue needs to establish certain things like character names and their relationships. Every scene needs to convey some idea of place and time. But the first issue has to establish something else—two things, actually.

Your Story World

Every chapter will do some of this, but your first issue has to establish what your story world is like. What are the rules in this world if they differ from the world we inhabit? Are ghosts real here? Do zombies walk the Earth? Or even less obvious, in most TV shows, violence is somehow less dangerous than in the real world. In TV shows, a person gets punched in the nose and it hardly bothers them. In real life, your eyes tear up and you're pretty much out of the fight. So your first issue establishes all of those nuances as well as genre and tone. You set the stage for your reader and bring them into your story world.

Your Series

Defining your series is a little more challenging. The first issue has an inciting incident (or should!), but it's also the single piece of your story that establishes what your entire series is going to be about.

In Paul Allor and Paul Tucker's comic book *Tet*, the first issue establishes the main characters during the Vietnam conflict. The series is clearly about these characters' lives and how they intertwine. The first issue sets the lead characters on an investigation of a murder, but at the end of the first issue, we realize that the series isn't really about the murder investigation. It's about how the Tet Offensive, which begins on the last page of the first issue, is going to interrupt people's lives and change them drastically. The first issue was about the murder mystery (which does continue), but the series is about how events can sweep up lives, chew them up and spit them out.

Allor and Tucker had to make what the series is about clear by the end of the first issue. That clarity didn't have to happen at the end of the first issue; the issue could have started with a scene that told us this, but it did have to happen *in* the first issue.

OUTLINING FOR A VISUAL MEDIUM

We've mostly been talking about story from a writer's perspective, but it's good to remember, even in these very early stages—like when we discuss character design—that comics are a visual medium.

What that means is that the visuals take precedence over the words and lettering. It doesn't mean that cool visuals alone make for good comics—but they sure do help.

If you are the writer and someone else is going to illustrate the comic based on your script, then the responsibility for clear and compelling artwork is largely on the artist's shoulders, but great art in a comic book certainly starts with the script.

We'll get into specifics about how to describe things and what to call for and all of that when discussing panel descriptions in Chapter 7, but you've got to start training your brain to think visually now if you haven't already.

Reread your outline (out loud can help) and let your mind conjure up images all on its own. When you hit upon an image, write it down—just a note to jog your memory about it later.

Once you've done this, take a look at what you've written. Are there any key images that sum up or define a certain moment in your scene or story? If so, there's a good chance you'll want to use some version of that image in the scene itself.

The above technique is helpful, but it's not easy to get used to doing it. To be honest, I rarely do the free-association exercise myself anymore, but I definitely did it a lot for the first few years I was writing for a living. There were some powerful images that I'm not confident I would have come up with without it.

A more mechanical approach for those of you who like rules and step-by-step instruction is to read your scene outline and ask this simple question: Is there a way to communicate this scene/emotional moment/reveal/whatever with an image (or several)?

An action sequence is almost by definition visual. But what about a scene where a character is trying to hide a secret? Or lying about something? Imagine a scene where a character is trying out for a school play and is nervous. Instead of writing dialogue where your character says to another, "I'm so nervous about this audition," can you figure out a way to show the reader that your character is nervous? Is he running his hand through his hair? Bouncing his knees as he sits? Tapping a pencil against a table? Sweating? Ringing his hands? What can you do to tell us he's nervous without having him say it?

The classic rule as it's been said to me (and I think it was originally said about movies) is: Show don't tell. It's a visual medium. So show me your story—let me watch it unfold, and let the dialogue fill in the gaps, adding flavor and color.

SCENE-BY-SCENE OUTLINE

By now you should have the bones of your chapter written out. It's time for the next layer, turning your chapter-by-chapter outline into a scene-by-scene outline. Let's go into each scene and determine a few things:

1. Make sure your scene starts and ends with different charges.
2. Make sure you understand how each scene moves your story in the right direction.
3. Make sure your main character is driving the action in the scene wherever possible (instead of being reactive).
4. Determine what exposition is needed for the scene and how to get it into the scene in the best way.
5. Now go to that larger list of exposition for your whole story and see if there's anything else you can slip in here in an unobtrusive way.

The last thing you want to do is review the staging of the scene:

1. Did you enter the scene as late as possible, and did you get out as early as possible?
2. Can you tell this scene in a particularly interesting way by changing your approach or point of view on it?
3. Is there exposition that would be better withheld than revealed?
4. How can you ratchet up the tension or turn the scene with more energy?

And that's it. Taking the time to really dig into each scene this way should save you hours of time later.

Now comes the fun part! Read your scenes and try to imagine how they will play out on the comic page. How many pages of a comic book do you think these scenes will take?

Imagine the number of pages you'd like for each scene and label them. I usually label them just above the bullet point. So if I have six scenes in a chapter and I think it would be ideal for them to each have three, six, four, two, five and three pages respectively, then I'll add those up (stay with me!) and it's a total of twenty-three pages.

BABYLON Chapter 1: Ten-Page Scene-by-Scene Outline

Here is my scene-by-scene outline for a ten-page chapter of Babylon. All of this text, with perhaps a few modifications, was in the chapter-by-chapter outline. I'm simply breaking up the blocks of text in that outline into scenes. I always do a little touching up as I go when I see ways to improve. But all you're doing at this point is breaking your chapter into its component scenes.

Scene 1 (Three pages)

We start off at the site of a mission launch into deep space. The crew of four say goodbye to Earth and blast off. There's a lot of rhetoric about them being Earth's last hope, etc. As the shuttle blasts off for space, we pull back from the shuttle and see that the area surrounding the launchpad has been burned to cinders.

Scene 2 (Three pages)

The shuttle docks in orbit and prepares for a space-fold jump. Even with the fold, the ship will take twenty years to arrive at its destination. Its mission is to find a ship that launched one-hundred years ago and was sent to what we believed was a habitable planet. It was sent to start the terraforming process, manned only by computers and robots.

We realize that Earth is doomed. There is mass destruction, the dead tally in the hundreds of millions, and the only reason the number isn't higher is because billions have already evacuated the planet. If our heroes fail in their mission, humanity will likely be lost forever. What's this plague they're fighting?

Scene 3 (Three pages)

They're fighting robots. And they're losing. They're losing because they don't know why the robots are fighting and destroying . . . everything. The fallout from the initial attacks led to widespread panic, human factions, more fighting and so on. And in all of this, the reason for the fighting has been lost . . . until now . . . they hope.

They were able to track down an idea that had been transferred from robot to robot, deleting its trail along the way. It took years to figure out where the source of the idea was, and they're not 100 percent sure that they know now. They know it came through the SFC (space-fold communications) with the Dawntreader, which was sent into space to terraform planet RBT1942, known more commonly as Sully. It is unknown if the transmission came from the Dawntreader itself, but our four astronauts are going to find out.

Scene 4 (One page)

The astronauts leave our solar system behind, plotting a course into the space-fold. They will sleep for eighty years before they arrive at RBT1942. A lot could happen in that time. . . .

BABYLON Chapter 1: Ten-Page Page-By-Page Outline

Here is my page-by-page outline for the same ten-page chapter of Babylon. All of this text, with perhaps a few modifications, was in the scene-by-scene outline. I'm simply breaking up the blocks of text in that outline into individual pages. I always do a little touching up as I go when I see ways to improve. But all you're doing at this point, is breaking your scenes into their component ages.

SCENE 1 (THREE PAGES)
Page 1: We start off at the site of a mission launch into deep space. The crew of four say goodbye to Earth. The countdown begins!
Page 2: BLAST OFF! Splash page!
Page 3: There's a lot of rhetoric about them being Earth's last hope, etc. As the shuttle blasts off for space, we pull back from the shuttle and see that the area surrounding the launchpad has been burned to cinders.

SCENE 2 (THREE PAGES)
Page 4: The shuttle docks in orbit and prepares for a space-fold jump.
Page 5: The crew enters the space station that will be their new home for the next eighty years. Even with the fold, the ship will take eighty years to arrive at its destination. Its mission is to find a ship that launched one-hundred years ago and was sent to what we believed was a habitable planet. It was sent to start the terraforming process, manned only by computers and robots.
Page 6: We realize that Earth is doomed. There is mass destruction, the dead tally in the hundreds of millions, and the only reason the number isn't higher is because billions have already evacuated the planet. If our heroes fail in their mission, humanity will likely be lost forever. What's this plague they're fighting?

SCENE 3 (THREE PAGES)
Page 7: The crew discusses their situation, what the people back home believe is their mission and now that they're out here alone, what their mission actually is.
Pages 8–9: We reveal the robots. The humans on Earth are fighting robots. And they're losing. They're losing because they don't know why the robots are fighting and destroying . . . everything. But the fallout from the initial attacks led to widespread panic, human factions, more fighting and so on. And in all of this, the reason for the fighting has been lost . . . until now . . . they hope.

They were able to track down an idea that had been transferred from robot to robot, deleting its trail along the way. It took years to figure out where the source of the idea was, and they're not 100 percent sure that they know now. They know it came through the SFC (space-fold communications) with the Dawntreader, which was sent into space to terraform planet RBT1942, known more commonly as Sully. It is unknown if the transmission came from the Dawntreader itself, but our four astronauts are going to find out.

SCENE 4 (ONE PAGE)
Page 10: The astronauts leave our solar system behind, plotting a course into the space-fold. They will sleep for eighty years before they arrive at RBT1942. A lot could happen in that time. . . .

If I know that my chapter has to be contained in twenty pages for a traditional North American comic, then I have to go back and find three pages I can trim out. That usually means to condense rather than drop a scene. Can I do the six-page scene in four? Or five? How about that five-page scene? Can I do that in four?

There's no need to overcomplicate this process of determining your page count.

If you're working on a stand-alone graphic novel, you're going to need to look at your scenes' page counts for the entire book at once. (I usually do this for a whole miniseries at once just to be on the safe side.)

Once you've got the right number of pages allocated to your scenes and you feel like it's doable, you're ready for the next layer in your outlining process.

PAGE-BY-PAGE OUTLINE

Now you've got your scenes broken down and you've got an idea of how many pages you think each scene will take in your final comic. After that, we simply go one layer deeper.

For any scene that you've allocated more than a single page, you'll now want to break that scene into its page-by-page components. You'll do this for every scene of the issue or graphic novel.

If I'm working on a miniseries, I tend to start breaking up my scripts at this point. I usually outline the whole miniseries at one time so that when I get to this point, I've got a good handle on what scenes and how many pages they will take for each issue in the series. Theoretically, we could continue each layer throughout the whole series.

However, you could break it into more bite-sized parts if you like, choosing to focus on one issue at a time or just one scene at a time. It's up to you how and when to layer each step.

INDIVIDUAL PAGES

My scene descriptions tend to be short. I know where we begin, what the turning point is, how characters react to things and how they end. Let's say you've got a scene that you think should take three pages. You know what needs to happen in it, so how do you take your prose description of the scene and turn it into comic pages?

I simply want to get from a scene description to an accurate page count of the scene and to determine what part(s) of the scene will be on each page of the scene.

Here's the process I teach to writers who are new to the medium:

Step 1: Make sure that your scene description is written out so that the story beats are in the order that you want them conveyed to your reader.

Step 2: Look for two things: turning points in the scene and good page turns.

Page Turns

We've already discussed turning points, so you should be able to identify those, but a page turn is different. A page turn has to do with the reading experience more than the structure of your story. In comics, the reader has to turn the page. The reader can see multiple panels on a single page all at once. If the reader chooses, she can easily look into the past, present and future all at once—but only on a single page at a time.

What this means for you as the writer is that the page turn becomes one of your biggest tools. Yes, you need enough pages to incorporate your scene comfortably, but the more you can compel your reader to want—to need—to turn that page, the better.

There are a number of ways you can use the page turn to your advantage, but almost all of them boil down to this: Your last panel should compel your reader to turn that page. That means the panel causes your reader to ask a question that he wants an

answer to or builds up anticipation for what comes next in your story. I think of them as kind of a "push" or a "pull" technique. Asking a question pulls your reader to the next page, while building anticipation pushes your reader. Either will work, but I try to do one on every page.

A word of clarification. I say "the last panel," but you really could do this over the course of the entire page or even over a multipage sequence for a particularly large buildup of anticipation. Remember that each act is about rising tension. So each scene is structured similarly, and each page should also be structured similarly. Release and build up until the reader has to turn that page to get the answer he seeks.

Let's go back to that example with the female detective going into the dark house from Chapter 3. I've changed the wording slightly to make it read like a scene so we can break it down into pages.

Our female detective enters a spooky house and is attacked. But during the struggle with her attacker, she wounds the assailant and shoves him into a dresser that shatters on impact, knocking the assailant out—one down, but there could be others. She looks down and the clue she needs has fallen out of the shattered dresser—she grabs the clue! She got what she needs and hurries out of the house with no further incident.

This is our scene. Now let's break it down into pages with some explanation of the breaks:

Page 1
Our female detective enters a spooky house and is attacked—but by whom?

Page 2
The attacker is revealed, and during the struggle with her attacker, she wounds the assailant and shoves him into a dresser that shatters on impact!

Page 3
The assailant is out—one down, but there could be others. She looks down, and the clue she needs has fallen out of the shattered dresser—she grabs it!

You could stretch it to four pages, but I don't see any reason to. In fact, once the assailant is knocked out, most of the tension is gone, so you might end the scene after the reveal of the clue that fell out of the dresser. That would make sense to me.

Page one ends on a standard cliffhanger: She's attacked (turn the page to find out who it is and if she survives the fight).

Page two asks whether throwing the assailant into the dresser was enough to defeat him (and you turn the page to find out it is).

Page three is the real release of tension—the bad guy is out, and the clue is revealed—but if you play your cards right, the reveal of the clue itself could propel your reader to the next scene. You may have noticed I cut the last bit where she hurries out of the house. Once she sees or grabs the clue, there's nothing more the scene needs to do. The clue itself hopefully pushes your reader into the next page, which is also the next scene.

You'll want to experiment with page turns to figure out how to make them most effective for your own writing. With every step of this "layering" process, there's always the opportunity to refine and improve your story.

TO SUM UP

Outlining is tedious, and it's rarely fun. But it helps us focus. It helps maintain direction in the story at all times. It helps remind us what we're driving toward.

Perhaps the most important part of outlining, especially for newer writers, is that it gives us confidence. There are other benefits as well, but when I was starting out, I was so intimidated by the professionals around me and my lack of experience that I found outlining and detailing how things would work gave me the confidence I needed, not just that I could pull the story off, but also that it was good enough to pitch to publishers. It's like having a mentor look down at your work and smile, telling you, "It's good." That's what a good outline does.

To recap, here is the layering and outlining process detailed in the last two chapters:

- One-page story synopsis
- Turns into a synopsis with chapter (issue) breaks
- Turns into a scene-by-scene outline
- Turns into a page-by-page outline
- The shape of the comic book or graphic novel is now visible

To be continued. . . .

REC

CHAPTER 7

WRITING VISUALLY FOR YOUR ARTIST

By this point, you've outlined your story down to the page, so you know, more or less, how much story is going to be on each page. In the last two chapters we touched on thinking visually in order to outline your story. It's not always easy—you've got a lot of other things to track during the layering process as well.

This chapter is about writing visually—how to write for comics specifically—not TV or film or novels. From this point on, you're writing a comic book. There's no going back now!

This page from **Babylon** illustrates a traditional panel-by-panel approach. You're deep into comics country now!
Babylon, interior. Written by Andy Schmidt; illustrated by Kieran McKeown. Copyright Andy Schmidt, 2017.

THE ANATOMY OF A COMIC PAGE

Before you start writing the script itself, you need to understand two different but fundamental things: The first is the anatomy of the comic-book page. The second is script formatting, and we'll get to that in a moment. For now, let's focus on the former. Here are a few terms you'll need to understand.

Page

A single page in a comic book is comprised of either one large image filling the whole page or of multiple images put into a sequence.

Tier

In America, we like our comics organized in an intuitive way. You may hear comics professionals refer to "the three-tier system" at some point, but whether it's three tiers or four or whatever, what's important is the tier itself.

The best way to think of a tier is to think of it like a bookshelf. The page is your bookcase, and the individual tiers are the shelves on which your books sit. In a comic page, the tier is the baseline upon which your images sit.

Also like books on a bookshelf, some images may be taller than others. Your books may jut up and down across the shelf. Your images may do that as well, but the bottom of your images will typically sit on an imaginary tier line across the page, the same way different-sized books sit on a single, straight shelf.

It's my personal preference, unless there is a particular reason to deviate, that my images on a single tier be the same height. I think it makes for an easier page to read, and it looks cleaner, but again, that's my personal taste.

What's important about the tier is that it's on a baseline. The reason for this is that your reader follows that baseline and if the image next to it sits on the same imaginary baseline, then your reader intuitively knows to move to that panel next in the sequence. So the baseline of the tier is the most important component.

Here we have a single page with four tiers. The first image sits on its own tier across the top. Images 2 and 3 are on a second tier—see how they sit on the same baseline. Images 4 and 5 are on a third tier, and images 6 and 7 are on the fourth and bottom tier.

You may notice that image 5 technically doesn't sit on exactly the same baseline as image 4 next to it. In this case, the artist eliminated the image borders, allowing for some variance in the style. Due to the strict nature of all the surrounding panels very clearly being on their respective tiers, this slight deviation does not cause any reader confusion.

Achilles Inc. no. 1, interior. Written by Andy Schmidt; illustrated by Daniel Maine and Francesca Zambon. Published by Comics Experience and Source Point Press, 2018.

Panel

A panel contains an image. Typically, as in the sample page here, panels have straight borders and are either square or rectangular in shape. Of course, one can deviate from this, such as with a circular panel or, as in panel five of the example, a panel with no borders that is still its own clearly defined space.

For the purposes of writing your script, you will rarely call out whether a panel has borders or not; in fact, you'll rarely call out when you switch tiers, but the language of comics is important to understand as you collaborate with others. The panel, for scripting, is each unique image on the page.

Panel Border

This is the line that surrounds any given panel. Again, panels one and five on our sample page don't have panel borders.

Bleed Panel

The top panel, our establishing shot of the diner, bleeds off the page on three sides (the left, right and the top) with a panel border across the bottom. That means that this panel, on the printed comic book, has no border save for the end of the page itself on three sides.

I recommend using bleed panels very sparingly. The temptation is to get more art on your page, but if all your panels bleed off the sides, then when you put your book together, your left-facing page's art and your right-facing page's art are going to collide in the fold of your comic. When that happens, it looks messy and leads to reader confusion. I suggest avoiding that in at least your first couple of stories if you can.

Gutter

The gutter is the space in between panels. Gutters don't get the attention I think they deserve. Even on this page, I wish I'd asked for wider gutters. A good, solid, white or black gutter is vital to the reading experience. This is where, as a reader, your brain rests for a moment—the gutter communicates to us that we're moving forward in the story (and probably in time), and it allows us to close the door on one panel and open the door to the next. It's in the gutter space where the reader's mind fills in all the gaps between the two panels. That's a lot of work for a little white space with nothing in it.

Inset Panel

An inset panel is exactly what it sounds like, a panel set inside of a larger panel. It might be a detail of the larger panel or a person's reaction to what's happening in the larger panel. The key to insets is understanding that it increases the immediacy of the relationship between the larger panel and the panel inside of it. In my own writing, I rarely call for an inset panel, preferring the artist to draw her own conclusions about when one makes sense.

Now you know your way around the basics of a comic page. You can start sounding like an expert today!

SCRIPT FORMAT

If you have access to a computer, I recommend going to our website, comicsexperience.com and clicking on Free Resources and the Script Archive where, in addition to scripts donated by comics professionals that you can download and study, you'll also find our very own Comics Experience script template that you're welcome to download. It's set up nicely, and many professional scriptwriters use it as their own template. And, hey, it's free!

So, here are the terms you're going to need to know:

Script

This is the document you're going to give to an artist (or editor). It contains the important story information for your artist as well as text for the letterer to place in the word balloons on the final comic-book page.

Sample Script Format

In this script example from Babylon, I want you to notice how whittled down the first three panel descriptions are. They're about action—about story. They're not about what things look like or where they're positioned in the panel. That's in the purview of the artist.

But you should also notice that panel 4's description is much longer. It's about mood and tone and what the characters are feeling. It's also establishing the physical attributes of the space station's interior. So it's longer, and it contains information that the artist will carry forward for the rest of the chapter.

Lastly, also notice the sparseness of the dialogue. Admittedly, this is more sparse than my typical page, but I like that it conveys only necessary information. Also note that the first dialogue is actually a caption, with an ellipsis that leads us into Luciana's actual line of dialogue that would be contained in a word balloon.

I really like this page due to how sparse it is. This is usually my goal. The fewer words, typically, the more I like it as a writer. That's not right for every scene in every book, of course. But this one is a somber science-fiction story, and I think it works well this way.

Page 4

Panel 1
A clamp approaches a lock . . .

SILENT PANEL

Panel 2
And latches

SILENT PANEL

Panel 3
Largest panel on the page. We pull back and reveal *Genesis*. This is the station/ship that will take them across the stars.

1. Luciana (caption): The Genesis is our home from here on out . . .

Panel 4
The crew (four of them) is in isolation. It's dark. *Genesis* has been completely powered down for God only knows how long. Condensation is everywhere. The whole place is wet, but that's a detail to carry forward for the rest of this chapter. What you're focusing on is this: They sit calmly as the world is going insane below. Their helmets are off, but they're just sitting around. It's a moment to breathe, and they look exhausted and defeated already. Nigel (left of panel) sitting on a bench, only his fishbowl helmet removed. The others taking off the bulky spacesuits.

2. Luciana: . . . so make yourselves at home.

Page Numbers

This may seem obvious, but when you write a page number on your script, you are referring to the final comic-book page number. This is true when discussing your script with an artist or editor. If you say, "on page 10, such-and-such," what you are referring to is the tenth page of the comic book, not the tenth page of your document. Page 10 of the comic may be described on pages 15 and 16 of your document, but you'd still refer to the page of the final comic book.

Due to the above, and since you'll want to influence the pacing, you should note the comic-book page number whenever you want to jump to a new comic-book page.

Personally, I also add a page break at the end of each individual comic-book page in my script. It makes for a longer script, but since I don't print my scripts, I'm not killing precious trees, and it makes it very clear when the artist should be starting a new page of art (which should be clear anyway, but, hey, why take chances?).

Panels

Unless you're doing experimental comics, your script will be broken down into panels per page. Each panel is accompanied by a number in sequence for the page and contains story information for your artist. This is called the panel description.

Panel Description

This is the story and visual information for your artist—everything your artist needs to know in order to create the panel illustration the story demands. We'll hit on this later, but the name "panel description" is something of a misnomer. In ideal circumstances it's not a strict description.

The panel description is actually organized information that your artist needs in order to create the illustration, not a description like how you would describe a photograph. We'll get into the different types later in this chapter, but it's worth stating early and often because this is the part of the script that causes the most trouble for beginners.

Dialogue, sound effects, captions, thought balloons, whisper balloons, bursts, radio balloons and all text that will be taken from your script and placed on the final comic-book page is listed after the individual panel description. These are separated out not by paragraph but by what text inhabits its own unique space on the page.

For example, a character may have three dialogue balloons in a row, uninterrupted. On your script, they would be listed separately and each be designated with a different balloon number. This indicates to the letterer (and your artist) that you want three unique balloons by the same speaker.

Balloon Numbers

Each unique dialogue, caption or text that appears on the final comic page should be designated its own number in sequence. The sequence starts over at the beginning of each new comic-book page. The same way that each new comic-book page in your script begins with a "Panel 1," your first dialogue balloon on any given comic page would start with the number 1 as well, and they would be labeled in sequence throughout the page, not in each panel.

Balloon numbers are important both for creating "balloon placements," which are rough indicators on the art where each balloon should go and for your letterer to easily grab the text he needs for each panel and page. Many writers ignore this step, but it makes things so much easier for your collaborators that it's really worth paying strict attention to.

Pro tip: I wait until my script is finished before I number my balloons. If you number them as you go, when you go back to rewrite, you'll be futzing with renumbering them the whole time and invariably, you'll make mistakes and your numbering will get messed up.

When writing dialogue (or text for the page) there are abbreviations that I use for certain things like sound effects. It's also sometimes necessary to use a parenthetical qualifier to define something different from a normal speech balloon. Here are a few examples:

- **SFX:** Sound effect
- **Locator Caption:** A caption without any border, typically large and used with a distinct font
- **Caption:** Simple narrator caption, not attributed to any single character

When calling for a particular type of balloon or caption for a specific character, the parenthetical might read:

- **Hero (whisper):** You are asking for a whisper balloon. There are several ways to indicate a whisper, so you'll want to work that out with your artist and letterer in advance.
- **Hero (thought):** You are asking for a thought balloon. These are the inner thoughts, not spoken words of your character, and the balloons are shaped like fluffy clouds.
- **Hero (caption):** You are asking for a caption attributed to the specific character, it may take on a specific color or shape. Again, you'll work this out with your artist and letterer in advance.
- **Hero (burst):** You are calling for a speech balloon that's also a yell.

These are just a few, and you'll probably make up some of your own. I've never had a letterer question any of these. Bottom line, the more intuitive you can make them, the better.

At times, you may have no dialogue or sounds in a panel. This is called, simply, a silent panel. In these cases, I will write under my panel description "SILENT PANEL" so the letterer and the artist both know there are no balloons or captions needed. This tells the artist that she doesn't need to leave room or plan for any balloons and assures the letterer that he isn't missing anything.

RULES FOR PANELS

Okay, before you get all high and mighty and tell me there's no such thing as an absolute rule, I'll confess that you're correct. But, assuming you're someone who's relatively new to writing comics, it's important to give you boundaries. You can break the boundaries later, once you've mastered these fundamentals.

Every Panel Must Have An Action

Every panel you write (with a few exceptions that we'll get to later) needs to contain an action of some kind. It can be big (e.g., "The house explodes in a ball of fire!"), or it can be small (e.g., "A sly grin curls on her face"). Both examples contain story information. If it's story, then it's moving forward. Every panel needs to move the story forward.

If there is no action, then there is no story movement. And, if your story isn't moving, you're losing your readers.

My old boss at Marvel, Tom Brevoort, once said to me, "Every panel is a chance for the reader to get bored, lose interest and put that comic down, never to come back to it." That is a terrifying thought. As an editor, putting it that way made sense; it trained me to look for inactive panels and point them out.

As a writer, I like to flip it around when I'm teaching and put it this way, "Every panel is an opportunity for you to drive your story forward, to bring your reader more tightly into your tale and dig your story's claws more deeply into that reader." Every panel is an opportunity to do that. Do not waste any of your opportunities.

Each Panel Can Have Only One Action

Conversely, each panel can have *only* one action. To be more precise, it can have only one important action for your reader to see and digest and process as part of the story.

You may be thinking, *no way, my artist and I can pack three characters, each doing a separate thing, into a single panel. We can pack three times as much*

> **EXERCISE**
>
> ### Identifying the Actions of Panels in Comics
>
> Take a comic you like, and do the following: Pick a sequence, maybe just three to five pages long. Now identify the single driving idea or action in each panel from start to finish. As you do this, write the idea on a small Post-It note and place that note directly onto the panel you've identified.
>
> Once you're finished, go back to the beginning of the sequence and type your notes in sequence into your computer. When finished transcribing, go back and edit those ideas and actions into panel descriptions without looking back at the comic. Remember to describe the action, not what the panel should look like. You should be able to reverse engineer the panel descriptions that could have been used for the sequence.
>
> This will help highlight what's really important to communicate to your artist (and what isn't) in your scripts.

story into every page this way! Maybe you're right. In fact, I believe you. You and your artist *can* do that. But I advise against it. Here's why:

As enthusiastic comic-book creators, we often get swept up in thinking about the awesome things we want to try and the boundaries we're going to push, and I applaud and encourage that. But we equally often have a tendency to forget the book has another very important participant—the reader.

Your typical comic-book reader isn't scouring each panel for every conceivable data point, mulling them over for thematic attributes and plot contrivances and nuances of character. Some are. And maybe you'll write for them. But assuming you're writing for a wider audience, the typical reader views a panel much like a sentence in a book.

So your comic reader looks for a subject and an action in each panel. She looks for one salient story point in each panel, and once she finds it, she tends to move on, sometimes noticing what's happening in the background but often casting it aside as not germane to the story.

What that means is you can have multiple actions in a panel, but only one of these actions should be important to the story. Only one of these actions—the dominant action in the panel—should drive your story.

In other words, it's not you (the creator); it's me (the reader).

TURNING YOUR PAGE-BY-PAGE OUTLINE INTO A PANEL-BY-PANEL OUTLINE

Sometimes it's easier to just show you what I mean. What follows is a simple approach to break your page-by-page outline into a panel-by-panel outline. Realize that this is still an outline—it's just broken down further, another step in the layering methodology discussed in Chapters 5 and 6.

Consider this page outline text from my script for *Achilles Inc.* no. 1, page 6:

Page 6 (Page-by-Page Outline)
Ransom rolls into work. Achilles Inc.—what a joke. The place is a dump. Clients are usually crazy; we meet Mishy and her attitude. Ransom reacts well to it. It's a pleasant relationship, but she gives him fair warning that there's someone waiting for him inside. . . .

All you really need to know is that Ransom is the owner and lead investigator for Achilles Inc., a private investigative firm. They specialize in cases involving people with superhuman abilities. I'm establishing his office, where we will see his clientele and his assistant Mishy for the first time in the series.

I take that text and simply break it down into approximately what I think can be communicated in one panel or another—one action/story point per panel. When I do that with this page, it looks like this:

Page 6 (Panel-by-Panel Outline)

Panel 1
Ransom rolls into work. Achilles Inc.—what a joke.
Panel 2
The place is a dump. Clients are usually crazy . . .
Panel 3
. . . we meet Mishy and her attitude.
Panel 4
Ransom reacts well to it. It's a pleasant relationship, but she gives him fair warning that there's someone waiting for him inside . . .
Panel 5
Ransom's curiosity is piqued.

All I've done is broken up the paragraph as written. I added the panel numbers and organized the information into single actions.

You'll notice a few tweaks but not many. I added ellipses at the end of panel 2 and beginning of panel 3 because that's two actions or story beats that were contained in one sentence in the initial paragraph that needed to be broken up. And I added the last sentence for panel five. I felt a reaction shot from him was necessary to add a break before we launch into the scene with his visitor on the next page.

This is now a panel-by-panel outline. Granted, this is only for a single page, so you'll want to do this for your whole scene or chapter or your whole story all at once. Making sure you've got a story action in every panel and organizing your information properly is going to become more and more important as we go along.

Note that these are not finished panel descriptions. This is still only a document that makes a lot of sense to me, the writer. But here's what the final page looks like, if you're curious. You can see how it's basically locked in from here.

Follow along with the notes in the Turning Your Page-by-Page Outline Into a Panel-by-Panel Outline section to see how page 6 of **Achilles Inc.** no. 1 transformed from a short paragraph in the page-by-page outline into this page of art.

During the scripting process, I wound up modifying the final two panels, fleshing them out for nuance. The five panel outline became a six panel page.

Achilles Inc. no. 1, interior. Written by Andy Schmidt; illustrated by Daniel Maine. Published by Comics Experience and Source Point Press, 2018.

WRITING GREAT COMIC-BOOK PAGES

When it comes to writing great comic pages and panel descriptions, there are *three absolutes* and *one good rule of thumb* you'll want to keep in mind. The usual caveat that there are exceptions to every rule still applies, but here you go:

No More Than Five Actions Per Page

Let's start with the rule of thumb. A standard American comic-book page can comfortably fit up to five actions per page. Obviously, if you have a big and important action, you may want that to take up some real room, so it may be the only action on the page or one of only two or three actions on the page. That's fine. This goes back to our discussion about contrast and its importance.

Realize that one story action could be spread across multiple panels in this case. So, let's say you've got a tense situation—a Mexican standoff. If you called for small, tight panels focusing on three sets of eyes, three more panels as hands inch closer to holstered guns and then three more panels of beads of sweat rolling down the three faces, well, that's nine panels, but it amounts to one story action. It all says the same thing—the tension is rising. That might be your whole page right there.

But if you flip back to that panel breakdown of *Achilles Inc.* no. 1, page 6, we have five distinct story beats:

1. A new location
2. Ransom is mobbed by clients.
3. Mishy conveys information (two panels).
4. Ransom enters his office.
5. Ransom sighs a breath of relief.

It's tight as is. You can look at the art. It's a tight page. You don't want to pack in more if you can avoid it. You're running the risk of overloading your reader already.

This is the first piece of advice Frank Miller gave to aspiring comic artists and writers circa 1990. You know, right after he and Klaus Janson finished their seminal work on *Batman: The Dark Knight Returns*. If you don't agree, don't argue with me. Argue with him!

Active Panel Descriptions

Now for those absolutes. First, your panel descriptions must be active. Everything about your comics writing must entertain and feel alive. That includes your panel descriptions and the script itself.

Let me put it this way: If you're panel descriptions are boring to read, how do you expect them to inspire an artist to create exciting artwork? Or if you're looking for work with an editor and you turn in a boring script, well, that hurts your chances of getting hired again; doesn't it? So your job is to think of yourself as a writer on every level. That includes, even though the world will never see it, writing a heck of an active and entertaining script.

What does an active script look like? We've already hit on the first key. Every panel should contain an action, no matter how small (the one exception is coming up soon). Simply by making sure that something is happening in your panel description, the hard part is already done.

From this point, as you type up the description, you need to make sure it's written with an active voice—the panel is happening in the present tense. Not: "Ransom ran across the street." Certainly not: "Ransom is running across the street." Active = "Ransom runs across the street." Or, even better, "Ransom dives/lunges/dashes/sprints (pick one) across the street." Keep it moving, and keep it concise.

Organize Your Panel Information Properly

There might be a lot going on in your panel. If so, then you'll be communicating a lot to your artist. You can do that. But let's take a look at our sample page from *Achilles Inc.* again. Let's isolate the second panel.

What information does my artist need for this? Assuming this is the first time we're inside Ransom's office (which it is), I need to let my artist know the following:

- What kind of office it is—one with a glass front and chairs in the waiting room
- Descriptions of the various clients, because they come back later as characters
- The fact that the clients are accosting Ransom as he enters

There's a lot to take in in this panel. But note how the art is consistent with the hierarchy of information as written in the panel description. Front and center is Ransom entering the room. The mob surrounds him; we see this second, and the mob points us to Ransom. Then we notice the back of Mishy's head and the glass in front of her, and it also points us to Ransom. That's why writing your panel descriptions with the proper hierarchy is important.

Achilles Inc. no. 1, interior. Written by Andy Schmidt; illustrated by Daniel Maine. Published by Comics Experience and Source Point Press, 2018.

- Ransom has entered and is trying to cross the room.
- Mishy is sitting behind a desk on the far end of the room.
- There is a glass window in front of Mishy.
- Mishy isn't making a move to help Ransom.

That's a lot for one panel! Now, if I presented the above list as is, I'd likely confuse my artist. You need to take the data points and put them in a hierarchy—the most important information comes first. The most important information is the *action* in any panel. That's what your panel is about. Here's the actual panel description from the page when it was finished.

Panel 2

Ransom wades through the office waiting room. It's like a mini riot as his clients grab at him, shouting their problems. Ransom has to shimmy through the seats, not directly talking with any of them, just trying to get by. Mishy is seated at a desk behind a window where guests sign in and whatnot. Like a doctor's office.

Note: We're going to come back to these clients in just a few pages, Daniel. So we need to make sure these characters are distinct.

The first sentence is about what Ransom is *doing*—the action—wading through the sea of clients. Then I describe the situation and clients a little more closely, that comes with the description of the room itself and the kind of office we're in, which is finalized in the last sentence about Mishy's location and her situation. There's a separate note at the end telling the artist that we're going to revisit these clients so they need to be distinct from one another, but I left him free rein to design them as he saw fit—no need for me to get pedantic about it; let him have fun.

Organizing the information in this way allows Daniel, the artist, to construct the composition of the panel, including the distance and angle of the subjects from the "camera," as he sees fit. He could have

filled the room with fifty people or six and still gotten the idea across that Ransom is being swarmed. He understood that Ransom is the focus, not the people, not Mishy, not the type of office it is. And all of that is communicated not in the words in the panel description but in the order in which the information is presented.

Inspire Your Artist

This one may seem strange, but it's important. If you're writing for someone else to draw—pump him or her up! Get their blood flowing and their excitement skyrocketing. In other words, *talk to your artist*. Don't just tell them stuff or talk at them—talk *to* them.

Neil Gaiman famously described his comic-book script-writing process as writing a letter to the artist. He imposes a bit more structure than that on his own scripts, but you can see what he means. He addresses the artist directly.

For me, assuming I know who the artist is (I usually do), I use the person's name. I often include a note up front just for the artist to talk about the overall themes of the script, maybe some stuff I'm experimenting with, and I invite the artist in to lend his own ideas or to offer her own suggestions.

If I call for something complicated or out of the norm, I write a note on the page itself, bringing it up and talking about why I'm suggesting that we do a sequence in a particular way.

If I need something to be super exciting, I put that right in the script. My favorite example of pumping an artist up was in a script for Marvel's *Civil War no. 1* by Mark Millar in which he wrote to the artist Steve McNiven about how cool it had to look when Captain America escaped from a group of S.H.I.E.L.D. agents and surfed on an F-15.

He had a note that made it sound so exciting that I, as one of the editors on the project, wanted to draw it. Then, as if that wasn't enough, he went on to say that if Steve hit it out of the park, just think of how much money he could sell that original piece of artwork for! I laughed out loud when I read it. That's a genius way to motivate an artist.

I often invite my artist to offer her own ideas. If she has a better way, let's talk about it. Part of inspiring an artist is also letting her know that her skills, her time, and her talent are valued. No writer has all the answers, so seeking input from your artist is a great way to get your artist more involved, more passionate and to make the book that much better.

TYPES OF PANEL DESCRIPTIONS

What follows is a list of the most common types of panel descriptions. I'll provide as many examples as I can. This list is not exhaustive, and there are probably types that have yet to be invented, but these are the fundamentals.

Establishing Shots

An establishing shot establishes a person, place or thing in your comic book. It's often the first time you see a location, a character or an object but not always. They're most commonly used in a change of scene from one location to another. Often, a new scene will start with an establishing shot that shows your reader the new location and which characters are involved in this scene.

It's more than just an exterior shot of a building or place. There is more to establish in a scene, such as where various characters might be in relation to one another. It's common to begin a scene by establishing multiple characters in a long shot, but then, after that, cutting in close to show detail and emotion.

Establishing shots are that one exception to the rule that every panel must contain an action. Sometimes, you just need to set the stage. That said, I often try to get some little action—a small movement or dialogue that still moves the story forward or at least kicks that start of the scene into motion—in that panel.

On this page of **Babylon**, we have two establishing shots in a row. The first is an establishing shot of the space station where the crew has docked. We see its position in space above Earth. The second panel is an establishing shot of the interior of the space station. I don't typically do two establishing shots in a row, but I thought it important, in this case, that the reader understand the mechanics of where the crew is now—a new craft, not the shuttle they lifted off in on the previous page.

Babylon, interior. Written by Andy Schmidt; illustrated by Kieran McKeown. Copyright Andy Schmidt, 2017.

It's also worth noting that not all establishing shots have to be the first panel in a scene. You may want to start with an extreme close-up on an object to get the reader asking what that thing is and then pull back to establish the scene and set the stage. But every scene should have an establishing shot in it unless you are intentionally trying to keep your reader disoriented and a bit off balance.

HIGH-ENERGY PANELS

I don't call out a high-energy panel by name in my scripts, but there are some panels that call for an increased sense of scope or speed. They are panels with true action in them. What you need to know about writing them is that even though fast action occurs quickly in real time, it has an inverse relationship to space on the comic-book page.

What that means is that if you want a panel to have high energy, one way to help achieve this is by giving it a large amount of space, even though the action in the panel itself may take place in less than one second.

It's also useful to tell your artist that you're going for high energy. Let the artist know that a lot of foreshortening or a "tilted camera" can help add extra energy to the action in the panel.

If you have five or six high-energy panels on a page, you may be better served with just two or three of these panels so that the energy comes across to your reader.

In this spread from **Achilles Inc.** no. 4, we have a high-energy panel due to its size. This image stretches across two pages, conveying that it is important—impossible to miss, really. This is high energy.

Achilles Inc. no. 4, interior. Written by Andy Schmidt; illustrated by Daniel Maine. Published by Comics Experience and Source Point Press, 2018.

This impact panel extends across a double-page spread and tells the reader what the rest of the spread is going to be about. The image conveys the central idea of the two pages: Robots are responsible for the deaths of millions.

Babylon, interior. Written by Andy Schmidt; illustrated by Kieran McKeown. Copyright Andy Schmidt, 2017.

IMPACT PANELS

An impact panel can have any number of applications. But the basic point is that you want this panel to have special import to your reader. There are dozens of reasons why this might be the case—a startling revelation about a character or plot point, a reveal of a new and powerful player, a sweeping and beautiful landscape, the death of a character that you want to have weight and so on.

Not all panels should have equal weight. So when you want to make an impact, you need your panel to make a statement. Here are a few ways you might consider doing that in your panel description.

Splash panel. A *splash panel* is a panel that takes up the whole page and often bleeds off the edges. Historically, splash pages have just been a single image, but lately there's been a trend to include one or two additional panels on these pages in addition to the large, dominant image.

Look back at the last two-page spread we saw from *Achilles Inc.* to see a page-turn reveal. Ransom has just escaped from the bad guys, comes out of the building where he was held prisoner, thinking he's reached freedom, only to discover all of the superpowerful bad guys are waiting for him on the street.

My hope is that this panel instills a sense of dread in the audience.

Close-ups. *Close-ups* or *extreme close-ups* are another way to get impact, even from a smaller panel. By going in very tight, your artist can create intensity in a panel because we've moved in closer than is, frankly, comfortable for your reader, which draws extra attention to the panel itself and its contents.

There are any number of ways to add impact to your panel, and you'll develop your own favorites. But the important thing is to understand the strategic purpose of them and use them sparingly.

DETAIL PANELS

Detail panels tend to be smaller panels that focus on, you guessed it, details. Small but important or insightful story items. Detail panels can be large but most often are small, giving us nuance in the story, focusing our attention on the specific.

Let's go back to the idea that contrast is important in all things. As important as large panels are, so are small panels. As important as big ideas are, so are

This close-up panel of our main character's face gives us a detail shot and some insight into her thinking in the situation. Even from just the one panel out of context, I still think it communicates her distrust of the man she's speaking with.

Exalt, interior. Written by Paul Allor and Andy Schmidt; illustrated by Matt Triano. Copyright Andy Schmidt, 2017.

Here's a detail shot of a woman drawing a pistol out of its holster. The detail shot allows us to clearly see the image and understand what's going on but removes the need for a sweeping gesture that a wider shot would require. It also allows us to slow the moment down, soak in the action and absorb the reaction of the man in the background.

Exalt, interior. Written by Paul Allor and Andy Schmidt; illustrated by Matt Triano. Copyright Andy Schmidt, 2017.

precise nuances. As important as it is to establish an entire scene, it's also important to give us the specifics of that scene. What's that jacket feel like? What's its texture? What kind of weave is it? Is it old or new? The details are what bring a scene to life.

Using detail panels in conjunction with and in contrast to larger panels or broader ideas is a useful tool in selling the reality of your story.

STEP-BY-STEP PANELS

Panels on a single page have an inherent relationship to one another. That is, as readers, our minds create connections between them simply because they occupy space on the same canvas.

Step-by-step panels use that relationship purposefully. The traditional way of creating comics is more or less a "one action, one panel" approach. With step-by-step panels, we're taking that one action and stretching it across multiple panels, often smaller ones.

The technique is used to emphasize an event, to slow down the reader, to build suspense and so on.

EXERCISE

Identifying Types of Panels

Take a favorite comic and go through five or so pages, listing on a sheet of paper the different types of panels you find. List them by page. You'll likely find that you have long shots, close-up shots and medium shots on every page. Maybe an establishing shot thrown in. How many true action panels do you have?

What you'll likely notice is that the types of panels and types of shots vary often, and that variation keeps the page from being visually boring. If you find a page that is all the same type of panel or shot, then it is likely done this way to elicit a specific reflection from the reader. What might that reaction be?

Get used to the idea that you want to free your artist to keep the visuals changing. Your artist can help keep the page itself interesting because he will see the whole page and will know what to push and pull and when. That's much more difficult for the writer to do as she writes panel descriptions.

TO SUM UP

Panel descriptions are often about organization and precision. The longer your panel description gets, even with an establishing shot, the more you should worry that you've got too much information or that it's not clear what the panel is about. A great panel description can be just two words. The longer they get, the more likely you're feeling the need to clarify.

Ultimately, if your focus is on a single action and that's what you start with, and you state that action clearly for the artist, you should be in good shape.

Let's move away from panel descriptions and talk about the page as a whole and how to write visually for your reader.

To be continued....

Here is an example of a step-by-step panel in which Ransom is telling a crowd of people to leave his office. It's one story idea, one major action. But it starts on the top panel, then has four tight panels where he gives each individual a reason to leave and finishes up with them all leaving the building. Technically, I'd say this is two actions—telling them to leave and the last panel where they all leave. But the first action is stretched, allowing us to get a sense of the reaction of each person being told to leave. It makes it more real and gives more weight to the action itself, which essentially establishes how intelligent Ransom really is.

Achilles Inc. no. 1, interior. Written by Andy Schmidt; illustrated by Daniel Maine and Francesca Zambon. Published by Comics Experience and Source Point Press, 2018.

CHAPTER 8

Writing Visually for the Reader

As panel descriptions are about specificity, the page as a whole is about understanding the ebb and flow of the reading experience. To put it another way, if the panel descriptions are for your artist only, writing for the page as a whole is about how the page will be read.

In this section, we'll discuss a few key traits unique to comics—a few characteristics of the medium—that you can use to create the ultimate reading experience.

Deadlock: Day to End a Life, interior. Short story written by Andy Schmidt; illustrated by Agustin Padilla. Copyright Andy Schmidt, 2017.

PAGE TURNS

We started talking about page turns in Chapter 6. There, we discussed how to identify them and their purpose. Here, we will get into the mechanics of how they work.

One of a writer's key tools is the page turn. The reason is that the page turn is a mystery waiting to happen. On any given page or double-page spread, the reader can see all the panels at once, so your best opportunity to surprise your reader or hide something from him is on the first panel at the top of the next page—the one place that your reader will look *exactly* when you want him to.

For that reason, many comics writers and artists try to see the comic-book page as leading to the page turn. We try to end each page in a way that propels our reader to turn the page. We end with a question, either overtly stated or implied, so that the reader wants to know the answer.

My personal favorite example of this is from when I was a young boy reading superhero comics and the last panel on a page would show our heroes with jaw-dropping shock on the second-to-last page of the issue while a word balloon would come from off-panel and say something along the lines of, "You do-gooders thought you had all the answers! But I am the true villain! I alone am more powerful than all of you combined! I. . . ." The balloon trails off at the end—oh, my gosh! Who is this vile villain?! I have to know! And I'd turn the page for the cliffhanger, and the villain would look all-powerful as he states his name in some cool font. Immediately followed by those lovely three words, "To be continued. . . ."

See if you can spot the implied question in these panels from *Achilles Inc.* and *Babylon*.

Oh, my gosh, he shot me! Am I dead?

Achilles Inc. no. 1, interior. Written by Andy Schmidt; illustrated by Daniel Maine. Published by Comics Experience and Source Point Press, 2018.

We made if off Earth—now where do we go?

Babylon, interior. Written by Andy Schmidt; illustrated by Kieran McKeown. Copyright Andy Schmidt, 2017.

Now follow those panels to the next two images from *Achilles Inc.* and *Babylon* to see if the questions are answered—or at least partially answered.

WRITING A PAGE THAT FLOWS

Every page has its own rhythm, its own use of large and small panels. Writing a page that flows depends on your intent more than anything else.

But as the methodology that I've been laying out for you shows, everything gets whittled down to bite-sized pieces to make it easier. You're building a tapestry, one thread at a time. So as we continue to examine the whole story, the acts, the chapters, the scenes and the page, you'll notice that every aspect has a function. The story tells the arc of a character as she attempts to achieve a goal. The acts are constructed by rising action and then release. The scenes must have a turning point, and now the page itself—what is the function of a page?

Whew! I'm not dead! Force field caught the bullet! Super cool!

Achilles Inc. no. 1, interior. Written by Andy Schmidt; illustrated by Daniel Maine. Published by Comics Experience and Source Point Press, 2018.

To the space station . . . AND BEYOND!

Babylon, interior.

Written by Andy Schmidt; illustrated by Kieran McKeown. Copyright Andy Schmidt, 2017.

111

A single comic-book page can have any number of functions to it, but ideally you're looking for those same turning points that you would in a scene. You can have a turning point in a line of dialogue, or the page can be one image that in and of itself is a turning point. That's the function of a page, but making it work—making it smooth—that's more elusive.

For my part, I think of a page like a paragraph in prose. Your novel is the story. Your acts are still your acts, your chapters are complete sequences, and your scenes are still scenes, made up of any number of paragraphs; so it stands to reason that the comic book page is like a paragraph in a prose novel. The major difference being the page turn of a comic. In a novel, not every paragraph attempts to propel the reader to the next paragraph—but it happens more often than you may realize.

When thinking about paragraphs, they tend to explore a complete thought. There are different functions for paragraphs in a novel, but if you think of a paragraph as communicating a complete idea, even a small one, then it's useful to think of a comic-book page in the same way. It's a building block for a scene, if not a complete scene itself.

A paragraph in your novel may describe a bold new setting and landscape. Your comic-book page may show you a sweeping view of a bold new landscape.

A paragraph in your novel may introduce us to a new character, tell us about his history. The comic-book page may show a new character making a dramatic entrance and communicate his backstory.

Your novel may discuss the actions of a sword fight, a slash that's blocked, a counterattack, a kick to the chest and the character blacking out. A comic-book page may show the same scene—at least up to the point where we're wondering if the character is defeated by that kick or not.

PANEL-DESCRIPTION CHECKLIST

This may seem like a no-brainer, but once you've written and rewritten your panel descriptions, it's imperative to go back one last time—waiting maybe a day or more if you can—to make sure they follow the appropriate guidelines. Here's what you want to check in each panel description:

- Does it use an active voice?
- Is it written concisely, using as few words as possible to get the point across?
- Is it exciting and inspiring to read?
- Does it contain all of the information that your artist needs to properly illustrate it?
- Is the information presented in a hierarchy, with the most important pieces of information coming first and holding proper prominence?
- Is the information consistent with the scene—for example, objects don't magically move or appear in a single panel?

If you're doing all of this, you're off to a great start!

EXERCISE

Write the Paragraph

Pick up a couple of comic books, choose a few pages, and then write the prose paragraph of the imaginary novel that it might have come from. If you don't want to go diving into your back issues, pick one of the full pages at random from anywhere in this book!

By reverse engineering the "novel paragraph," you'll gain a solid understanding of how to flow a comic-book page and evaluate your page's effectiveness.

> **EXERCISE**
>
> ### Lay Out Your Comic-Book Script
>
> At this point, you've got the action in your scripts written out. When we break it down into panels, we can see what happens when the rubber meets the road.
>
> Take your script, and, loosely with a pencil and paper (or a computer if you prefer), draw the layout of the page. Use stick figures if you don't feel confident with more precise shapes.
>
> Watch how the page takes shape. Which panels are you placing on a tier together? Really think about what you're drawing and why.
>
> Do your panels have enough space for the impact that you want them to have?
>
> By doing your own layouts, you will learn how useful your panel descriptions really are. It's important that you draw them out, at least for a while. You'll likely notice that you have a tendency to ask for (either overtly or indirectly) a particular kind of illustration very often.
>
> For example, it's very common that writers who are new to comics call for a lot of "medium shots." The reason for this is that they often call for more than one character in a panel. When we do that, almost by definition, you can't have a close-up. But the artist wants to show body language or expression, so she crops in as close as she can, and you wind up with two or more torsos. A medium shot—not too far away, not too close.

> **EXERCISE**
>
> ### Have Someone Else Lay Out Your Comic-Book Script
>
> Ask another writer friend or an artist to do rough layouts for your comic pages. See what they draw and compare it to what you had in your head when writing and/or what you drew for the layout.
>
> This is extremely helpful for new writers. You'll quickly notice that you left out information that you thought was intuitive. Or they'll frame things in a different way that still works but is simply different from what you had in your head. That's a good thing! Or it can be. Maybe they did something that you didn't think of but that enhances the story. This will help you immensely!

PAGE LAYOUT

This might be something that, as a writer, you don't think you need to know too much about, and you might be right. In fact, I recommend avoiding dictating page layout and panel design unless you have a very specific effect you're trying to achieve. Certainly, this shouldn't occur all that often.

That said, you still need to be able to speak the language. When I was editing at Marvel, they brought in master comics storyteller Klaus Janson to teach the editors about the fundamentals of comics storytelling. Janson and I used to talk often about storytelling, and this is something he said that really stuck with me: "There are only two kinds of page layouts for comics."

I thought that he was joking, but he wasn't. So what were these two magical designs? They are *grid* and *freeform*.

Rough Layouts

Here are a few examples of rough layouts, just so you know you don't have to be a great artist to make them. In fact, there's a good chance you won't even know what you're looking at (especially in that last one—that's by me, and I'm not an artist!). Normally, these aren't for the reader to see, but I'm including them here so you can feel comfortable with your own art skills.

Grid: A comic-book page in which all the panels are the same size and shape and distributed evenly on the page. That's a grid layout. There can be no exception to it because...

Freeform: Any layout that isn't strictly a grid. In American comics, we often use the three-tier system. This *can* be a grid, but it doesn't have to be. So a freeform layout can be based on a grid, but it can also be wildly different, with panels in crazy shapes, panels with no borders at all, panels of different sizes and so on.

What's important is that you understand the pros and cons of both. If you're new to writing comics, and your artist is also relatively inexperienced, then I recommend that you both choose to use the grid or something very close to it.

The reason for that is simple (and another thing I learned from Mr. Janson). A comic book has two functions, and they must come in this order:

1. A comic book must be clear in communicating the story.
2. It should entertain.

The reason they're in that order is because it's very difficult to entertain your reader if they're busy trying to figure out what is happening in the story. Cool art that makes no sense winds up looking like a mess. So it must be clear first and then entertain.

Grid

Pros: In terms of clarity of storytelling, a grid layout does the hard work for you. With a grid, we know exactly which panel to start with; we always know to move to the right across the page, then down to the next tier and so on. Just like reading a book. The layout itself will lead your reader's eye naturally to the correct reading order. Grids are organized in a pleasing way and look clean.

Cons: Because the panels are the same size and shape, emphasis and wonder and dynamics must be conveyed entirely within the confines of the panel borders, making a push for emphasis a little more difficult.

Freeform

Pros: With freeform, because you can enlarge some panels, creating emphasis, power and contrast is much easier than with grid. You can also experiment a lot more, which is always fun.

Cons: The trade-off is that, as soon as you move away from the grid, clarity is jeopardized. You'd be surprised how easy it is to throw your reader off—to unintentionally make him read the panels in the incorrect order. We think, especially if we've been reading comics a long time, that every reader will know how to read a page, even if the layout is abstracted in some way. I've been reading comics my whole life and still find that, often, I'm not entirely sure which panel I should read next because it's not clear from the page design.

DOUBLE-PAGE SPREADS

We've already hit on what a double-page spread is. But we haven't talked about when and how to use them.

The first use is the same as a splash page, so those same rules apply. But there are also some potential pitfalls, so heed these rules carefully.

Spreads Must Start On Even-Numbered Pages

Assuming you're writing a comic that starts on page 1 (the first page when you open the book) and does not include any ads, every double-page spread must start on an even-numbered page. Page 1 is on the right, with the inside front cover on the left. Then page 2 is on the left, and page 3 is on the right, facing page 2. This will continue for the rest of the book.

The consequence of starting a double-page spread on an odd-numbered page is either a broken spread or having to place a design page in your book somewhere to make it line up correctly. Both outcomes look unprofessional.

In this grid layout example, there are six equal-sized square panels, two at the top, two in the middle, two on bottom. This is the classic grid that Jack "King" Kirby tended to use for most in his work in the 1960s.

In this grid layout example, there are five panels that stretch horizontally across the page and are the same size and shape. Still a grid. Remember: A grid doesn't necessarily mean "squares."

This grid layout example is the nine-panel grid: three rows of three equal-sized panels. This layout was made famous by Alan Moore and Dave Gibbons' seminal series **Watchmen**.

Here's an example of a freeform layout. We've modified just the middle tier, barely breaking the grid. But we have broken it. While this layout maintains the basic structural elements of the grid, it isn't one technically.

In this freeform layout, we've modified only half the page, but it makes for an entirely different reading experience. Also, this violates another rule—don't stack panels on the left! I don't know if I go down from the top-left panel or to the right to the big panel. You can see how quickly breaking from a grid leads to storytelling problems.

This freeform layout is another modification of a grid layout. Technically, this also is not a grid. But again, it retains a readable and easy structure.

The Top Tier Must Cross The Fold

If you have multiple panels on your spread, it's wise to order them using the tiered system to make it easy for your reader to follow, but this rule is important. Let's say you've got eight panels on your double-page spread, with three panels on the top tier, two in the middle and three more on the bottom tier. In order for your reader to read across the spread—over the fold of the book—one of your three panels on the top tier *must cross the fold of the book*.

If the top tier doesn't actively and clearly cross the crease or fold of the book, then the left page will *look* like a normal single page. Your reader will likely stop halfway through the spread, drop down to tier two and then be quite confused when reading the rest of the spread.

Let's look at two quick examples from *Praetor* and *Achilles Inc.*

In this example from **Praetor**, Ryan Gutierrez and I modified the rules to make this work. There are essentially three tiers here, but the top tier stops at the right side of the left page, doing exactly what I said **not to do**. However, the next panel is actually the first panel of the second tier, so the reader's eye does properly go to the correct panel, which takes up more of the right-hand page. So, in this example, we make an exception to the rule by breaking the letter of the law but not the spirit of the law.

Praetor, interior. Written by Andy Schmidt; illustrated by Ryan Gutierrez. Copyright Andy Schmidt, 2017.

In this double-page spread from my book ***Achilles Inc.*** no. 4, the first tier is one panel that's two-thirds the height of the page and extends all the way from the far left, across the fold and to the far right of the right-hand page. Then it goes back and to the bottom left for the second tier, which is structured so that none of the panels cross the fold. This was useful because there's a fair amount of dialogue in those panels and you really shouldn't put balloons and captions near the fold, so by making the fold normal gutter space, we don't lose precious real estate to the fold. The spread reads correctly because the top tier goes right through that fold.

Achilles Inc. no. 4, interior. Written by Andy Schmidt; illustrated by Daniel Maine and Francesca Zambon. Published by Comics Experience and Source Point Press, 2018.

118

SPLASH PANELS VS. MULTI-PANEL PAGES

When do you want to use a splash page? A splash page, just to remind you, is a page that is one big image instead of several smaller pieces.

Let's figure it out. Remember that your page is like a paragraph in a novel. Using this analogy, you want to use a splash page for something that would be *worth* spending a paragraph on in your novel.

Here are a few common uses for splash pages:

Hook
Use a splash page, maybe the first page of your issue, to make a statement and hook your reader into the scenario. The same way that a novel will try to hook you with its very first sentence and very first paragraph, the large image will help draw in your reader.

Impact
We talked about impact panels earlier in this chapter, but if an event or a character's appearance is supposed to weigh heavily on the reader, then using a splash page signals to your reader that this page is important. With a novel, a small event like a couple holding hands may seem trivial, but if the writer were to spend a paragraph on it, telling us about the tenderness of their feelings in this moment and so on, that gives it special weight. In the same way, a splash page gives weight to an event, even a smaller one.

Revelation
My favorite is the revelation of some major event or situation that surprises your character (and hopefully the reader). The use of a splash page for a revelation causes pause and allows the importance of the revelation to set in. It tells the reader that this surprise is also a surprise to the characters.

Setup
Using a splash page to set up a situation—especially one that looks grim for your hero—is another great use.

Cliffhanger
Using a splash page to leave your reader dangling at the end of the chapter, yearning to know what happens next, can increase the feeling of urgency. It enhances a good cliffhanger.

THE RELATIONSHIP BETWEEN TEXT AND ART

In comics, the images are dominant most of the time. It's rare that the text dominates the images, though it can happen. You have to realize, as a writer, what that means. We writers tend to like our words—well, we tend to like working with words, even if we find the flaws in our own work. Comics sort of automatically put your ego in check. You're writing the story, but people are going to notice and respond to the art first. This is your lot in life.

In fact, this is so true that when I tell people I write comic books for a living, the number one follow-up question is: "Oh, so you draw them?" *Sigh . . .*

In practical terms, this should reinforce the point that your story should be told by the visuals. Ideally, if you add no captions and no word balloons, a reader should get the gist of the story, if not the nuance. The story is told visually, and our text is an add-on. The text is often used as punctuation, clarification, nuance and counterpoint to the art. Probably not all of these at once.

I'm overstating the relationship but only a little. If what I say is true, then why bother having word balloons at all? It's a fair question, and you'll find, at times, you get art back that's so good, so clear

and effective, that you wind up deleting your words because they get in the way of what the art is already doing so well.

The most interesting aspect of text and art is how they interact on the page. The placement of balloons on a page and within panels is an extremely important aspect of your page design.

As you learn more about comic-book art and layout, you'll learn more about how comics lead the reader's eye. It's a huge part of the artist's job to lead the eye effectively. Balloons and captions become visual elements on the art. That means they are a part of the design and therefore can help lead the eye or interfere with the artist's intentions.

I recommend that both artists and writers sketch out where they think the balloons should go on a page of artwork and discuss why. They must read in the correct order, and they should help the eye move appropriately around the page. That's a tall order when they're added after the artwork is drawn. That's why I ask my artists to rough in where they think balloons should go when they work from a full script. That way they're considered part of the page design from step one.

It's also fun to think about reading order. A balloon on the left of a panel could ask a question that the image to that balloon's right answers, and then a balloon on the bottom right of the panel may comment on the answer. That means the flow of time across the panel goes from the top left to the bottom right corner, with those items actually taking place at different times.

Consider this: The image my script calls for is of a man tightly making a fist. The dialogue calls for John asking James, "Can you make a tight fist?" James responds, "Ow! I'm getting a cramp in my hand." These three items need to occur and be digested by the reader in the right order. If both balloons are on the right side of the page, it doesn't work. Why ask the question if the reader has already seen that James can make a fist?

As you write for comics and see the pages come to life, you'll begin to get a feel for the myriad ways that text and art interact. It's a good idea to start giving it some thought now as you are starting out on your journey.

WRITING FOR COLOR

Most of the color choices (from the writer's point of view) are handled in the design phase for characters and in preliminary discussions with the writer's creative partners.

Ultimately, it is the color artist's job to make sure the colors are compelling and work with the storytelling of the project.

There are times when you will need to call for certain color choices in the script itself. Again, remembering that this is a visual medium, so it stands to reason that if you are not thinking about color as you write, then you're cutting yourself off from a weapon in your storytelling arsenal.

While you most likely shouldn't be dictating the color scheme of every detail, there are two levels of color notes that you'll find useful (and so will your partners).

The first is simply giving enough information in your script so that the colorist is oriented. Your artist should also be doing this. But your colorist will want to know about the general lighting in the room. Is it dark, bright or dim? It's useful to call out the time of day once in a scene for both penciller and color artist.

Along those same lines, having general notes about a color palette is useful. If you know you want the lighting washed out, you need to tell the colorist. If you know you want the book to feature a lot of earth tones, you need to tell your color artist this directly. They're not mind readers.

The second level of color notes has to do with theme and specific effects. Broadly, you may talk

about associating particular colors with particular themes. I already talked about how Chee and I did this in *Five Days to Die*, and I've been known to request certain color schemes to be associated with particular themes or particular characters on other projects. I'm currently working on a science-fiction project that is intentionally muted in its color palette.

There will also be specific callouts that you want to make in regards to color. If I want the color green associated with one character, I may ask for that color in specific places. For example, if that character is emboldened for the first time, then we may want to color the area around him green, emphasizing that this is his time and that he's powerful and confident in this panel.

Pro tip: If you want to make sure your colorist sees the note, highlight it in your script. The best colorists read the scripts—*every colorist should read the script*—but many don't. I don't know why. So it's a good idea to point your color artist to the script and tell him there are color notes in it.

TO SUM UP

Understand that your ultimate goal with any story is to manipulate your reader. I know it sounds sinister, and maybe it is—but it's also true. You want to bring readers to untold highs and sink them in the depths of despair. You want to surprise them, scare them and make them laugh, all on your timing.

Understanding the effects that various elements in the medium of comics have on readers and how readers digest the pages you present gives you the last giant piece of the puzzle to telling effective stories. You can assert some control over your reader now.

Many years ago, I taught a class called "Applied Media Aesthetics" at Webster University. Sounds fun, I know. The whole class was about how to manipulate your audience, how to make them believe something that's not there without overtly lying and how to make them feel a certain way. This is your job as a storyteller, but to do it, you have to know what these tools do and how they work.

And now you know.

To be continued. . . .

CHAPTER 9

WRITING DIALOGUE FOR COMICS

In this chapter, we're going to tackle the basics of writing good dialogue, the content our characters will speak. If you're anything like me, you will struggle to write dialogue. As the years have gone by, I feel as though I've gotten much better at it, but it's still an ongoing challenge.

As with many of the chapters in this book, it feels like a first chapter to a much larger and more in-depth book, but let's get you to the point where you have a fundamental grasp of writing dialogue, shall we? By the time you've worked on your current project for a year, maybe we'll have that dialogue book ready to go!

Terse dialogue from a terse man.

Five Days to Die no. 1, interior. Written by Andy Schmidt; illustrated by Chee. Cover by Chee. Published by IDW Publishing, 2010.

WORD BALLOONS, CAPTIONS AND SOUND EFFECTS

Here are some handy definitions and proper terminology for your dialogue.

Word Balloon

Word balloons are the standard for dialogue in comics. These are typically oval-shaped bubbles that contain the spoken text of a character. They have an attached pointer that indicates who is speaking the contained text. Whatever font you choose to use, keep it consistent for normal speech.

Thought Balloon

These are the rounded bubbles that look like clouds. Their pointers serve the same function as the word balloon's pointer but are made out of little clouds. These indicate the real-time thoughts of the indicated character, not spoken word.

Thought balloons have fallen out of favor in North America in recent years. Their function has largely been taken over by first-person narration captions.

Electronic/Radio Balloon

These are balloons that indicate either an electronic or computer voice or that the text is broadcast over a frequency. A modification to the shape of the bubble, a couple of jagged lines perhaps, indicates the special communication of the balloon.

These often do not have pointers, as they are text that a character may hear, but the speaker may be out of panel. Use them carefully so that it is clear who the speaker is.

Caption

Any text contained in a box is called a caption. Typically, these do not contain text that is intended to be heard by your in-story characters. These are primarily used for narration or internal thoughts.

With the advent of digital lettering techniques, making custom captions became easy. A change

Standard word balloons

Five Days to Die no. 1, interior. Written by Andy Schmidt; illustrated by Chee. Published by IDW Publishing, 2010.

Here are two standard word balloons and a radio or electronic balloon. Note the different shape and electronic flare on the radio balloon. Yours don't have to look exactly like this, but this is one way to denote that it's not a standard spoken word.

Achilles Inc. no. 1, interior. Written by Andy Schmidt; illustrated by Daniel Maine. Published by Comics Experience and Source Point Press, 2018.

> YOU WANT TO KNOW WHAT WE'RE GOING TO DO?

Here I chose a black caption box, but the box color, the corners and the color of your font can be whatever you choose.

Achilles Inc. no. 1, interior. Written by Andy Schmidt; illustrated by Daniel Maine. Published by Comics Experience and Source Point Press, 2018.

of color or shape or font may indicate that different looking captions serve different purposes.

When using different lettering techniques for captions, anchoring the technique to a character or to its function is key for your reader to understand the intended meaning. Also, once you've correlated a particular look and a particular function, it can only be used for that function thereafter. This is the same principle we discussed that enables flashbacks to work through a consistent technique.

Sound Effect

Usually, sound effects are larger lettering not contained in a box or bubble. I recommend that you try to integrate the look of the sound effects with the surrounding art.

Title

Titles are typically used only for the literal title of the chapter or comic, and not often as in-story lettering.

Credits

Most comics have credits in them. Some publishers have begun putting credits on the inside front cover

These sound effects were created by the letterer, but many writers and artists prefer to draw the effects in themselves. Drawn-in sound effects would be more difficult to translate into another language, but I think they feel more a part of the story if the artist creates them on the page itself. But that's personal taste.

Five Days to Die no. 1, interior. Written by Andy Schmidt; illustrated by Chee. Published by IDW Publishing, 2010.

of comic books, but many still incorporate credits into the story itself. When deciding who to credit, I recommend erring on the side of inclusiveness. It costs you nothing to list someone's name, and it's very cool to be recognized for your contribution. It's better to build goodwill with collaborators than risk bad blood by leaving someone out.

SCRIPT FORMAT

There are a lot of nuances in a comic script. There is also no set script format for comics, so you will want to find one that works for you and your creative partners. The following example is based on the format I currently use, showing each of the elements included on the comic page. Refer back to the Sample Script Format sidebar in Chapter 7 for a visual.

1. Character: This is a regular speech balloon in a script. Use the name of the character, followed by the dialogue she speaks.
2. Caption: This is contained in a square or rectangular box. It could be a character's inner monologue or just be a narrator.
3. SFX: BAMM! "SFX" is the abbreviation for a sound effect!
4. Locator Caption: This is typically open on the page, with no balloon or box around it, to identify time or place.
5. Title: Your title is awesome!
6. Credits: I usually put credits in a list.

The text elements are numbered for your letterer (though I don't usually number credits) and are indented to stand out from your panel descriptions.

Within these labels or terms, you may also need modifiers. I usually put these in as parentheticals after a character's name or a caption box. Such as:

1. Character (burst): My character is yelling in a special big balloon!
2. Character (whisper): Shhhh, be vawy, vawy quiet. I'm hunting wabbit.
3. Character (electronic or radio): Asks for the letterer to design the balloon so it has an indication that it might be from a computer voice or broadcast over a radio frequency.
4. Character (caption): If I have multiple people with their own captions, I'll signal that this is a specific character's caption box this way. It should have a unique element such as its own color so the reader can identify it.

This is a burst balloon.

Achilles Inc. no. 1, interior. Written by Andy Schmidt; illustrated by Daniel Maine. Published by Comics Experience and Source Point Press, 2018.

This is one way of indicating that your character is whispering.

Five Days to Die no. 1, interior. Written by Andy Schmidt; illustrated by Chee. Published by IDW Publishing, 2010.

This is a weak or wobbly balloon. In this case, Ray is injured and barely conscious, exerting great effort to speak.

Five Days to Die no. 1, interior. Written by Andy Schmidt; illustrated by Chee. Published by IDW Publishing, 2010.

5. Character (weak): This would signify a wobbly balloon to make your character look like he is weak in the moment.
6. Character (thought): Now you know what I'm thinking because I've told the letterer to make one of those cloud-looking balloons that tells you these are my inner thoughts.

The modifiers are there to communicate directly with your letterer. They're not universal. Again, there is no set script template for comics like there is for screenplays, but most letterers will know what to give you if you use these elements and modifiers. When in doubt, just write it out plainly. Keep it simple and say what you mean if you're just not sure what term to use.

That said, writer Paul Allor and I created a script template that you can find in the free resources section at comicsexperience.com in the Script Archive. You can download it and start using it now.

Bold

If you want certain words to appear in bold lettering in your final comic book, here's a tip—underline the words in your script rather than using boldface or italics. It's a quirky thing about importing text from Microsoft Word or a PDF into Adobe Illustrator, the program most commonly used for lettering. The text will not retain a bold when pasted into Illustrator, but an underlined word will stay underlined. So this is a good way to indicate bold words to your letterer.

WRITING BELIEVABLE DIALOGUE

I'll admit that dialogue is tremendously difficult for me. It always has been, and I imagine it always will be. While my dialogue has gotten significantly better than a decade ago, I still feel it has a long way to go.

The good news is that I've worked hard as heck on my dialogue and have a lot of tools for you!

The key to writing believable speech is not, as some would have you believe, to write the way people talk. People don't know how to talk when you really listen to them—we interrupt, switch topics suddenly and stumble over our words. Our vocabulary is limited—most of us choosing to use the same ten words over and over. For the last two decades, I have been saying "Dude" to mean any number of things—it's my own personal "I am Groot." I say "uh" and "um" all the time. Please don't write the way I or anyone else actually speak. Your dialogue will get boring, and it will feel like you're trying too hard.

The key is to make your dialogue read the way we (the readers) *think* we talk. We all think we're much more clever than we really are. Your dialogue has to feel like how we talk while avoiding repetition in word choice and other verbal foibles.

So, how do we do that?

Subtext

The most important thing about writing realistic dialogue is to never say what your character means. The way we speak, we rarely just come right out with what we're thinking. We tend to wrap it up in something else.

Consider this fictional situation in which my friends and I stumble upon some criminal activity and we're likely to be discovered by those criminals. I say, "You know, I forgot to pick up jelly at the grocery store. We should probably go back and get

> ## EXERCISE
>
> ### Write the Way We *Think* We Talk
>
> There is a big difference between how we actually speak and the perception of how we speak. When we speak in real life, our speech is filled with um . . . uh . . . yeah . . . like . . . and other repetitive word uses. We use the same words over and over.
>
> For this exercise, write down or record a conversation between two people (please ask for permission first!). As you do this, you'll quickly notice two things: That's not the way you want to write dialogue, and most of us are pretty boring.
>
> Once you have a transcript of a conversation, take that conversation and reshape it as dialogue for a comic. Remember: The goal of good dialogue is to present the way we think we speak.
>
> Take out most of the filler unless it's for an effect such as to show how nervous a character is in a particular situation. Find punchier ways to communicate the ideas and vary the word usages. It will still read in a realistic manner, and that is what we're trying to do with our dialogue. Create the illusion of reality, only better, because reality is often boring.

in all forms of storytelling. "You had me at hello" means, "I forgive you, and I love you." "I know" means, "I love you, too."

The trick is not just avoiding saying what your character means but doing these two things:

1. The text must lead the reader to the subtext—the true meaning.
2. The text must also be filtered through your character's unique personality. It has to be the text that she would say, not what some other character would say.

If you can do these two things with your text, then the subtext becomes that much clearer. And, while the subtext can be clear, it should, on some level, be intuitive.

This is tricky to do, so it'll require a lot of practice, but you can do it. You just need to keep at it.

Economy of Dialogue

Your dialogue communicates character, accentuates action and drops exposition. One of the key things you'll want to do is make sure that you're not repeating information. Are you sensing that as a theme in this book? Once your data point has been shown or stated, no need to say it again, even if you think the character likely would bring it up.

It also means finding the shortest route to get your point across that still has subtext and communicates clearly. Consider this:

You need one character to say the following information: There is a plague coming that infects the human body, kills the host and then resurrects the human as a flesh-eating monster. And it's on its way here to our town. We can either leave our homes and run away, or we can get prepared and fight against it.

That's a lot to put into your dialogue. But when you boil it down, it can be communicated quickly. Let's say Sheila, your main character, is addressing the town when she communicates this. Here it is with no subtext.

Sheila: Zombies are coming to town. They'll be here by nightfall. And if they bite you, you will die and

some." What I mean is, "This situation is dangerous, and we should really consider getting out of it immediately." The text is: "I forgot something and need to go get it." The subtext is that I should be doing something else—something safe.

What using subtext does is bring your reader closer to the story. Your reader now has to unravel your subtext, peel it back and reveal the true meaning underneath. We do this all the time. Subtext is

come back as one of them. We can run away, or we can fight. What say you?

That's thirty-six words . . . and fairly lifeless.

Instead of saying all that above? Why not simply say:

Sheila: The Pale Rider is upon us. But we don't scare so easy; do we? Ain't no zombie gonna get me.

Down to twenty words. It could probably be even shorter. I've reorganized the information, cut it down and put a little punch in it. I indicated an accent and some of her cultural beliefs. The scope of the situation is clear, the choice is clear, and her decision is clear. And then I clarify at the end that it's about zombies.

Tricks

What follows are a few particular tricks I've used from time to time to add a little more flavor to my dialogue. Maybe some of these will help you. But a word of caution: If you overuse these, they lose their impact and can get tedious quickly.

Rhythm: Most of us have a certain cadence to our speech. There are a few basic patterns. Try to develop a few different patterns for your characters and switch them up.

Ticks: Give a character a speech tick of some kind. Some inflection or nuance that is unique to him.

Catchphrase: Many of us have a catchphrase or two—things we repeat often. Sometimes one of these will help with a character in a pinch.

WRITING DIALOGUE FOR A VISUAL MEDIUM

One of the first "rules" you'll hear from comics pros is "show; don't tell." Which means, instead of having a character say in a word balloon, "I've got a gun," it's better to simply call for an image that shows the character carrying the gun, and then you don't have to write the line of dialogue. If I'm looking at it, you don't need to tell me.

> **EXERCISE**
>
> ### Exercise: Dissecting Art and Dialogue
>
> 1. Take a page of a comic book. Cover up the word balloons and look at just the art.
> 2. Write down what the art tells you.
> 3. Cover up the art on the same page and read just the captions and balloons.
> 4. Write down what the balloons tell you.
> 5. Now look at both.
> 6. Figure out and write down any instances where the captions and dialogue work differently when you see the visual with it.
> 7. Are there any cases where the visual causes you to read the balloon or caption to understand it? This shouldn't happen often. Sometimes it's done because the storytellers think they didn't communicate something in the visuals as clearly as they would have liked, but sometimes it's intentional.
>
> Now you've dissected the art, captions and balloons. Do you see how the more effective—the more engaging—panels have some level of interaction between the art and dialogue? They shouldn't tell parallel stories; they should be woven together.

When you're writing your outline, the main reason I recommend that you think visually and do the image-association exercise is so that when you write your panel descriptions, ideally, you're primed to tell your story visually.

You may also still have that list of exposition you need to fit into your story. Include as much of that

It looks to me like Ray here is about to kill someone. He's angry and he's aiming that gun. So just looking at the visual, I'm thinking that someone's about to be dead.

Five Days to Die no. 5, interior. Written by Andy Schmidt; illustrated by Chee. Published by IDW Publishing, 2010.

But now look at it again with four words added. Still think he's going to kill someone? Still think he's angry? You shouldn't. When we add those four words, we know he's conflicted. He's trying to figure out if he should kill someone. The art with the dialogue gives us a picture that neither one alone would communicate. That's your goal.

Five Days to Die no. 5, interior. Written by Andy Schmidt; illustrated by Chee. Published by IDW Publishing, 2010.

as possible in a visual fashion. The establishing shot in *Five Days to Die* is an easy example of this. You've established who is here in the room, where they are, what else is in the room. We get that all in a glance without having to be told. Great. Now you don't need to write captions to explain it.

Make sure you're not writing dialogue that conveys information that we're already getting from the visuals. As I mentioned previously, after I get art back from an artist, I usually do a script polish and find that I can cut dialogue because it is communicated in the visuals already. Sometimes the opposite happens and I need to add dialogue to clarify something, but thankfully, that's been happening less and less.

Once you've done that, then you can get into the more fun stuff. Like, can your dialogue tell us more about a situation? Can it serve to tell us something we don't know? Can we get into the character's emotional state? Can it comment on the visual? For example, if we see that someone points a gun at another character but he's saying, "I'm a pacifist," what does that tell us? He's a liar; he's threatening

someone with a gun and claiming that he doesn't believe in violent conflict. So our brains, as readers, are engaged and have to put the image and the words together and draw our own conclusions. That's reader participation, and good dialogue encourages reader participation.

This is where comics become really interesting. The dialogue, at its most effective, doesn't just add what the visual can't tell us, and it doesn't just cover story points. It should interact with the art. When the dialogue points my brain to the visuals, that's the best dialogue.

WRITING DIALOGUE—COMIC-BOOK MECHANICS

We've covered a lot about *what* to write and even *how* to approach dialogue writing. And the most important part: marrying your dialogue to your visuals. These are essential keys to writing great comics.

Now let's focus on your comic-book page. What you write in your script is going to take up *space on your page*.

I tend to like my captions and balloons to be relatively small. If I have one character with a lot of dialogue, I'm prone to break up the speech into several smaller balloons. The first reason to do that, you may think, is that I'm starting a new paragraph in a speech. That might be true but not necessarily.

I break up dialogue for a few reasons:
- I don't want my balloons to be too big. Giant white spots on the page dominate other visual elements. The last thing I want is for the balloons to overpower the art. Keeping the text short in any given balloon minimizes the visual impact on the page.
- Breaking balloons up into smaller balloons can help dictate the cadence of how the character might speak. It's a kind of acting for your character.
- I need to switch topics. I sometimes will break a balloon in order to change topics or to indicate a change in the line of thinking.

Take a look at these pages and see if you can identify the techniques being used to break up the dialogue. Each one is an example I've discussed.

Five Days to Die no. 1, interior. Written by Andy Schmidt; illustrated by Chee. Published by IDW Publishing, 2010.

BELIEVABILITY, BREVITY AND READING ORDER

A mark of good dialogue is that your reader doesn't notice it all that much. Sometimes you want it to be punchy, sometimes you want it to recede into the background and other times you want your reader to dig for meaning.

The best way to check your dialogue for believability is to read it out loud. Or better yet, see if you can get someone else to read it out loud. You will know instantly when it doesn't sound right. When that happens, consider revising it.

One important distinction to remember when reading it out loud is that your dialogue is meant to be read, not heard. Unlike in movies, the dialogue in comics is not typically spoken out loud. Some dialogue works just fine written but is clunky when spoken. So if it sounds like it's not right, it's probably not right, but just be sure you're aware there is a difference.

You also want to check for brevity. Can your character communicate what she's saying with fewer words? I don't take the hard-line stance that you should always, no matter what, use the fewest words possible. To go to that extreme cuts you off from certain tools, such as when a character is nervous and has a tendency to babble. You could do it in fewer words, but then you'd lose the point of that dialogue.

The most challenging thing to write is a one-on-one exchange. You don't want it to read like a question-and-answer session. You want to break up the rhythm to give it its own cadence. You want the character's voices to come out.

Consider the image of the father-daughter chess match.

Two characters, five word balloons. Even in this single panel, I didn't want it to read 1-2-1-2-1. Instead, it reads 1-2-1-1-2. Not just back and forth, it's uneven, asymmetrical. And that's good.

Likewise, I wanted to communicate a number of things, such as their relationship. Ransom, in this panel, talks to his daughter, Mary, in a way that he speaks to no one else in the series because she's both his daughter and because she's so young. So his voice has to change.

The rhythm of the dialogue in this panel reads the way a parent might talk with a child. Notice the layers in it. This is all part of the process.

Achilles Inc. no. 2, interior. Written by Andy Schmidt; illustrated by Daniel Maine and Francesca Zambon. Published by Comics Experience and Source Point Press, 2018.

I also wanted to take this scene (which is only two panels, so this is half of the scene itself) and toy with some themes. This is a flashback, and when we come back to the present day, we learn that Ransom and Mary no longer speak. Mary, as her future self, may very well see her father as her opponent. The truth, in my mind, is that he thinks she sees him that way but that really she doesn't. Also, chess is a theme throughout the book, so it made sense for him to be teaching her chess. Later in the series, Ransom claims he's never been good at chess, but we have a hint, due to this sequence, that he's maybe better at it than he would have us believe.

Did I do a great job on this panel? That's for someone else to judge. Is it close enough to the way people talk that you can read it without tripping over it? I hope so.

One note about reading order. If you have more than one speaker in a panel, make sure that your panel description lists these characters in their speaking order. That's the best chance you'll have of getting the characters drawn from left to right in the correct speaking order. It sounds silly, but if your dialogue lists Character A first and then B and C, but your panel description lists them starting with Character B, then A and then C, there's a good chance your artist will draw them in the order they're listed in the panel description. This is going to cause you a headache when you get to the balloon placements.

Ryan Gutierrez illustrated this page form **Praetor** no. 1 based on my script. Then I went in and created the balloon placements that you can see here. The numbers in the balloons correspond with the numbered dialogue on the script for that page. Notice how I tried to lead the eye (or at least not disrupt the flow of the reader's eye) with the placements.

Praetor no. 1, interior. Written by Andy Schmidt; illustrated by Ryan Gutierrez. Copyright Andy Schmidt, 2017.

BALLOON PLACEMENTS

Balloon placements are guides for the letterer to match up the dialogue and captions in your script with where they should be placed on the page.

The traditional way to do this is to take the line art (black-and-white art) and the corresponding script page, draw a simple balloon on the art itself with a tail/pointer and write in the corresponding number to the dialogue from the script (see, I told you numbering your dialogue and captions was important!). This can easily be done by hand if you've printed the page or on a computer if you have a program that allows you to do so.

Pretty simple, right? Of course! You've already got your script and your art, so how hard can this be? If that's what you're thinking, you're falling into a

trap! Take a look at the comic page with the balloon placements on it. You'll notice it starts with a caption and includes a couple of dialogue balloons, a sound effect and then five more word balloons. Easy! Done! Right?

Let's break this down into the five basic steps for creating effective balloon placements.

1. Size of Balloons and Captions

The first thing you need to be relatively accurate on is the amount of space your captions, balloons and sound effects will take up. On the previous page, none of my dialogue balloons are more than twelve words long. That's an average length for a balloon, so the sizes are fairly small. I added the caption at the top after the page was drawn to clarify where we are. The page wasn't designed with that caption in mind, and it's more cramped than I'd like. You'll notice the sound effect in panel 3 is drawn larger than the balloons because that's the way it'll look on the page.

It takes a little practice, but you'll get the hang of estimating your sizes appropriately. I bring it up because the tendency is to be optimistic about the size of balloons and draw them too small, which can make for a lot of changes after the page has been lettered, so it's best to strive for accuracy early on.

2. Reading Order

The most important aspect of balloon placement is ensuring that the balloons will read in the proper order. This is the primary function of the balloon placements. In North America, we want to read from top left to bottom right on any given tier.

In panel 1, I wanted the locator caption to be the first thing you read and see. Therefore, it's in the top left corner. In the second panel, the character on the left speaks first, then the character on the right. To make it as clear as possible, I've butted the left character's balloon into the corner at top left. There's no way it will be read second. The balloon for character on the right is both farther to the right and slightly lower, not touching the top border. That panel is a lock.

Panel 4 only has one word balloon, so it's pretty easy. I butted it to the top border to give the art as much space to breathe as possible.

The trickiest panel is the last one, which effectively acts as two panels, one with a character getting cut down and a second of a boy reacting to it. The tricky part here is to make the reading order work. You'll notice that the four balloons in this panel start at the top left and cascade to the bottom right. They should read in the correct order.

Note that when a balloon or a caption is butted to a panel border, it makes a statement to your reader. It anchors it to a certain place in the panel. If a balloon is butted to the top border, it will be read before any balloon that is not attached to the top border. Likewise, balloons butted to the bottom border will be read after balloons floating higher than them.

3. Leading the Eye

The second most important function of balloon placements is to lead the reader's eye. In an ideal situation, as in most of the example page, it's simply to make the design and reading process a little more fluid. Panels 2–4 are designed with the balloons in mind. In order to lead the eye, it was important that I not butt any balloon from panel 2 to the bottom of that panel. That would lead the reader's eye down toward panel 4 and its balloon, which would have appeared right next to the balloon from panel 2 that is butted on the bottom. So in panel 2, I needed to keep the balloons in the upper half of the panel to avoid any confusion. They nicely lead us into panel 3, and then panel 4 stands as its own moment.

In the final panel, leading the eye was tricky. The violent action and the alien's word balloon needed to be seen and read before balloons 6–8. They're set off on the left, the word balloon butted to the top of that panel. That works. I am using balloons 6 and 7, which comment on that action (reacting to the violence) to guide the reader to the boy commenting on the right. Then balloon 8 is in the lower right to pull the reader's eye across the boy's face.

4. Conversation Flow

If you've got the reading order working and you're leading the eye properly, you'll then want to make note of how your placements affect conversation flow. We're looking beyond reading order, indicating things to a reader such as a pause between balloons or a change of topic.

You'll notice that in panel 2, those two balloons are the end of a conversation. They relate to one another—statement and response. Then the conversation ends in the next panel. I wanted the exchange to take place in a single panel. That's intentional. That's controlling the conversation flow. You'll also notice that, in the last panel, balloon 8 is a slight change in topic, so pulling it apart from balloons 6 and 7 helps the transition from one topic to the next feel more natural.

5. Covering Up Art

If you're able, the last thing you'll do is adjust placements to cover up as little art as possible. There's no way to avoid it, but you're going to cover up art with balloons. You need to decide what art is most important. Often, as in panel 2, it's obvious that the word balloons should go at the top of the panel; it was clearly designed with that in mind. Other times, like on the bottom tier, it's tougher to know exactly where to put those balloons. You'll notice balloons 6 and 7 could have also gone in that space below the attacker's arm and off the boy's shoulder. There's a nice spot there for them—that's appealing.

MARRYING YOUR TEXT AND ART

Once the art is drawn and you're doing your balloon placements, you may notice that the art doesn't quite communicate what you hoped it would or that it communicates something more effectively than you expected. Both situations happen often, and it's nothing to freak out over.

When the art communicates something better than expected, that's always a good thing! In those cases, I find it's usually best to cut dialogue. I often leave dialogue in my scripts that gives hints as to what's happening in the art. Then I see what the art looks like. If I don't need that dialogue, I cut it or alter it. I love cutting balloons when the art is doing that work for me.

Sometimes the art comes back and isn't communicating what I wanted or anticipated. If it's not totally wrong for the project (in which case I might ask the artist to go back in and adjust the art), I simply adjust my dialogue to go with the flow. It's difficult to talk about this in the abstract, but the key to rewriting to complement the art is not to force it.

For example, if you wanted a happy expression on the character and, instead, you got a face that looks angry, don't contradict the art outright by writing dialogue in which the character declares

> **EXERCISE**
>
> ### Balloon Placements
>
> Take any page of art from this book that doesn't have lettering on it and design balloon placements on that page. I haven't always given you a script, so first you'll want to figure out what you think is happening on the page. Write a script, break it down by panels, and number your balloons and captions. It can be silly, you can tell jokes or you can make it serious. It doesn't really matter, so have fun with it.
>
> Once you've got your script, do balloon placements on the art. Follow the guidelines and see if you can produce balloon placements that read in the correct order, that lead the eye, that affect the conversation flow and that cover up as little art as possible. See what you come up with.
>
> To make it extra challenging, make sure your script includes captions, dialogue and sound effects!

how happy she is. It's just not going to play correctly and will cause confusion. A better course of action might be to shift from happy to maybe a little nervous about the situation. You could do that in a way that doesn't take the joy out of the situation but, instead, focuses on the character being nervous that she might lose the thing that's making her happy. You still get the idea across that this thing makes her happy, but then you've shifted to a scenario that works with the art. It's a whole lot less work for you and your artist than asking for changes to the art all the time.

The other way to marry your script and art (and you can and should be doing this as you write the script, not just after the art comes in) is to look for ways that your dialogue interacts with the art. For example, if a visual element needs to be read in a certain order, your dialogue has to be arranged with that in mind. It creates a more seamless reading experience.

In the balloon-placements illustration, you can see a case of that in the last panel. The balloons need to be read before and after the action on the left side of the page. It's also a way of establishing the flow of time across the panel. The more interactive your dialogue and the art are, the more natural the medium feels to a reader.

MASSAGING YOUR SCRIPT

If you've been writing a script as you work your way through this book, then you deserve congratulations. If you've reached this step, then you've already got a draft of your comic-book script. I bet you'll agree that it was harder than you thought it would be when you first decided to write a comic.

If you've got a script at this point, you're ahead of 99 percent of the people who say they want to write comics. The vast majority of people who think they want to write comics never actually get around to writing a script. If, on the other hand, you've read this far and are thinking you now want to write a script—then go do it! If you want to be a writer, you need to write.

Okay, so let's say that you've got your script (which is awesome) and now you want to give it a massage. Go through it from start to finish, and trim extraneous words where you can, smooth over transitions from one scene to the next or from one page or even one panel to the next. Tighten up that dialogue. Adjust it so that it's not hitting the nail on the head.

For the first time, you're looking at the script holistically. You're reading it and making changes because you're seeing how all these approaches are interacting with each other for the first time.

The "massage" of the script can be a fairly quick process, especially if you're already experienced in writing prose fiction. But it can also take a lot of time. Don't fret if it's taking time. That's good. It means that you've learned a lot and you're catching a lot of things that you didn't see before or may not even have known to look for when you initially wrote those pages.

Go over the whole script this way. It will likely take more than one sitting, depending on the size of the script. Refer back to parts of this book if it helps. Take your time and get it right.

When you're done with the massage pass . . . relax. Rest. Smile.

You've completed a first draft of your comic-book script.

FIRST DRAFT READY!

Your first draft is done. So what does that mean?

It means you've come a long way. That you started out on a difficult journey and have made serious progress. This can't be overstated. If you've got a completed first draft, that's a monumental achievement.

After I've completed a first draft, I let it sit. Preferably for a couple of weeks but, more often than not, I have a deadline, so sometimes it's just a couple of days or even one night. The point is that I let it sit. I go and do other things. I let my mind take a vacation from the project.

That way, when I come back to it, I'm looking at it with as close to fresh eyes as possible. The goal when I come back is to do a rewrite. This is when, for me, I try to tighten up my theme or a character arc, making things more effective. Hopefully, I don't find a large plot hole that requires a lot of rewriting, but it does sometimes happen.

When I was writing *Challenger Deep* for Boom! Studios, I wrote a scene on page five of the third issue (of four issues) that simply didn't work. I squinted my eyes and just kind of hoped no one would notice. That was mistake number one. It's tempting to do that, to say, "It kinda works. . . ." If you're doing that, let me tell you; it doesn't work. In this case, the mistake was big enough that when my editor, Mark Waid, called me out on it, I had to rewrite my outline for the entire second half of the series. But you know what? I liked the new version even better than the original!

My point is that hopefully you won't run into that, but you might. If you do, try to be glad you caught it early instead of after the art was drawn. Rewriting is what makes your work better, so be prepared to embrace it.

If you've submitted your first draft to an editor or to an artist, you might get feedback. Welcome the feedback and take it to heart. Evaluate that feedback and make changes accordingly on your rewrite. I could write a whole other book about what to do with your script after the first draft is done, but it boils down to this: Know yourself, know your story, and stay focused on the integrity of both. If you can do that, then when you get feedback, in whatever form it comes, you'll be able to sort through it and determine what actions are appropriate when you reexamine the script.

TO SUM UP

Hopefully, you now have the tools and the insight to complete a competent first draft you're happy with. If this is your first comic-book script, you'll probably look back on it and not like it all that much. That's fine. It's to be expected. But remember that this is a completed comic-book script—and most people don't ever get this far.

Writing a comic book script is a long learning process. I've been a professional storyteller since 2002, and I'm still learning more with every project. Whether I'm writing it, editing it or consulting on it—I'm still learning. I'm still experimenting and trying new things, and you will, too, if you choose to continue. And I hope you do! The world needs more great comic-book creators.

To be continued. . . .

Chapter 10

Overview and Quick Guide

This chapter is an overview or a recap of everything we've covered up to this point. I didn't give this quick guide to you up front because I wanted you to take it one step at a time, concentrating on each topic as an individual unit. Now that you've gone through the details, having a handy reference for the overall process will help you tie it all together for your future projects.

What follows is my process for developing one chapter of a longer story. This first chapter is ten pages long. I have left these things largely unedited, showing some warts. Also, if you read closely, you'll see how things often change from one step to the next.

Let's jump into the process together!

Babylon, interior. Written by Andy Schmidt; illustrated by Kieran McKeown. Copyright Andy Schmidt, 2017.

STEP 1: STORY SENTENCE

Like you, I start the process with a story sentence:

"Four Astronauts (my character, collectively) launch into space (action), evading certain death (clarification of action/conflict) in order to commandeer a larger spacecraft and begin a mission outside of our solar system (goal)."

You'll notice a few actions here, and that's fine. Each of these actions takes only a page or two. In a longer story, of which this is only the first chapter, it's very common to have more than one action.

The other thing you'll notice is that the goal is to "begin a mission." For a true story sentence, that's not a sufficient goal. That's the goal *for this chapter*, not the whole story. That's important to note because I'm using a subgoal to help give this sample chapter its own identity so that it feels like a complete story unit.

STEP 2: CHARACTER BIOS

The next step is to develop and describe the main characters.

Luciana Rebrar
Function: Captain and Lead Navigator
Body Type: Athletic

Chosen for her natural leadership abilities, Luciana is a genius navigator and physicist. She instills confidence and has a natural commanding style. She thinks fast and is constantly moving when awake, jogging, pull-ups, hiking, whatever. She embraces life. She believes in nothing that she cannot touch but believes strongly that humanity must survive—that there's something about humanity that is important. This idea may be challenged by Godo, who is so atheist that she thinks humans are unimportant.

Goal: Save humanity

Nigel Lanter
Function: Engineer
Body Type: Overweight but able-bodied

He's an engineer and has won multiple national competitions for out-of-the-box thinking and designing better objects. Nigel is a family man who happens to be a genius. He's the nicest of the bunch, the most openly emotional and friendly, the heart of the group.

Goal: See his kids again

Babylon, character design. Written by Andy Schmidt; illustrated by Kieran McKeown. Copyright Andy Schmidt, 2017.

LUCIANA REBRAR

Babylon, character design. Written by Andy Schmidt; illustrated by Kieran McKeown. Copyright Andy Schmidt, 2017.

NIGEL LANTER

Babylon, character design. Written by Andy Schmidt; illustrated by Kieran McKeown. Copyright Andy Schmidt, 2017.

Babylon, character design. Written by Andy Schmidt; illustrated by Kieran McKeown. Copyright Andy Schmidt, 2017.

Jana Cole

Function: Communications Officer
Body Type: Thin

She is a workaholic who cares about her job and nothing else. She has no family to speak of, at least none that aren't estranged. Her devotions are entirely about her work, potentially incapable of empathy. The only thing that can derail her is a question she can't answer. Psychologically, she's not an ideal choice for this mission, but she's too darn good at her job not to send. They simply couldn't afford to send anyone else.

Goal: Do her job

Godo Itsuko

Function: Psychologist and Navigation Officer
Body Type: Overweight

Itsuko is a bit of a nihilist. She doesn't believe in anything at all. She believes that all life is random. She's on board to assess the rest of the crew. Out of everyone, she's the only one who accepts the fact that they could all be exterminated. But she's not cold like Jana.

Goal: Wants there to be more to life than just science and randomness and is looking for those big answers

STEP 3: STORY SPINE

What follows is the story spine for all seven chapters of the story. Following this, I excerpt the first chapter and expand on it.

A crew of four astronauts quickly boards a shuttle and blasts off just before being overrun by raging robots on Earth. They rendezvous with *Genesis*, an interstellar craft that can open up wormholes. The journey will take them eighty years, and their mission is to find the source of a transmission that came to Earth and infected the world's computers and robot systems, seemingly turning the robots against humanity.

The crew will hibernate, one of them waking up every twenty years to inspect the craft and to check in with Earth. The first to do so is Nigel. Wanting to see his family, he is allowed to wake first, but he finds news from home is not good. His family has been mostly wiped out, and the situation is worse than before. He clings to the hope that he can bring his surviving family answers after they arrive.

Jana wakes up twenty years later and goes about her work. She hears the reports from Earth, again:

SHUTTLE GENESIS

Babylon, station and shuttle design. Written by Andy Schmidt; illustrated by Kieran McKeown. Copyright Andy Schmidt, 2017.

bad news. But it doesn't faze her. She goes about her work until she starts to feel that she's being watched. Is it *Genesis* itself? Is there something out to get them all? As her feelings of paranoia grow, Jana eventually escapes the ship via the airlock—but with no spacesuit—her escape is final. It appears that the *Genesis* was actually trying to save her, but she would have none of it.

Twenty years later, Godo wakes up and discovers Jana's demise and cries. The connection with Earth is no longer operating, and Jana was the only one who had the know-how to reestablish the link. Godo is compassionate, and the situation tests her. But unlike Jana, who found that she had no belief system to cushion her situation, Godo believes in science. It's not always comforting, but it can help. She evaluates the crew as best she can and eventually does a psychological evaluation on *Genesis* itself, finding comfort in the idea that humans have created something that cares about them.

Twenty years later, Luciana wakes up. They are close to arriving at their destination, a planet that Earth sent a robot to more than a century before our astronauts ever departed. That robot was aboard the ship the *Dawntreader*, and its mission was to explore and take notes—and eventually land on a planet that was believed capable of supporting human life.

Upon landing, Luciana wakes the crew and makes contact with the robot. Perhaps it knows what sent that signal that turned Earth's robots against them. After a long walk, our crew arrives at the *Dawntreader*, completely remade now using this planet's natural resources. They enter and find the robot, now calling itself Zero, waiting for them and offering them tea.

Zero is pleasant and tells them that he sent the signal to Earth. He explains his reasoning, all very calm and chipper. Then he blows up *Genesis*. They may know the truth, but they'll never get off the planet to tell anyone.

Incensed by the destruction and danger of the plan, our crew destroys Zero, records the truth, and launches it into space. Someone someday will get the package and know the truth. Zero's plan won't work. Unfortunately for our crew, they are stranded for the rest of their lives.

STEP 4: CHAPTER BREAKS

Here I took the above story spine, chipped off Chapter 1 and expanded on it. I'm not proud of it, as you'll notice that the writing is not particularly good. Rather than clean it up and make it look all nice and neat, I thought it made more sense to show it to you warts-and-all. There are some really awkward phrases in here and some cheesy bits. Remember: What's important as you write is to understand your outline's foundation. Only the final draft matters to the reader.

Chapter 1

We start off at the site of a mission launch into deep space. The crew of four say goodbye to Earth and blast off. There's a lot of rhetoric about them being Earth's last hope, etc. As the shuttle blasts off for space, we pull back from the shuttle and see that the area surrounding the shuttle launch has been burned to cinders. The launch was protected by an army fighting off some unseen threat.

The shuttle docks in orbit and prepares for a space-fold jump. Even with the fold, the ship will take eighty years to arrive at its destination. Its mission is to find a ship that launched 100 years ago and was sent to what we believed was a habitable planet. It was sent to start the terraforming process, manned only by computers and robots.

We realize that Earth is hosed. There is mass destruction, the dead tally in the hundreds of millions, and the only reason the number isn't higher is because billions have already evacuated the planet. If our heroes fail in their mission, Earth will likely be lost forever. What's this plague they're fighting? Robots.

And they're losing.

They were able to track down an idea that had been transferred from robot to robot, deleting its trail along the way. It took years to figure out where the source of the idea was, and they're not 100 percent sure that they know now. They know it came through the SFC (space-fold communications) with the *Dawntreader*, which was sent into space to terraform planet RBT1942, known more commonly as Sully.

It is unknown if the transmission came from the *Dawntreader* itself, but our four astronauts are going to find out.

At the end of our first chapter, they leave our solar system behind, plotting a course into the space-fold. They will enter cryogenic sleep, but one of them will wake every twenty years for two months to do a complete system check, look for new orders and do any repairs needed along the way.

Babylon, character design. Written by Andy Schmidt; illustrated by Kieran McKeown. Copyright Andy Schmidt, 2017.

STEP 5: SCENE BREAKS AND PAGE ALLOCATION

I revise very little of the story here. My goal is to allocate the number of pages per scene or sequence. The whole thing must fit into ten pages.

Chapter 1: Ten Pages
Scene 1 (Five Pages)
We start off at the site of a mission launch into deep space. The crew of four say goodbye to Earth and blast off. There's a lot of rhetoric about them being Earth's last hope, etc. As the shuttle blasts off for space, we pull back from the shuttle and see that the area surrounding the shuttle launch has been burned to cinders. The launch was protected by an army fighting off some unseen threat.

Scene 2 (Three Pages)
The shuttle docks in orbit and prepares for a space-fold jump. Even with the fold, the ship will take eighty years to arrive at its destination. Its mission is to find a ship that launched 100 years ago and was sent to what we believe was a habitable planet. It was sent to start the terraforming process, manned only by computers and robots.

 We realize that Earth is hosed. There is mass destruction, the dead tally in the hundreds of millions, and the only reason the number isn't higher is because billions have already evacuated the planet. If our heroes fail in their mission, humanity will likely be lost forever. What's this plague they're fighting? Robots.

Scene 3 (One Page)
And they're losing.

 They were able to track down an idea that had been transferred from robot to robot, deleting its trail along the way. It took years to figure out where the source of the idea was, and they're not 100 percent sure that they know now. They know it came through the SFC (space-fold communications) with the *Dawntreader*, which was sent into space to terraform planet RBT1942, known more commonly as Sully.

 It is unknown if the transmission came from the *Dawntreader* itself, but our four astronauts are going to find out.

Scene 4 (One Page)
At the end of our first chapter, they leave our solar system behind, plotting a course into the space-fold. They will enter cryogenic sleep, but one of them will wake every twenty years for two months to do a complete system check, look for new orders and do any repairs needed along the way.

STEP 6: PAGE-BY-PAGE BREAKDOWN

Here, I'm taking the story scenes and breaking them into individual pages now that I know how many pages per scene I've got to work with.

 You will notice that I've started moving things around for dramatic purposes. I like to fine tune as I go from one layer to the next. There is a good amount of revision here as I start to see the individual pages. I'm looking for reveals and page turns.

 At this stage, I'm starting to focus in on the execution of the story—on how I want the reader to experience the story.

Page 1
We start off at the site of a mission launch into deep space. The crew of four say goodbye to Earth and . . .

Page 2
Blast off!

Page 3
There's a lot of rhetoric about them being Earth's last hope, etc. etc. As the shuttle blasts off for space, we pull back from the shuttle and see that the area surrounding the shuttle launch has been burned

to cinders. The launch was protected by an army fighting off some unseen threat.

Page 4
The shuttle docks in orbit with the *Genesis*.

Page 5
The crew prepares the *Genesis* and makes it their new home.

Page 6
The crew has last thoughts about Earth, what they're leaving behind, what the mission means. We realize that Earth is hosed. There is mass destruction, the dead tally in the hundreds of millions, and the only reason the number isn't higher is because billions have already evacuated the planet. If our heroes fail in their mission, humanity will likely be lost forever. What's this plague they're fighting? Robots.

Page 7
Luciana and the crew prepare for a space-fold jump. Even with the fold, the ship will take eighty years to arrive at its destination. Its mission is to find a ship that launched 100 years ago and was sent to what we believe was a habitable planet. It was sent to start the terraforming process, manned only by computers and robots.

Pages 8-9
And they're losing.

They were able to track down an idea that had been transferred from robot to robot, deleting its trail along the way. It took years to figure out where the source of the idea was, and they're not 100 percent sure that they know now. They know it came through the SFC (space-fold communications) with the *Dawntreader*, which was sent into space to terraform planet RBT1942, known more commonly as Sully.

Babylon, interior. Written by Andy Schmidt; illustrated by Kieran McKeown. Copyright Andy Schmidt, 2017.

It is unknown if the transmission came from the *Dawntreader* itself, but our four astronauts are going to find out.

Page 10
At the end of our first chapter, they leave our solar system behind, plotting a course into the space-fold. They will enter cryogenic sleep, and one of them will wake up every twenty years for two months to do a complete system check, look for new orders and do any repairs needed along the way.

STEP 7: PANEL-BY-PANEL BREAKDOWN

For demonstration purposes, instead of breaking down the whole chapter panel by panel, I'll zoom in on just the first three pages of the chapter.

Here, I flesh out the specific panels on each page. For this story, I was intentionally trying to keep the panel count low.

You'll notice that the panel descriptions aren't fleshed out, nor are they ready to go to an artist. That happens in step 8.

Page 1
Panel 1
Astronauts running! They're in a hurry.
Panel 2
They climb aboard a shuttle, not sure what the whole scene is yet, just a sense of urgency. Four of them.
Panel 3
In the cockpit. Launching.

Page 2
Panel 1
Blast off!

Page 3
Panel 1
We see the surrounding area as the shuttle blasts off.
Panel 2
Pull back more. Fires are raging everywhere.
Panel 3
Now we're in space. The planet looks more peaceful.

STEP 8: VISUALIZATION AND CLEANUP

Here, I'm just fleshing out the panel descriptions, making sure there's an action in each one and that the story is being told as visually as possible. Ideally, after this step, the panel descriptions are done.

Babylon, interior. Written by Andy Schmidt; illustrated by Kieran McKeown. Copyright Andy Schmidt, 2017.

Page 1
Panel 1
Close up of astronaut feet in full gear running! They're in a hurry.
Panel 2
The four astronauts climb an exterior ladder to their ship. It's not a rocket using traditional fuel, but that's not important right now. It's still basically a giant missile pointed up, and they're high up. They are in silhouette on the ladder. Behind them, we can see the fires of destruction. There's a battle going on behind them, but we can't really make out the

particulars. It doesn't look good. I suggest a lot of fire and smoke rising from the horizon.

Panel 3

In the cockpit. Getting ready to go to launch. Still hurried.

Page 2
Panel 1

Blast off! Important that, as the rocket is headed up and right for us, we see the ground below. The army is overrun by robots. Tanks blowing up. Real destruction.

Page 3
Panel 1

As the rocket blasts off for space, we pull back from the rocket and see that the area surrounding the shuttle launch has been burned to cinders.

Panel 2

The launch was protected by an army fighting something off . . . what—we don't know. Fires are raging over a great distance.

Panel 3

It looks more peaceful from this distance, but the red from fires can be seen. It's just pretty now. . . .

STEP 9: DIALOGUE

I add the dialogue to the panels now. I also bold my panel descriptions to set them apart from the dialogue text.

Page 1
Panel 1

Close-up on astronaut feet in full gear running! They're in a hurry.

Luciana (OP): Go! Go! Go!

Radio: Hurry; you're losing your launch window!

Panel 2

The four astronauts climb an exterior ladder to their ship. It's not a rocket using traditional fuel, but that's not important right now. It's still basically a giant missile pointed up, and they're high up. They are in silhouette on the ladder. Behind them, we can see the fires of destruction. There's a battle going on behind them, but we can't really make out the particulars. It doesn't look good. I suggest a lot of fire and smoke rising from the horizon.

Radio: The army is breaking through our defenses. They're almost to you!

Luciana: How much time?

Radio: Five minutes!

Panel 3

In the cockpit. Getting ready to go to launch. Still hurried.

Jana: I don't know about the rest of you, but I'm not at all worried about the fact that we're launching a day early without going through proper safety checks and procedures.

Luciana: Less sarcasm, Jana . . .

Page 2
Panel 1

Blast off! Important that as the rocket is headed up and right for us that we see the ground below. The army is overrun by robots. Tanks blowing up. Real destruction.

Luciana: . . . and more action!

Page 3
Panel 1

As the rocket blasts off for space, we pull back from the rocket and see that the area surrounding the shuttle launch has been burned to cinders.

Radio: The old Kennedy Space Center was annihilated.

Panel 2

The launch was protected by an army fighting something off . . . what—we don't know. Fires are raging over a great distance.

Radio: Human civilization is almost extinct. Our own creations having turned against us.

Step 10: Polish and Cleanup (Final Script)

I clean up the dialogue and get it as close to final as I can before I see art come in. Here, I'm trying to get more personality from my characters and clarify action and story flow. Once the dialogue is nailed down, I also number all the text that will be placed on the page by the letterer. Part of the cleanup includes nailing down the formatting, including indents, numbering balloons and so on.

Page 1

Panel 1
Close-up on astronaut feet in full gear running! They're in a hurry.

1. Luciana (OP): Go! Go! Go!
2. Radio: Light fire, heroes! We're about to lose our launch!

Panel 2
The four astronauts climb an exterior ladder to their ship. It's not a rocket using traditional fuel, but that's not important right now. It's still basically a giant missile pointed up, and they're high up. They are in silhouette on the ladder. Behind them, we can see the fires of destruction. There's a battle going on behind them, but we can't really make out the particulars. It doesn't look good. I suggest a lot of fire and smoke rising from the horizon.

3. Radio: Their forces are breaking through our barricade.
4. Luciana: How much time before they hit us?
5. Radio: Five minutes—max!

Panel 3
In the cockpit. Getting ready to go to launch. Still hurried.

6. Jana: I don't know about the rest of you, but I'm not at all worried about the fact that we're launching a day early without going through proper safety checks and procedures.
7. Luciana: Good.
8. Jana: Just so we're clear, I didn't actually mean that.
9. Luciana: Less sarcasm, Jana . . .

Page 2

Panel 1
Blast off! Important that, as the rocket is headed up and right for us, we see the ground below. The army is overrun by robots. Tanks blowing up. Real destruction.

1. Luciana: . . . and more "save the world."

Page 3

Panel 1
As the rocket blasts off for space, we pull back from the rocket and see that the area surrounding the shuttle launch has been burned to cinders.

1. Radio: Just seconds after launch, the old Kennedy Space Center was annihilated. But the launch made it off the pad.

Panel 2
The launch was protected by an army fighting something off . . . what—we don't know. Fires are raging over a great distance.

2. Radio: Human civilization is in jeopardy of extinction. Our own creations having turned against us. But now we have hope.

Panel 3
It looks more peaceful from this distance, but the red from fires can be seen. It's just pretty now. . . .

3. Radio: The fate of humanity rests with four astronauts about to attempt something that's never been tried by a human before.
4. Luciana: We're approaching our first stop. Docking stations, everyone.

Balloon placements for page 1 of *Babylon*

Babylon, interior. Written by Andy Schmidt; illustrated by Kieran McKeown. Copyright Andy Schmidt, 2017.

Panel 3
It looks more peaceful from this distance, but the red from fires can be seen. It's just pretty now. . . .
Radio: The fate of humanity rests with four astronauts about to attempt something that's never been tried by a human before.
Luciana: We're approaching our first stop.

TO SUM UP

Layering. It's all about layering. Taking something small—a concrete idea for a story—and fleshing it out with characters and plot. Then adding chapters, scenes, pages, panels, dialogue and polish. All that's left is to rewrite and send it to your artist!

Up next, we talk about the comic-book industry and networking!

To be continued. . . .

PART 3

Navigating the Comics Industry

Up until now, we've been focused on story and the craft of writing for comics. But as you write your script, it's equally important to consider your collaborative partners and the comics industry as a whole. In Part 3, we'll cover the basic tenets of this complex (but rewarding) industry to help further you on your path to producing great comic-book scripts.

RRRNNN

CHAPTER 11

Networking and Collaboration

Writers with scripts that they feel are ready for publication often come to me for advice on how to network and get published. They may ask how to find an artist to illustrate it. While it's totally understandable to want to focus solely on the writing work, if your intention is to go a traditional publishing route, it behooves you to simultaneously develop relationships with fellow creators and to engage with the comics industry as a whole.

It takes time and effort to network and meet people in the industry, and there's no reason you can't network while you write. Writing and networking are not mutually exclusive. In fact, it improves your chances of finding a publisher if you're doing both simultaneously.

Working together is hard, but finding the right partner is the key.
Exalt, interior. Written by Paul Allor and Andy Schmidt; illustrated by Matt Triano. Copyright Andy Schmidt, 2017.

HONING YOUR CRAFT AND NETWORKING

One of the ways that you can network is by using the fact that you're honing your craft as a conversation piece. It's nice to have something to discuss with industry professionals. Talking about craft and learning is a good, safe topic.

By safe topic, I mean you're not asking an industry professional to do something that puts him on the spot. You're not shoving a pitch in the person's face to be reviewed. You're talking about the craft of writing and about different kinds of stories. It's a good way to start any interaction without immediately asking for something from the person.

It also lets the person know that you take craft seriously and that you're growing as a creator. That's good, too. When it comes to networking, the goal isn't to collect business cards; it's to have multiple interactions with people over a long span of time. As such, you want to leave room for the conversation to evolve. If your first interaction with someone is "Here's my pitch; please read it," then there's not a whole lot of room for that conversation to grow.

On the other hand, if your first interaction is about story and the kinds of stories that you and the person tend to gravitate toward, then you've learned something valuable—the type of story she might be interested in reading about later—but you've also left the conversation space to develop.

Some months later, you may meet the person again or interact with her over social media, and then you can talk about something new you've learned or been experimenting with in your writing. You might get some feedback from that, too. Then let's say you have a third interaction a full year after your first meeting, in which you can say you've completed a graphic-novel script and it's your best yet. It's almost like giving the person a progress report.

By the time you finally get around to showing her a project for review (if she's an editor, for example), you've had multiple exchanges. During this time you've learned the type of project to show the person, and she will see that you're a hard worker because you've been pursing this for some length of time.

Sound like work? It is. Just as you hone your craft of writing, you must hone the craft of networking. You may be thinking that you don't want to do that or that you're not good at networking. Here's the truth: No one wants to network. Networking sounds like some corporate doublespeak intended to manipulate people. So we're going to stop thinking of networking as a business tool. Whenever you see the word networking, I want you to mentally substitute the word conversation. Because the best networking, genuine networking, is simply conversation between two people with at least one common interest.

DEVELOPING YOUR VOICE

As you continue writing—I recommend trying shorter stories before you tackle that epic you've probably already started and stopped nine times—you'll likely start to identify themes and commonalities in your work. That's a good thing. This is how you start to develop your own voice.

I've been asked many questions about how someone is supposed to find her voice or develop one. The idea of finding your voice is an interesting one. It's as if we've somehow lost our voice, as if we've put it down somewhere and forgotten where we left it. I find the idea of developing one's voice equally off the mark because the idea of your voice implies that this is something you already have, not something you're creating from scratch.

Ultimately, the language we use is probably just imprecise. Whether we're talking about finding or developing a voice, either can make sense to you, and that's all that matters. From what I can tell, your voice is a combination of things that make your writing uniquely yours while also providing a consistency—often a recognizable consistency—throughout your work.

The elements that comprise your voice are:

1. Your Talents

All of us have certain things we're more inclined to be good at doing. For me, when it comes to writing, I have a talent for a more conversational style—the style of this book, in fact. This comes fairly easily to me, whereas a more formal academic style does not. I can write formally, but it requires more work. Your talents may lie in writing action scenes or in characters that are deeply flawed or in a particular narrative device, such as a twist ending. You will find that in your writing, you have certain strengths. While I greatly encourage you to develop your other skills, there's no reason to deny your strengths. You'll naturally want to play to them from time to time, and that's okay.

2. Your Interests

We all have things that interest us. For me, I'm always reading about discoveries and theories in science, especially physics. I'm also interested in adventure stories, heroics and themes about community. These are a few of my interests. It is not the case that just because I am interested in something, I am also naturally talented or gifted when it comes to that subject. Hopefully, there's some overlap. For example, I've got a pretty good head for physics, but I'm by no means a physicist.

3. Intersection

Your voice, as we've come to define it, lies in the intersection of your talents (or strengths) and your interests. This intersection is what makes your writing uniquely yours. Many writers may refer to this as their wheel house or their comfort zone, but it all means the same thing: You're good at writing a particular kind of story or executing stories in a certain way or with particular kinds of scenes or characters, and your stories tend to deal with certain themes or questions.

I realize this sounds a bit nebulous, but that's because it's not specific yet. When you look at your own writing and you want to define it (to be clear, I don't think you necessarily need to define it), then this is what you're looking for. Your interests and the types of stories you're best at executing—that's all there is to it.

Some writers want to consciously develop their voice. Others never want to think about it, and if it happens, it happens. They leave that up to others to decide. Personally, I tend to lean more toward the latter. I don't think about how I would define my writing, but I don't think there's anything wrong with considering it and acting on it deliberately.

EXPERIMENTATION

As you continue to grow as a writer, and as you become more comfortable with the principles outlined in this book, you'll naturally start experimenting. I encourage this. There are two keys to experimentation that will improve your writing. The first is understanding the underlying principle or principles that you're testing and pushing against.

As you become comfortable with principles, such as every panel needing to contain one action and one action only, and you understand the reason behind these principles (e.g., the reader is looking for only one action per panel), you've got a basis to experiment. Now you test that boundary, you play with multiple actions in a panel, and you test to see what works and what doesn't. A secondary action that's not integral to understanding the whole story may work just fine. If it's missed, it's okay. It doesn't hurt the reader or play unfairly. But if it's noticed, it may add a thematic layer or just be something fun for your reader.

You may try to do multiple actions and find they wind up competing with one another, which is why I encourage beginners to stick with one action per panel. When you experiment, you're testing the

> **EXERCISE**
>
> ## Pushing Boundaries
>
> Here are a few quick experiments to challenge yourself to experiment. The key to any experiment is being able to identify when it's concluded and if it worked. To do that, you'll need to wait until the comic is finished and find out if readers got out of the sequence what you were hoping they'd get out of it.
>
> Here are a few things to try as writing exercises:
>
> - Write a script with no dialogue or captions, just panel descriptions.
> - Write a script with only long vertical panels.
> - Write a script about a dream.
> - Write a script that takes place all in one room.
> - Write a scene with only two characters.
> - Write a script about a group of animals.
> - Write a script in which the captions tell a parallel story to the visuals.
> - Start with the last page of the script and write backward one page at a time.
>
> These types of experiments will help you formulate your own approach to comics. There is no limit to the way you can experiment. Anything you do that changes your process or limits you in some way is going to force you to get creative and deconstruct the way comics work, which is going to automatically improve your comics-writing skills.

boundaries. You're defining the parameters of any rule more closely and specifically.

Experimentation leads you to a deeper understanding of the foundational elements discussed in this book and some that aren't covered here. Experiments that aren't successful define boundaries in your writing, and experiments that are successful add to proven techniques that you can use again.

Evaluation

The second key to experimentation as a learning tool is evaluation. The tricky part isn't in the experiment itself but rather in the evaluation of how successful (or not) it is. What I often see from younger or newer writers is an experiment that is worth doing and trying but that ultimately doesn't have the intended effect. But instead of realizing it didn't work out as intended, he assumes that it worked just fine and continues to use the method to his own detriment.

The key is to develop a system for evaluating the success of the experiment. Just because you wrote it and someone else drew it, that doesn't mean that it has the desired effect on the reader. So you'll want to check in with readers, without telling them what you were going for, to see if they understood the experimental portion the way you had intended. If they didn't, learn what they got out of the scene. It may still be a tool you can use, even if it's a different one than you had planned.

Keep your focus on continuing to expand your skills and your command of the craft. Experiment, but make sure you've got a good system for evaluating the results.

WRITING EFFECTIVE PITCHES

If you've followed the steps in this book, you've created a story document. A story document is designed for you to read and not for public consumption, and it's almost definitely not a good sales tool. Use this

as the basis for your pitch if you intend to write one. A pitch is the document that you send to a potential publisher or in some cases a potential collaborator in the hopes of playing interest in your project. Usually an editor will evaluate it and determine if he thinks the company might be interested in publishing it when completed. It's called a pitch because it's essentially your "sales pitch."

Any good pitch includes the following elements:
- Your name and contact information
- Title of the project
- Date
- Cover letter: Personalize it to whomever you're sending it.
- Premise: This is used to try to hook whomever is reading it.
- Parameters: Page count, perhaps the intended audience (keep this fairly general such as "Boys, ages ten–seventeen").
- Character descriptions: These will differ from your story bios. They are designed to make the reader want to read more about your characters. In your story document, they're designed to provide you with a clear path for the character—to help you more effectively write the characters. In the pitch, you want to design the bios so that a reader will want to learn more about them. It's more about who they are and the trouble they might get into rather than who they are and how they will change. Feel free to mention the character arc, but that need not be the defining characteristic in your pitch bio.
- Story synopsis: Unlike your story spine, this is designed to entertain a reader. So while you will likely base this off of your story spine, you'll want to make sure it reads in an active voice and is engaging. The key is to remember that you're *telling the story*. If you tell the story in the pitch and it's not entertaining, that's not going to fill your reader with a lot of confidence that a longer version of it will be compelling.

Best Practices

Remember that whenever you're writing for an audience—any audience—write in an active voice. And be sure to triple-check your spelling and grammar. When in doubt, go brief. Again, the key to a pitch for a story intended for the entertainment industry is that it should be . . . entertaining.

PERSONAL NETWORKING

If networking is really conversation, then it's conversation over a longer than normal amount of time and potentially over one or more communication platforms. What that means is that your conversation with someone may start on a convention floor and then get followed up on Twitter or an email exchange. Then you may become Facebook friends with the person. All of this will happen over months or years rather than in the span of an hour.

Think of networking as a conversation rather than some kind of business initiative. The hardest part of any conversation with someone you don't already know is getting it started.

The first thing you and someone else will do is look for common ground or interests. Here's a tip: If you're talking to people in the comics industry, and you want to be in the comics industry, there's a pretty good chance that you've got comics as a common interest. You'll want to get more specific than that, what type of comics the person likes or creators she follows or genre or a particular run on a comic book.

The more obscure the common ground, the better. But you really do need to share that interest. So for example, you find out from me that my all-time favorite supervillain is the Living Monolith, which is pretty specific and obscure. If you don't know who that is, don't pretend that you do. You may be interested to read about the character, but it's better to keep searching for legitimate common ground than to try to pretend that you are on it.

Also, if for some reason, the conversation veers away from comics—let it. I talk comics with literally thousands of people each year. That's not a great way to stand out when talking to a comics professional. However, if our conversation veers off into some other topic and you and I meet later online and you remind me that we talked about our favorite dog breeds or our experiences skydiving or whatever it is, then I'm more likely to have a specific context for you. It's okay for the conversation to go away from comics, and in some ways, that might even be preferable.

Remember that conversations are always awkward at the start. They just are. It's okay. Most people in the comics industry are at least polite. We get it. We've been in a lot of awkward conversations, and some of us are even good at making them less awkward. Try your best not to be nervous. We're all on the same planet, and we're all human beings. The more relaxed you are, the more at ease the conversation is likely to be.

HOW TO WORK A CONVENTION

You're going to your first comic-book convention with the intention of making a few contacts. That's great! Many new creators buy their ticket and then show up and expect the networking to take care of itself. While that could happen, it's not likely to occur all on its own. It helps to have a plan. Here are a few good ideas for prepping for your convention visit.

First, research who is going to be at the show. Usually, the show's website has a list of exhibitors—these tend to be companies that will have a booth on the main show floor. There's often a separate list of creators who will have tables where they'll be selling art, taking commissions and talking with fans.

You'll likely know some of the names on both lists. If you don't, do a quick Internet search on as many as you can. Determine whether the company would be valuable to talk with to help you reach some of your creative goals. Make a list of everyone you want to meet.

Most connections you'll make that are of real value will be with other creators, not within the publishing companies themselves. I recommend trying to speak with creators who are a little ahead of you in their careers. As fun as it is to talk with a big-name creator, unless they had a swift rise to fame in the last year, they're likely to be a bit out of date with the specifics of breaking in today.

Likewise, if you're looking for artists who might be interested in collaborating with you, it's more likely that you'll be able to team up with someone earlier in his career than a seasoned pro who regularly works for larger publishers. While this isn't a hard-and-fast rule, it tends to be true.

When talking with someone at a publisher's booth or a business, I suggest asking questions rather than making statements. Your real aim in going to the convention is to learn. And it's a lot easier to learn something if you let the other person speak.

Ask a question about what the person does at the company, what the day-to-day of the job is, what they think the company's overall goals are within the industry. What type of projects does the person really like to see? What projects has she been involved in that she's most proud of? Many editors, for example, don't get a lot of recognition or genuine interest in what they do. Most people are looking to see what that editor can do for them, so if you can be someone with a genuine interest in their work and how they see things, then you'll likely stand out in a positive way.

After you've interacted with someone in a positive way, you may feel comfortable asking for recommendations of anyone else that you might want to talk with. If you get a couple of names, that's great. That gives you an easier conversation starter with those recommended people. And it's always a good

idea to ask if you can follow up with the person later and how—by e-mail, phone, social media, etc.

After the convention, follow up with a polite e-mail thanking the person for her time and reminding her very briefly of your conversation. And boom! You've made first contact, made a good impression and established a baseline for future interactions. Well done!

HOW TO WORK A CONVERSATION

The most important aspect of a conversation is finding the balance between getting what you want to get out of it and allowing the conversation to flow naturally. When you have an agenda, that's probably working against organic and natural conversation. So how do you do both?

The first aspect is to know what you want to get out of a conversation with an industry professional. Likely, you won't want the same thing out of a conversation with a potential collaborator that you will with an editor at a publishing company. Think about the different kinds of conversations you'll have with the different kinds of people you're going to try to meet.

Then figure out what your goal is for each conversation. Make your goal flexible. Make the goal less defined and less aggressive than simply getting your pitch read by an editor. Remember that a conversation equally involves two or more people. So a goal for an initial conversation might be to find common ground. That allows you more options. Or it might be to learn something about how the person evaluates projects or even simply what kind of projects the person tends to enjoy.

A similar technique that allows for more flexibility is to have a few goals in mind and decide which one to go after once you're in the conversation. It's not fun to start a conversation and then realize there's little to no chance of getting to your goal. We may start to flounder when that happens. So give yourself a couple of goals, and let the conversation direct you toward one that seems most achievable.

Think of these conversations as information gathering. You're trying to learn as much as you can about what goes on behind the scenes. We all know that Marvel and DC Comics publish superhero comics about characters they already own. But what can you get through a conversation that isn't public knowledge? What's going on in editorial? What are the priorities today? Is there a push for a particular type of content—to reach a certain audience perhaps or to push certain boundaries? Just ask questions and then more follow-up questions. And answer honestly when you're asked questions in return.

Don't be afraid or shy of where you are in your career or in your writing process. If you're at the beginning and have no published work, that's okay. No one is born with published work, and we don't all start our comics careers at the same age, nor do we all have the same goals. We do things at different paces and that's okay. There's nothing shameful about being at the beginning of your journey. There's nothing wrong with not having everything figured out—no one ever does. There's only where you are now and where you're headed.

Hopefully this goes without saying, but be polite to everyone. You may have to wait for someone's attention. Be sure to thank the person for his time.

If you are talking with a creator who is set up with a table, it's a good idea to buy something from the person if you can. Also, if you're talking with him, stand a bit to the side of the table so that other people can easily see prints, artwork and the creator. The last thing you want to do is hinder that person's ability to make money. Always be courteous and encouraging of others to come up to the table and interact. If they do approach the creator's table, step aside and wait patiently. Don't try to sell the artist's work for him or her; simply make sure you're not in the way of commerce taking place.

FINDING AN ARTIST

How do you find an artist, and what should you pay for art? We'll get to the second question in a moment, so let's start with finding an artist.

The typical ways to find an artist are:
- You know the artist personally; she's a friend or someone in your hometown.
- You are introduced to the artist by a mutual friend or acquaintance.
- You meet the artist in person and start a conversation.
- You find the person's artwork online, and you reach out through digital means.

There are variations on these, of course, but these are the four ways I hear the most. And they are how I have found every single artist that I have worked with on my own projects.

The question is less about how to identify an artist but more about how to find the right or appropriate artist for you and your project. Here is what you're going to look for:
- The artist's style is appropriate for the story, or it's good enough that you will happily adjust your story some to accommodate the artist's style and still maintain the quality of the project.
- The artist knows how to tell a story. There are many fine illustrators in the world, but it's a rare illustrator who is also a good storyteller. Evaluating an artist's storytelling ability can be complicated, but go over the art to see if you can follow the thrust of what is happening.
- The artist has a reputation for following through on her commitments. This can be hard to track down, especially earlier in this process. You may work with an artist without much of a track record, but do what you can to try to get comfortable with the idea of being in business with her.
- Make sure you get along with the artist. You don't have to be best friends or anything, but being able to speak openly about the creative process is extremely helpful.
- If possible, make sure the artist is open to discussion and criticism. I'm not suggesting you criticize the art much, but, if there's an issue, you want to be able to address it. In the same way, if there is an issue with your script, you would want the artist to raise the concern with you so you can make changes if necessary.

It's likely you won't be able to determine all of the above right away. It's okay to have a conversation with an artist that takes time and goes through a couple of stages. These things are important. Who you work with and how you work with her is sometimes more important than the work itself. Likely, this is a passion project for you, so you want to do all you can to ensure that you enjoy working on it, and that means finding the right partners.

COLLABORATION—GETTING TO YES

Once you're confident that you're talking to the right collaborator, you need to work out the deal. That means the business terms of how you will work together.

What follows is taken from the Creators Workshop that I run online. Our forums are filled with a ton of collaboration advice, but this is the first post on the topic, and it's got a lot of good information.

There are essentially three types of collaboration:

1. Creator-Owned Partnership

In this form, all creators share ownership, and no money changes hands during production, only after something goes to market. These types of collaborations are common in the indie-comics world. It means that two or more people co-own the work/project together and enter into deals together.

2. Work-Made-For-Hire Partnership

In this form, one creator is paying another creator in a work-made-for-hire scenario. In this case, the partners would have a written and signed agreement in which one creator pays the other creator for her work and ownership of the work is transferred 100 percent to the paying creator. This form of partnership is common by large companies such as Marvel or DC Comics, who do not want to share ownership with individual creators.

3. Combination

In this form, there is some combination of the previous two options. There may be money changing hands as an advance, and due to this, the ownership structure (who owns what percentage of what) may be different. This is common when one creator needs some income while working on the project but still wants to have participation in the project overall.

What Form of Collaboration is Right for You?

Here are a few guidelines that may help you reach an agreement more quickly.

- The goal of any collaboration is that all parties feel *valued*. The goal is to establish a relationship in which each party feels respected and a part of the process.
- Ask questions. It may be better to ask what kind of deal someone is open to in order to get the conversation started.
- Know your own limits. If there's a point where a collaboration is a deal breaker for you, it's good to know that going into a conversation so that you know when and if to pull out of the negotiation.
- Think about what value you and your partner(s) bring to the table. We all have different skills and experiences. There is no one-size-fits-all deal.
- Remember that there are three major levers to pull and adjust. As one goes down, one or both of the others will go up, so finding the right balance is important for the whole team. Those levers are (1) ownership percentage, (2) upfront compensation and (3) time/schedule. Beyond these, there are still a million details that can be adjusted and these categories can be subdivided to death, but these are the big three.
- Keep your deal as simple and straightforward as possible. Try to avoid a lot of tricky accounting or ownership divisions. They usually don't matter much and will cause you and your partners to waste hours going over details that (often) amount to pennies.

DIGITAL PRESENCE

In today's world, your online presence and persona can be a powerful ally in getting a project approved and finding collaborators.

The most important thing about your online presence is defining your goal. Are you trying to cultivate fans of a particular kind of genre? Are you trying to make inroads with industry professionals? Are you trying to learn as much as possible about the craft of writing? Are you trying to show off your work?

These aren't mutually exclusive, but as you prioritize what's most important to you, that should help you determine the kind of content, tone and persona that you present in the digital world. You're basically trying to figure out who you want to be.

Your goals may change, and you can make adjustments once you're online and interacting with people. But you have to start with a plan in order to be able to evaluate how it's going. For example, your Twitter account may be your primary mode of interaction, or you may design your Twitter use to drive people to your website so they can check out your work.

You may want to maintain several social-media profiles. Facebook, Twitter and Instagram are all popular as of this writing. By the time this book sees print, there may be others that are popular, and some of these will be waning. It's difficult to keep up with the various platforms, but this can be worth doing if you're comfortable interacting via social media.

Taking charge of who you are in the digital space isn't easy. In fact, many people make careers out of helping companies and individuals define achievable goals and design strategies. There's a lot of effort and research that goes into determining and implementing who and what you are online.

SOCIAL-MEDIA BEST PRACTICES

Here are a few things to consider when designing your digital presence to drive toward achieving your goals:

Are you going to genuinely be yourself? It's my belief that far more people can see through an act and are turned off by it than are convinced and want to buy into the act. That's just my opinion, but my advice is to not present yourself as someone substantially different from who you really are.

That doesn't mean that you should let whatever comes into your mind fly out into the digital web unfiltered. Think of it as putting the best version of yourself into the digital domain.

Unless your goals specifically steer you away from doing the following, I recommend:

Being professional at all times and deciding how you're going to talk online. I steer clear of potentially offensive language, for example. I try not to engage heavily in politics. I try to remain open-minded, but I also have my limits. I do not engage with overly negative people, especially if they're mean-spirited.

I try to be helpful to people wanting to learn about making comics or the comics industry, often giving out pro tips on certain aspects of comics creation.

> **EXERCISE**
>
> ### Social-Media Marketing
>
> In order to better understand how social-media self-promotion and networking work, track three writers and three artists through their digital and social-media presences. You don't need to interact with them. You can follow them on Twitter, a public Facebook page and so on. See if they're on DeviantArt, Tumblr or whatever today's equivalent is (these things do change quite quickly). Does the person have a website?
>
> Now take note of how often they're actually on those platforms. How often do they update their own website or Facebook page? And lastly, how are the interactions different from platform to platform? Is one used primarily to promote the person's work? Chat with fans? Network with other professionals? Are any of the platforms off limits to contact them through? Do you get a sense that they do or do not want to be approached through digital platforms?
>
> How can this information help you think about what your own digital presence will be like? Are you comfortable interacting in the same ways that they do? Does this seem like a fun way to spend your time?

Present yourself as someone who is serious about his craft, as someone who is striving to always be better than you are today.

Engage with others online in a friendly manner. If things turn ugly, it's often better to just disengage quietly rather than escalate.

By way of example, I have had people tell outright lies about me online, some of them in public places. It hasn't happened often. And yeah, I've gotten angry

about it. At times, I've typed up lengthy responses, but ultimately, I determined it's better for me not to respond. Once the initial remarks are posted, the damage (if any) is done. By arguing or presenting my side of the story, I'm drawing more attention to it, giving the accusations more credence.

In those cases, I've tried to figure out what the person is trying to get out of it. Sometimes I think the person is likely depressed or is trying to get attention, and in some cases, I think the person has wanted me to respond so that he feels more important. It's better to simply not engage. There's no winning in it for you. I hope that nothing like this happens to you because, as stated above, it's infuriating. But it's also worth bringing up so that you realize that often your best option is to say nothing and let it simply fade away.

On the other hand, if you want to stir up controversy as a means of promotion, then offensive language and politics may be at the top of your online list of to-dos. It's not for me, but it might be for you.

MESSAGING

You want to have a message when engaging with the community. As a default, if you don't have anything specific that you're trying to convey, convey that you are constantly moving forward toward your goals—that you're learning, that you're working on a new project and so on.

If you and I meet at New York Comic Con in October of this year and you tell me that you're working on project X and it's off to a great start, then when I bump into you at New York Comic Con next year, it's ideal to be able to say that project X is done and came out and you learned a lot. Then you can say you're currently working on project Y. You've progressed forward, not content to stand still. You want to be someone who is moving forward.

But what if you haven't finished project X? What do you do? Then make sure you present yourself as working on project Y or working on some other aspect of your career. It doesn't always have to be a new project. It can be career development, but projects are the easiest to understand and give you something to talk about, and ultimately, that's what the industry is about. You should always have another project waiting in the wings to move up if and when you need it.

If you're standing still, people will notice—or more accurately, they won't notice at all.

I took several years off from comics during which all I was doing was teaching classes. At that time, I was working for Hasbro, where the terms of my employment prevented me from pursuing my own personal projects. So for several years, I'd go to conventions and have nothing substantially new to talk about. Even though I was good at talking about what I was doing in my day job, the lack of new comics work did have an impact on my comics career.

In my case, that was a trade-off I was willing to make. The job at Hasbro was both interesting work and provided stability for my family. That was a fair trade in my mind, but it did have an adverse effect on my comics career in the short term.

Hopefully, you'll be able to avoid that by simply planning your message so that you know how to talk about yourself in a positive light.

TO SUM UP

Understanding how to market yourself and network is extremely important if you're planning to produce and sell your own comic book or graphic novel. It's also important in furthering your creative development if you intend to develop a career in comics and earn a living making them.

Your creative development will keep you interested in your own work and likely fans as well. Your marketing and networking efforts can widen that audience.

But there's also a need to understand the industry itself.

To be continued....

Chapter 12

Building a Career in Comics

Most of us don't set out to be businesspeople. In all likelihood, you've picked up this book because you're more engaged by the idea of being a creative person. But the harsh truth is that one can't really separate the two anymore.

In this chapter, we'll touch on the ever-changing industry and how you might fit into it. You will learn how to recognize the shifting winds within the industry and interpret them with a little more accuracy in order to apply them to your career goals.

Achilles Inc., unused cover. Written by Andy Schmidt; illustrated by Daniel Maine. Published by Comics Experience and Source Point Press, 2018.

COMICS-INDUSTRY-LANDSCAPE OVERVIEW

The comics industry is a small sliver of the entertainment industry. As such, it functions in much the same way, but due to its relatively small size, it also behaves differently in a few notable ways.

First, the comics industry in North America has a few major players. The two largest publishers are Marvel Comics and DC Comics. Both of them publish primarily superhero comic books, and they fully own their large slates of characters.

Branching out from the superhero genre, we then have other major publishers like Dark Horse Comics, Image Comics and IDW Publishing. They have what Diamond Comic Distributors calls premiere publisher status. This means their content is placed in the front of the monthly catalog from which retailers order. There are other substantial perks, but for an overview, it means their projects tend to sell decently well simply by virtue of being published by them.

After these five publishers, we have smaller publishers that tend to specialize in certain kinds of content. The following publishers, as of this writing, have reputations for putting out quality projects: Oni Press, Fantagraphics, Source Point Press, First Second, Black Mask, Action Lab, Drawn & Quarterly, Boom! Studios, Dynamite Entertainment, Abstract Studios, Kodansha, VIZ Media and Valiant.

They provide a wide range of content, and there are others that I have missed. Some are notable for one reason or another. For example, Valiant is the only one of these that competes directly with Marvel and DC Comics in the superhero genre. Fantagraphics publishes art-house books as well as classic reprints like *Peanuts*.

Some of these smaller publishers are more like art-house publishers or tend toward more niche content. When looking for a publisher, you'll want to find one that publishes material similar to the type you're producing.

After these publishers, everyone else is competing for the remaining retailer dollars. It's very difficult to get much traction if your project isn't published by a major publisher. And to be clear, by traction, I mean sales of your book. Publishers like Action Lab and Black Mask have made great strides in the last few years.

We have one major distributor, and that's the aforementioned Diamond Distributors. It provides one catalog to retailers. Diamond does not allow just anyone to solicit projects in its catalog. Every project must meet certain criteria in order to be listed, so, in a very real way, Diamond is a bottleneck for the entire industry.

Other distributors have tried to compete with Diamond to provide alternative content, but none have become truly competitive on a national level.

SELF-PUBLISHING

The flip side of the comics industry is self-publishing. What this means is that the creators decide to play the role of publisher (and potentially distributor). This is a wholly different scenario.

For one thing, you control all aspects of printing and shipping, and you can also price your project however you like.

The best part about self-publishing is that you get to make all the decisions. If you want a strange page count or a different-sized book, go for it. The downside is that you make all the decisions and are responsible for all aspects of production, printing, shipping, distribution and storage. There's no one else to share in the hard work, and there's no one else to share in the expenses if something goes wrong.

Depending on your goals, there are some real advantages to self-publishing. For one thing, you can publish something that may not have huge commercial appeal but that you think showcases your talents

well. You might self-publish material to use as a kind of calling card and portfolio piece.

Some of the folks that have come through my courses or the Creators Workshop have done this to great effect. And it's helped kick off several comics careers.

You are in charge of your own destiny with these projects. And you can take your time selling the project without having to constantly nag a publisher to continue to promote it.

If you have the time and ability to attend multiple conventions per year, self-publishing can help you build your own fan base. It's through multiple interactions with a comic reader that he might become a fan of your work.

As with networking, if you're attending multiple shows, it's also good to have something new every year to promote and grow your fan base.

MARKET FORCES

Some things you can control, and others you can't. It's helpful to know the difference.

You have control over the pricing of your project, the page count, the marketing and the timing. If you're self-publishing, you have the maximum amount of control possible. If you're working with a publisher, the publisher may dictate all of these things.

You don't have control over the media and other websites. You can't force websites to review your comic or help you spread the word. You can try to cultivate relationships with these websites, but you can't force them to do anything. Try your best to get an article or review, but try not to get upset if it doesn't happen.

You have control of your budget, but you don't have control of what people are willing to pay for your project. This is one area where many people get it wrong. We have a tendency to overvalue our work and price it too high or assume interest will be greater than it turns out to be.

You don't have control over big news from bigger publishers. If you time your project to come out in May and DC Comics kills off Batman that month in a highly touted event, you're likely going to suffer because comics-news outlets are going to be dominated by the flood of promotion around that event, and it can box out your project. There's the off chance you can counter-program against that, but the reality is that if something big happens when you've planned your launch, it could hurt you and there's not a darn thing you can do about it. This applies to world events as well.

When my book *Five Days to Die* came out in a weekly release in September of 2010, Marvel also had a weekly event that same month. Their event was called *One Month To Live*. Sounds like these two projects are similar? Yes, it does. Was Marvel aware of my book? Nope. Was I aware of theirs? Nope. We both became aware of the other one when that Diamond Previews catalog hit shelves and both books were listed. In that case, it worked out okay for me because my little book kept being mentioned alongside Marvel's event book. There's a decent chance that it actually helped raise awareness of my project. On the other hand, it may have also hurt sales of my book since people may have chosen to read Marvel's book instead of mine. I'll never know.

There's no way we can control larger market forces. So I encourage you to focus on what you can control. Focus on the quality of your project, focus on your follow-through in getting the project into the hands of people who order it, and focus on being positive and upbeat when dealing with potential fans and the media.

If something outside of your control comes along and takes the wind out of your project's sails, do your best not to let it bother you. The alternative is that you do let it bother you, yet you still can't do anything to change it.

YOU'RE A BUSINESS AND A CREATIVE PERSON

Most of us to want to focus on the creative side of making comics. Let's face it, that's the fun part. But the reality is that the creative side needs the business side to pull its weight, too.

The bulk of this book is about the creative strategies and techniques that go into writing comics, but if making comics more than one time is your goal and you want to fund them without losing money, then you need to treat your art like a business. Because it is one.

There are three major aspects to running your art as a business:

First, your job as a businessperson is to get the best product for the least amount of money spent. Now, contrast this with my notes on collaboration. For example, there are times when negotiating with an artist where you could squeeze five dollars per page out of the artist and shave that off your budget. But it could backfire if the artist feels like she's being taken for a ride. It's difficult to weigh things like that. Generally, the idea is to keep your costs down as low as you can. I try to temper that with both reason and compassion.

The second thing you must do is find similar projects to yours. We call these comps. So, if you're just starting out, you may look for projects by creators with little fan following that are the same length as yours and are in the same or similar genre as yours. Then you look at what they sold if you can find that information (the website ICv2 puts out a sales chart every month of the top-300 comics). You're trying to estimate what your sales will be. I highly recommend estimating your sales conservatively. So if you think you can sell 1,000 units, maybe estimate that you can sell 800 units and do the math from there. Better to exceed expectations than to underperform.

From there, you should be able to get an idea of whether you can earn back the money you're going to spend. There's no guarantee that you will, and in fact, most self-published comics don't. But remember that money is often not your goal or at least, not your only goal. You may find it reasonable to lose some money if the project helps you in some other way.

The last major thing you have to do is market the project. Marketing takes on many forms, and there are far too many to go into here. Suffice it to say, marketing ranges from previews of the project to interviews with the creative team to advance reviews, pull quotes from known professionals, getting buzz about your project on social media, paid promotions, outreach to retailers and so on.

All of this is, of course, rolled up into your budget for the project. We'll talk about budgets soon enough. But remember that the three keys to a successful project are keeping the quality high but at a low cost, knowing where to set your expectations through comp projects and research and then marketing the heck out of your project in person and on social media.

THE CAREER PATH (CREATOR-OWNED)

One of the big ongoing debates in the comics-creator community is which is more advantageous to you as a creator: creator-owned or work-for-hire content. When thinking about your own career, it's good to have a handle on what both mean.

A creator-owned project means exactly what it sounds like, that the creators of the project own it. To clarify, the creators own not just the comic story but the characters, the storyline and any future storyline with the characters. That means they have total control of all those things.

Should Hollywood come calling, a studio will negotiate a deal for the rights to make a movie with you, not with a publisher who doesn't care if you get a piece of the action.

It also means that you own the merchandising and licensing rights, so if a company wants to make cuddly plush toys of your characters, then they negotiate that deal with you.

The creators reap the potential rewards of the project.

Sounds great, right? Well, it sure can be; just ask Robert Kirkman and Tony Moore, the creators of *The Walking Dead*. I think they've done okay with their little comic book.

But it also means that you'll likely have little help promoting your project and getting it into the hands of potential fans and buyers. It's hard work to go this route, and there's certainly no guarantee of a big payoff. The risk is entirely on you and your collaborators.

THE CAREER PATH (WORK-FOR-HIRE)

On the flip side is work-for-hire comics. These are typically comics in which a company or person pays you a flat fee to write stories with new or preexisting characters. In exchange for the upfront, guaranteed fee, you transfer all of your ownership of the material to the company.

You get a paycheck. But you have little or zero participation or control about what happens with your work. This is controversial because, for example, the creators of Superman were paid a work-for-hire fee for their first Superman story in 1938. Since then, DC Comics has made untold millions, probably billions of dollars off of the character. Meanwhile, Superman's two creators struggled the rest of their lives to pay their bills.

It's not a pretty picture when looked at in that light. There are some very real differences between the deals that creators made from the 1930s to the 1960s and the ones being made now. The most significant difference is that most creators today better understand exactly what it is that they are signing, and that wasn't true back in the 1930s. Often, creators didn't know that holding onto their creation was even an option. So creators today are making more informed decisions.

Another major difference is that some work-for-hire contracts may transfer your ownership; they may also put additional incentives into the contract beyond your flat fee. For example, if the comic sells over a certain quantity, then you get additional payments, or if a character that you created for the company turns up in other media, you could get another payment for that as well. Not all companies do that kind of thing, but some do.

You may wonder what my opinion is on the debate between the two—do I think one is good or just and the other not? I don't have a concrete opinion. I think we make our own decisions that are in our best interests as we see them at the time. The key is simply to know the deal you're making when you make it and to be okay with it—to make sure it has value to you.

BUDGETING

I saved the least popular topic for the very last section of the very last chapter. Most of us aren't independently wealthy, so we want to minimize our financial losses or, even better, maximize our profits.

The key to budgeting is knowing both your expenses and your reasonable revenue estimate. As you start out, assuming you're self-publishing, your expenses will likely be larger than your revenue. As I said before, that can be okay if your goals encompass more than just financial gain.

In the comics industry, we tend to do things by page rates. This is to say that you would agree to pay someone X amount for every page of their job that they do. So let's say you're paying $20 per page for lettering. If your project is four issues long at twenty pages per issue, you're looking at a total of $1,600 for your lettering alone. Beware the multiplier of pages! The fastest way to go over budget is to increase your page count.

169

The reason you want to budget prior to the outset of the project is simple. If it turns out that you likely won't get enough money back to achieve your other goals, you may want to either adjust the size and scope of the project or look into doing a different project altogether.

I don't want anyone getting into financial trouble if she can avoid it. That means doing the research, doing the math and knowing what you're comfortable with. There's no easy or quick way to do that. I spend a lot of time in the Creators Workshop answering and teaching budgeting lessons because they are so important, but they're also not flashy. Like taking medicine, most people don't want to talk about budgeting even though it's vitally important.

I encourage you to learn more about budgeting, forecasting and marketing. It's beyond the scope of this book, but I can't overstate the value of it.

TO SUM UP

The comics industry is always changing—and often quickly. In the 1990s, the market collapsed for a brief time. It changed again in the early 2000s, pulling itself out of the collapse.

You should always be working to grow your skills and your understanding of the market itself. If you are moving forward in relation to where you were six months ago or a year ago or five years ago, then you're doing the right thing.

One of the most important things you can do is focus on your progress (and yours alone) and the things that are within your power to control.

The comics industry can be a wonderful place to work. I have spent much of my career in comics, and I have greatly enjoyed my time crafting comics and helping others do the same. I hope that you'll find as much joy and value in the endeavor of making comics as I have.

NOTES

INDEX

A

action
 in panels, 98–99
 on pages, 101
acts, 19–20
art
 and dialogue, 129
 and text, 119–120, 135–136
art board, 13
artists
 finding, 160
 inspiring, 103

B

balloon numbers, 97–98
balloon placements, 133–134
 conversation flow, 135
 covering the art up, 135
 leading the eye, 134
 reading order, 134
 size of balloon and captions, 134
beats, 61
bleed, 14
bleed panels, 95
bullet time, 59

C

captions, 14, 124–125
 size of, 134
career path
 budgeting, 169–170
 business and creative aspects, 168
 creator-owned, 168–169
 work-for-hire, 169
catch phrases, 129
chapter breaks, 143
chapters, 70–71, 79–80
character arcs, 32–34
character bios, 140–141
character swap test, 72
characters, 15
 ancillary, 46–47
 background of, 25
 boons of, 29
 challenges of, 30
 creating characteristics for, 29
 details or idiosyncrasies, 30
 diagram template, 27
 goals of, 25–26
 motivation of, 25
 and plot, 24–25
 traits of, 26, 29
 turning points, 71–72
 unique attributes of, 25
 visualizing, 30–32
cliffhanger, 119
closeups, 105–106
collaboration, 160–161
color artists, 12, 120–121
color choices, 120–121
colorists, 12, 120–121
comic page anatomy, 94–95
Comics Experience, 7
comics industry, 166
concept, vs. story, 18–19
conflict, 18, 40
contrast, 62–63
conventions, 158–159
conversation flow, 135
conversations, 159
copy, 14
copy safe, 13
costuming, 32
credits, 125

D

data points, 78
denouement, 20
dialogue, 147
 and art, 129
 believability, 127–128, 132–133
 brevity, 132–133
 comic book mechanics, 131–132
 economy of, 128–129
 for visual medium, 129–131
 reading order, 132–133
 tricks, 129
digital presence, 161–162
double-page spread, 13, 115, 117

E

editors, 12
electronic balloons, 124
energy, 61
evaluation, 156
experimentation, 155–156
exposition points, 77
exposition, 75–76, 79
 dos and don'ts of, 76–77, 79
 examples of, 76
 setup and payoff, 77
extreme closeups, 105–106

F

facing pages, 13
filler, 44
first draft, 136–137
first person, as narrator, 48
flashbacks, 60–61
freeform layout, 115–116

G

genre blending, 63, 65
genres, 15, 17
grid layout, 115–116
gutters, 95

H

high concept, 14
hook, 18, 119

I

imagery, 55–57
impact, 119
inciting incident, 20
info dump, 76–77
inkers, 12
inset panels, 95

L

layering, 149
letterers, 12

M

mapping a movie, 43

INDEX

market forces, 167
messaging, 163
moment-to-moment action, 59
movie adaptations, 84
multi-panel pages, 119

N
narrator, 48, 57–58
networking, 154
 at conventions, 158–159
 in conversations, 159
 personal, 157–158

O
omniscient narrator, 48
outlines and outlining, 73–74
 cleaning up, 74
 individual pages, 89–90
 issue, 84–85
 page-by-page, 89, 99–100
 panel-by-panel, 100
 scene-by-scene, 86–89
 for visual medium, 85–86

P
pacing, 61–62
page layout, 113–114
page numbers, 97
page turns, 89–90, 110–111
page-by-page breakdown, 144–145
pages, 13, 94
 that flow, 111–112
panel borders, 95
panel descriptions, 97, 101
 checklist, 112
 detail panels, 105–106
 establishing shots, 103
 high-energy panels, 104
 identifying types of, 106
 impact panels, 105
 step-by-step panels, 106–107
panel information, organizing, 101–103
panel-by-panel breakdown, 145–146
panels, 13, 95, 97
 rules for, 98–99

paragraphs, 112
parentheticals, 98
partnerships, 160–161
pencillers, 12
pitches, 48–50, 156–157
plot
 and character, 24–25
 turning points, 72–73
protagonist, as narrator, 48
publishers, 12–13

R
radio balloons, 124
reading order, 132–133, 134
revelation, 119

S
scenes, 17, 45
 anatomy of, 45–47
 scene breaks, 144
 turning point in, 45
script, 95, 113
 first draft, 136–137
 format, 95–98, 126–127
 massaging, 136
 sample format, 96
second person, as narrator, 48
secondary character, as narrator, 48
self-publishing, 166–167
setup, 119
social media best practices, 163
social media marketing, 162
sound effects, 14, 125
splash panels, 105, 119
story concept, 18
story density, 84
story sentence, 38–39, 140
 central conflict, 40
 obstacles and antagonists, 39–40
story spine, 47, 51, 141–143
story structure, 19–20, 42, 44
 acts, 44–45
 scenes, 45–47
storytelling
 contrast in, 62–63

decompressed, 84
subtext, 127–128
symbolism 54–55

T
text, and art, 119–120, 135–136
themes, 14–15, 54
third person limited narrator, 48
third person narrator, 48
 as commentator, 48
 as detached observer, 48
 as interviewer, 48
 limited, 48
 secret character as, 48
 unreliable, 48
thought balloons, 14, 124
ticks, 129
tiers, 94
time
 expansion of, 59–60
 flashbacks, 60–61
 moment-to-moment action, 59
 and size, 50
 time jump, 60
titles, 125
trim, 13
turning points, 20, 45–46, 71–73

U
unreliable third person narrator, 48

V
villains, 41–42
visualization, 146–147
visualizing characters, 30
 color scheme, 31
 costume functionality, 32
 distinctive markings, 32
 matching looks and traits, 32
 silhouette, 31–32
voice, 154–155

W
word balloons, 14, 124, 131
writers, 12

Comics Experience® Guide to Writing Comics. Copyright © 2018 by Andy Schmidt. Manufactured in China. All rights reserved. No part of this book may be reproduced in any form or by any electronic or mechanical means including information storage and retrieval systems without permission in writing from the publisher, except by a reviewer who may quote brief passages in a review. Published by IMPACT Books, an imprint of F+W Media, Inc., 10151 Carver Road, Suite 300, Blue Ash, Ohio, 45242. (800) 289-0963. First Edition.

fw a content + ecommerce company

Other fine IMPACT books are available from your favorite bookstore, art supply store or online supplier. Visit our website at fwmedia.com.

22 21 20 19 18 5 4 3 2 1

DISTRIBUTED IN THE U.K. AND EUROPE BY F&W MEDIA INTERNATIONAL, LTD
Pynes Hill Court, Pynes Hill, Rydon Lane, Exeter, EX2 5AZ, UK
Tel: (+44) 1392 797680, Fax: (+44) 1626 323319
Email: enquiries@fwmedia.com

ISBN 13: 978-1-4403-5184-6

Project managed by Noel Rivera
Edited by Mary Burzlaff Bostic
Production edited by Jennifer Zellner
Designed by Jamie DeAnne
Production coordinated by Jennifer Bass

Photo of Andy Schmidt by Alix Schmidt.

Copyright Andy Schmidt, 2013.

DEDICATION

This book is dedicated to my students at Comics Experience and the members of our Creators Workshop. As much as I have to offer you, I'm certain that I receive twice as much back in the myriad of ways that you all inspire me, motivate me and teach me new things about comics and myself.

 I am a better person for having known you all.

ABOUT THE AUTHOR

Andy Schmidt is a former senior editor at IDW Publishing, former editor at Marvel Comics and writer of such comics as *Five Days to Die, X-Men: Divided We Stand, G.I. Joe: Future Noir, Achilles Inc.* and other titles you've seen in this book. Andy launched Comics Experience (comicsexperience.com) for people who want to make comics or work in the comics industry.

During his nearly six years at Marvel Comics, Andy edited such popular comic books as *X-Men, X-Factor, Alias, Secret War, Captain America: The Chosen, Iron Man/Captain America: Casualties of War, Avengers Classic* and the *Annihilation* saga. As an assistant and associate editor, Andy worked on nearly every major character in the Marvel canon—from Spider-Man to the Avengers and Fantastic Four.

In 2007, Andy founded Comics Experience to pass his knowledge on to students. In 2008, Andy wrote an authoritative, Eagle Award-winning book about making comics, *The Insider's Guide to Creating Comics and Graphic Novels*, published by IMPACT Books.

In 2010, he created the Creators Workshop as part of Comics Experience, where students can learn and grow together as creators.

In 2013, Andy left corporate life and began consulting and writing in the entertainment industry on properties such as Spider-Man, the Avengers, Guardians of the Galaxy, Star Wars and Transformers as well as consulting with film and television studios. Andy wrote several video games, including the critically acclaimed *Transformers: Devastation*.

In April of 2018, Comics Experience teamed up with publisher Source Point Press to launch a line of comics dedicated to helping new creators break into the industry. These comics are created by Comics Experience students and Creators Workshop members. The line launched at Chicago's C2E2 show.

Andy is the co-host of the Comics Experience *Make Comics* podcast, and you can follow him on Twitter at @ComicExperience.

ACKNOWLEDGMENTS

This book couldn't have happened without the good folks at IMPACT Books, especially Mona Clough, Noel Rivera and, of course, my editor Mary Bostic. Their support and faith in the project has never wavered.

I have literally hundreds of comics creators whom I think of as my mentors and whose lessons and inspiration I draw from every day. A small selection of those mentors include Robert Atkins, Brian Michael Bendis, Tom Brevoort, Peter David, Joshua Hale Fialkov, Michael Higgins, Klaus Janson, Michael Oeming, Tom Palmer, Khoi Pham, John Romita, Jr., Chris Ryall, Chris Sotomayor, Marc Sumerak, Mark Waid, Joshua Williamson and so many other industry veterans who have given so much of themselves to the industry and to me.

The rest of my inspiration and support comes from my wife Alix, two sons Cale and Oliver, my parents Pam and Dick and my brothers Arne and Craig. Nothing I do is possible without their support and help.

And, of course, all of the creators that worked on (or are currently working on) the various projects featured in this book. For *Achilles Inc.*: Daniel Maine, Francesca Zambon and Marco Della Verde. For *Exalt*: co-writer Paul Allor with artist Matt Triano. For *Babylon*: Kieran McKeown and Adam Cutrone. For *Avalon*: artist Andrea Di Vito. For *Deadlock: Day to End a Life*: artist Agustin Padilla. For *Praetor*: character designer Ladronn with artists Ryan Gutierrez and Adam Cutrone. For *The Courier*: artist Joshua Flower. For *Five Days to Die*: Chee and letterer Chris Mowry as well as cover artists David Finch and Chris Sotomayor.

Lastly, you, the comic creators of tomorrow who have purchased and read this book. You are who this was all done for. I hope to see you at shows, perhaps in a course or our Creators Workshop. Wherever I see you, I hope you're constantly moving forward and pursuing your dreams and that maybe, just maybe, this book can, in some way big or small, help you achieve them.

Ideas. Instruction. Inspiration.

Check out these *IMPACT* titles at IMPACTUniverse.com!

Follow **IMPACT** for the latest news, free wallpapers, free demos and chances to win FREE BOOKS!

Follow us!

IMPACTUNIVERSE.COM

- Connect with your favorite artists
- Get the latest in comic, fantasy and sci-fi art instruction, tips and techniques
- Be the first to get special deals on the products you need to improve your art